SECRETS
of
LIGHTING
on
LOCATION

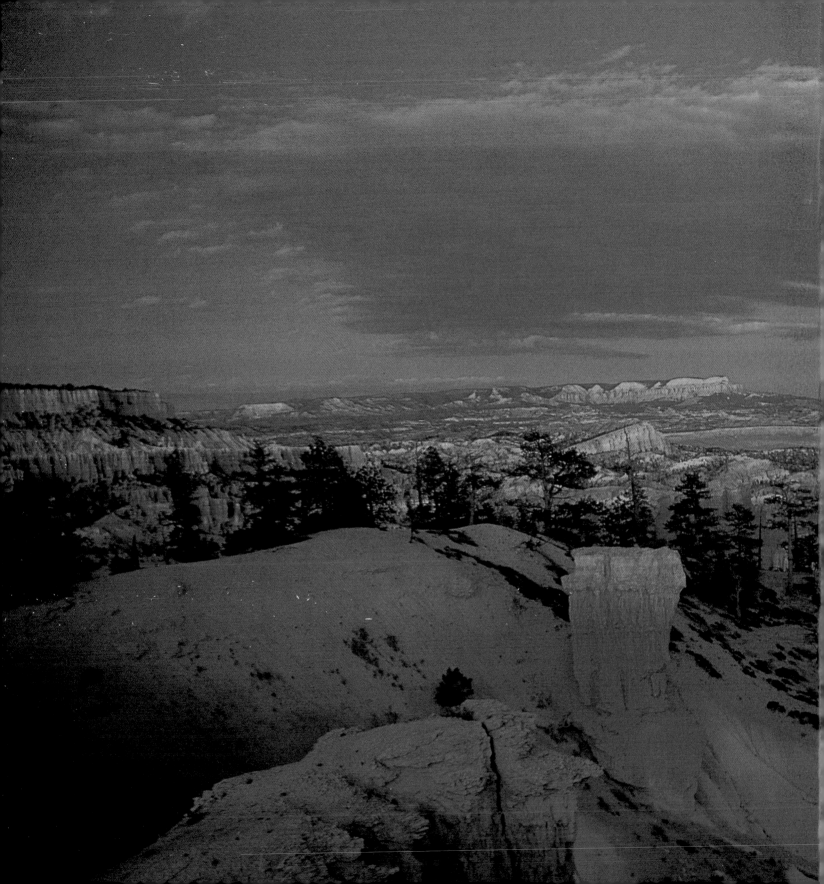

SECRETS *of* LIGHTING *on* LOCATION

A PHOTOGRAPHER'S GUIDE TO PROFESSIONAL LIGHTING TECHNIQUES

B O B K R I S T

Half-title page:
FAMILY IN CANOE, Boundary
Waters Canoe Area, Minnesota.
Nikon 8008S, Nikkor 20-35mm
AF zoom lens, Fujichrome Velvia
exposed for 1/125 sec. at
f/5.6.

Title-page:
HOODOOS, Bryce Canyon,
Utah. Nikon 8008S, Nikkor
20mm wide-angle lens, tripod,
Fujichrome Velvia exposed for
1 second at f/5.6.

Page 5:
MOTHER AND CHILD,
New Jersey. Nikon 8008S,
Angenieux 28-70mm AF zoom
lens, Kodachrome 64 exposed
for 1/60 sec. at f/4.

Page 6:
STONE MOUNTAIN LASER
SHOW. Atlanta, Georgia.
Nikon 8008S, Nikkor 24mm
wide-angle lens, tripod,
Fujichrome 64T exposed for
1 minute at f/4.

Senior Editor: Robin Simmen
Editor: Liz Harvey
Designer: Bob Fillie, Graphiti Graphics
Lighting diagrams: Jay Anning
Production Manager: Ellen Greene

Copyright © 1996 by Bob Krist
First published 1996 in New York by Amphoto Books,
an imprint of Watson-Guptill Publications,
a division of VNU Business Media, Inc.,
770 Broadway, New York, N.Y. 10003
www.watsonguptill.com

Library of Congress Cataloging in Publication Data
Krist, Bob.
 Secrets of lighting on location : a photographer's guide to
professional lighting techniques / [Bob Krist].
 p. cm.
 Includes bibliographical references and index. .
 ISBN 0-8174-5823-9 (paper)
 1. Photography—Lighting. I. Title.
TR590.K75 1996 96-3187
778.7—dc20 CIP

Manufactured in Hong Kong

3 4 5 6 7 8 9/04 03

This book is dedicated to
the real lights in my life:
my wife, Peggy, and my sons,
Matthew, Brian, and Jonathan

Bob Krist is a freelance photographer who works regularly for such magazines as *Travel/Holiday, Travel & Leisure, National Geographic, National Geographic Traveler, Gourmet,* and *Islands*. His photographs from these assignments have won awards in the Pictures of the Year, *Communication Arts,* and World Press Photo competitions. Krist is also an accomplished writer, serving for seven years as a contributing editor and photography columnist at *Travel & Leisure*. Currently, he is a contributing editor at *National Geographic Traveler,* where he writes a photography column. He also writes and illustrates how-to and feature articles for several magazines, including *National Wildlife, Shutterbug's Outdoor and Nature Photography,* and *Outside*. Along with his magazine work, Krist photographed two coffee-table books, *Caribbean* and *West Point: The US Military Academy*. He also appears periodically as a photography correspondent on "CBS This Morning" and teaches a travel-photography class at the annual Maine Photographic Workshops.

ACKNOWLEDGMENTS

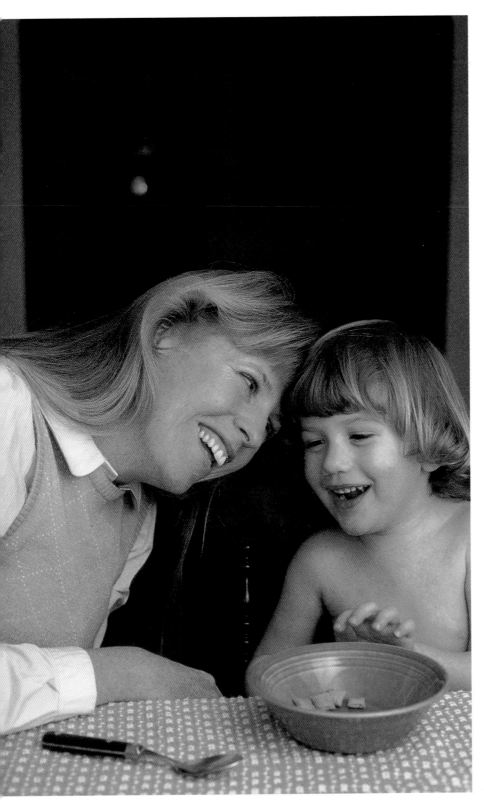

My thanks go out to many people in helping this book come together, especially to my editors Robin Simmen and Liz Harvey, who took a mass of raw material and made it readable. Special thanks go to my colleagues Ken Haas, Ian Lloyd, Chuck O'Rear, Jim Richardson, Bob Sacha, and Jeff Smith, who have generously shared their talents, insights, and remarkable photographs in the Gallery section.

Other lighting and equipment gurus to whom I owe a large measure of gratitude include Bryan Allen, Paul Armato, Jon Falk, Allen Green, Ken Kerbs, Eddie Lambert, Steve Moore, Paul Peregrine, and Paul Schwarz.

Finally, my continuing gratitude goes to all the photo editors, designers, and art directors who have been dispatching me into the field for nearly two decades in pursuit of the sweet light.

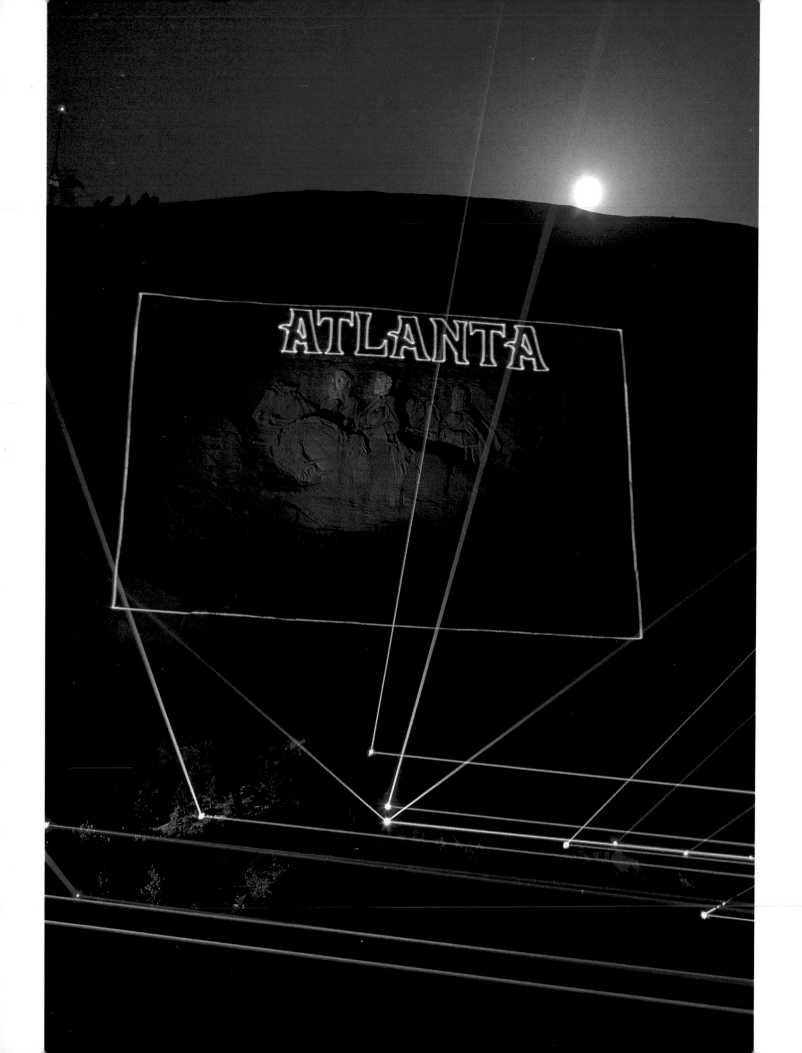

CONTENTS

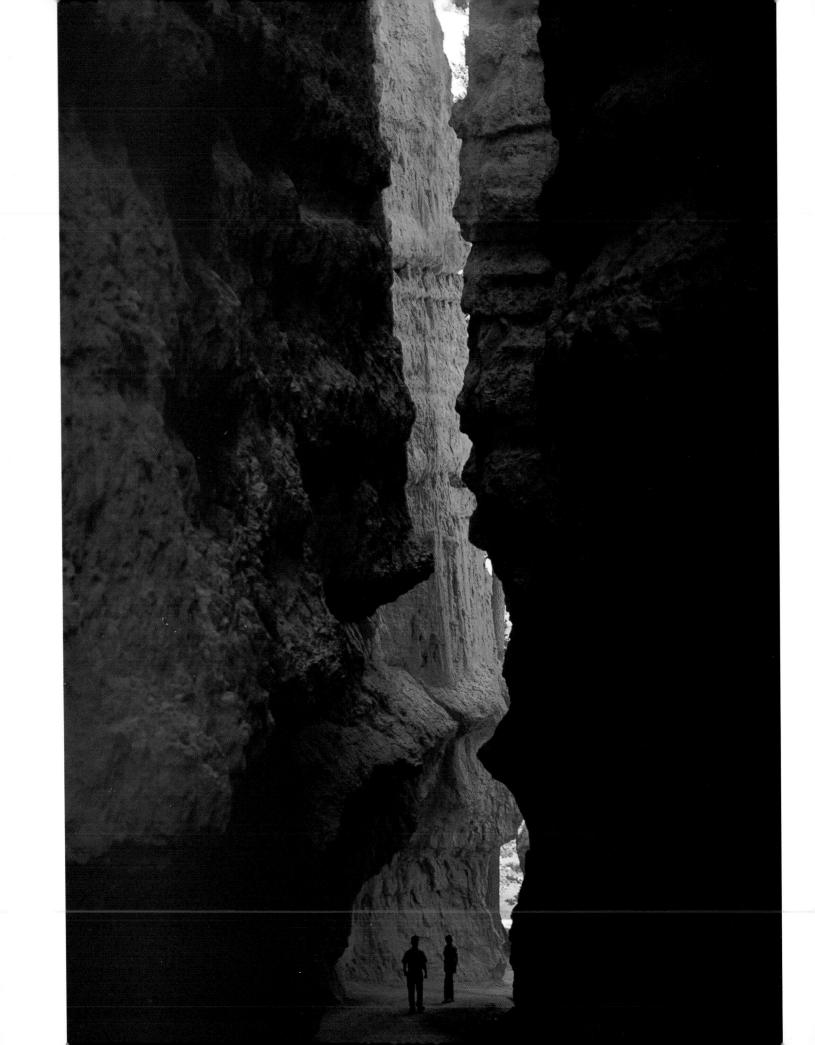

INTRODUCTION

Sooner or later, every photographer is forced to leave the safe confines of the studio or office and head out into the cold and often dark world to make pictures. Although some photographers look forward to shooting on location, others dread the experience. For all photographers, however, one thing is certain. Once you leave your quiet, organized, and orderly studio, you find that chaos reigns supreme. It is a jungle out there, full of wondrous discoveries, as well as pitfalls and unforeseen obstacles. A lot of what happens to you depends on both how versatile and well prepared you are to deal with the unknown and how quickly you can react and improvise.

Survival in today's competitive environment requires a great deal from a photographer. On one hand, you have clients whose demands for visual excellence are becoming more and more sophisticated. On the other hand, you face a general belt-tightening that has eroded budgets and the amount of time you have to produce good work. And when you add to the mix the seemingly unending supply of talented photographers vying for assignments, you can easily see how Darwin came up with his theory!

While studio photographers have always been expected to be experts when it comes to artificial lighting, the requirements have been less clear for location shooters. There are photographers with long, distinguished careers whose knowledge of auxiliary artificial lighting is so rudimentary that it is almost nonexistent. These individuals have survived strictly by their mastery of light from the sun, circumventing or turning down assignments that call for any lighting gear beyond a tripod. While you can admire and learn from these available-light maestros, emulating them is foolish; for every available-light-only photographer who is working, there are literally thousands who have dropped by the wayside and have been swallowed up by the photographic jungle's heart of darkness. Photography students and art-school denizens aside, the days of making a virtue out of someone's ignorance of artificial lighting are over. This is especially true for anyone who is serious about making a living with a camera.

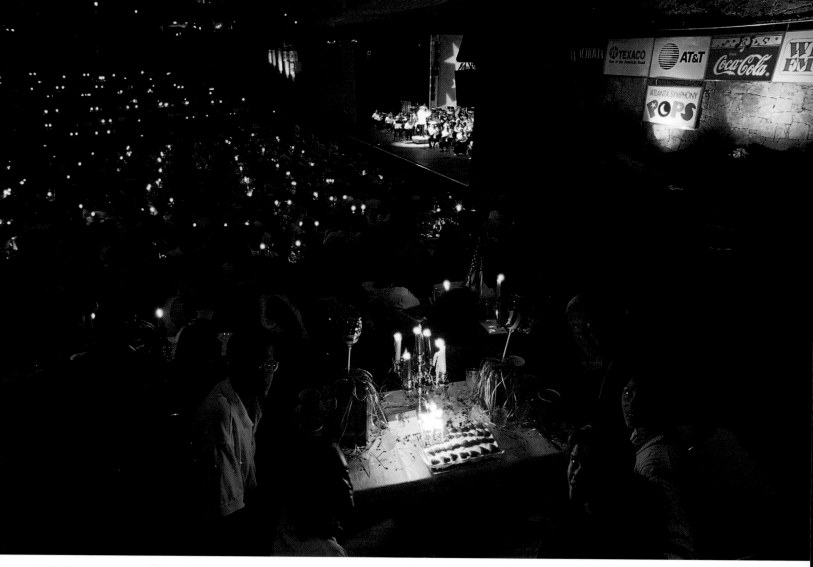

CANDLELIGHT CONCERT,
Atlanta, Georgia. Nikon
8008S, Nikkor 20-35mm zoom
lens, tripod, Fujichrome 100
exposed for 1/2 sec. at f/4.

At the Atlanta Symphony's
open-air concerts in Chastain
Park, people go all out with
their alfresco dining. On this
National Geographic Travel-
er assignment, I wanted to
capture the mood, so I scouted
the audience until I found this
attractive family at their
beautifully decorated dinner
table. After securing permis-
sion to photograph them, I
took an incident-light reading
near their faces to determine
the proper exposure. Shooting
at dusk, I knew the rest of the
scene would be underexposed,
but light enough to register on
film. I hoped that the orches-
tra wouldn't burn out com-
pletely in the much brighter
stage light.

THE K.I.S.S. PRINCIPLE

While you must understand and know how to work with artificial lights, you don't need to become a lighting virtuoso who has a dozen cases of heavy, high-priced strobe gear and a couple of assistants to lug them (although for some jobs, that is precisely what you need). You've read the interviews with the photographers who like to create the most elaborate lighting setup possible. You know the drill. "I sent my 12 assistants with 54,000 watt-seconds of light coming from 24 heads to light up the entire mountain to get enough shadow detail for this sunset picture . . ." and so forth.

When the resulting pictures actually reflect the amount of effort and creativity that go into these setups, I take my hat off to the photographers. But all too often, the final images don't reflect the energy put into them. In the end, such a time-consuming, exhausting overproduction can be as dangerous to

photographers as a complete ignorance of lighting technique can be. It can burn you out and alienate—not to mention bankrupt—your client.

My aim here is to present a wide-ranging series of situations you might encounter on location and some ideas for the simplest way to light them. In fact, a large number of the pictures in this book, none of which I shot in a studio, were photographed with only one or sometimes two lights. The key to effective location lighting is to find the most basic appropriate response to the shooting situation you're faced with and to utilize whatever is at your disposal. In other words, "Keep It Simple, Sweetheart." I call this the K.I.S.S. principle. While I used electronic flash for most of the photographs included in this book, you'll also find such sources as flashlights, campfires, car headlights, ambulance "lollipop" flashers, and candles. If it emanates some type of light, I've probably used it in a picture.

TRANSFORMING LOCATIONS WITH LIGHT

RESEARCH LAB, Rahway, New Jersey. Nikon FE2, Nikkor 20mm wide-angle lens, tripod, Kodachrome 64 exposed for 1/2 sec. at f/8.

Most laboratory environments pose two problems: fluorescent lights and clutter. To simplify the background, you can often use seamless paper to simulate a wall. Here, since the background seamless was translucent tracing paper (a useful item for lab shots), I decided to put the light through it, bathing the set in diffused backlight. To avoid an unnatural-looking hotspot, I bounced the single Dyna-Lite head into an umbrella behind the paper. I exposed Kodachrome 64 at f/8 for 1/2 sec. in order to burn in the computer screen.

The ability to improvise, to take leads and ideas from the environment itself, is critical to successful location lighting. Occasionally, you'll come across locations that are incredibly bad, dark, and disorganized. In these shooting situations, your only option is to completely transform the locations with light.

In the boom time of the 1980s, I, like many other location photographers, worked a great deal in the corporate annual-report field. This was an era when American businesses used their annual reports as lavish showcases for their achievements. (Today's sparse, nuts-and-bolts reports are meant to suggest what lean, mean, no-nonsense outfits the companies have become in the 1990s.) Bold, graphic, and colorful photographs were the order of the day, and I traveled all over the world shooting the labs, offices, and fac-

tories of such large companies as DuPont, AT&T, and Merck & Co.

I could always count on the locations being horrible, ranging from cold and sterile to filthy and disgusting. The best corporate photographers could take an awful location and make a beautiful picture. Some of this entailed physically moving elements in the scene. As the great photographer Gregory Heisler once said, photography is "10 percent genius and 90 percent moving furniture!" But most of the time, the essential ingredient in transforming the mundane into the magical was the photographers' command of light. To squeeze out a good picture often took a half day and sometimes even a full day.

At one point, the graphic designers I and many of my colleagues worked for became so used to seeing slick, beautiful photographs of these locations that they began to take the images for granted. To counteract this—and to prove how hard I had to work to earn my day rate—I began to include "before" pictures along with my final products, the "after" pictures that were the result of my lighting labor. The old saw about a picture being worth a thousand words worked wonders, and I found that I got more respect (and some new business) when my clients were able to see what a mess a place was when I first arrived. I've included some of these "before" and "after" treatments in this book, and there is no better illustration of what light can do for a location.

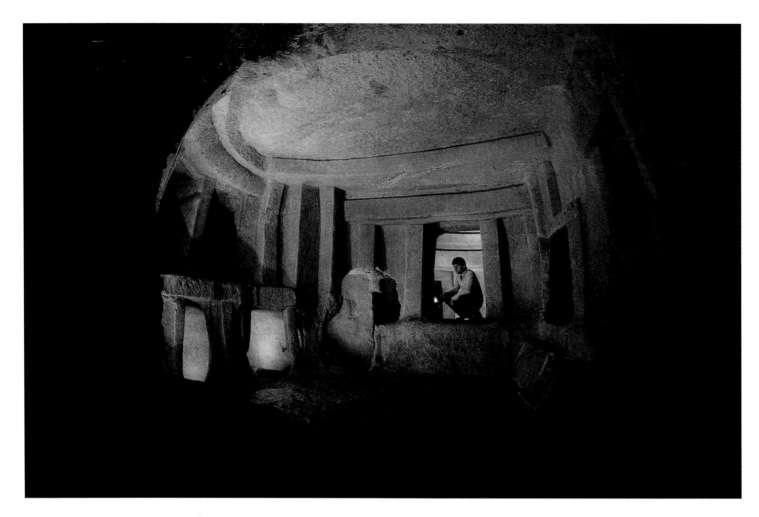

CATACOMBS, Malta. Nikon
FE2, Nikkor 16mm wide-angle
lens, tripod, Kodachrome 64
exposed for 1/8 sec. at f/5.6.

*Working for National Geo-
graphic magazine, I needed a
shot of the Hypogeum, a
Bronze Age burial temple and
burial chamber. It is pitch
dark down in the Hypogeum,
and there is no electricity. So
I used five battery-powered
flashes, each covered with a
Roscolux #18 flame gel to re-
tain the warm feel of the sand-
stone. I bounced an Armatar
300 at full power into the
wall to illuminate the main
chamber. For the chamber
behind the archeologist, I used
an Armatar 200 at full power,
removing the reflector for
bare-bulb lighting. Next, I illu-
minated the small chambers
on the left with Sunpak 444
flashes. All units had a slave,
and I triggered them with a
Wein SSR infrared transmitter.*

LESS IS MORE

While corporations and magazines were willing to
pay for photographers to take one or two assistants
along with 10 to 20 cases of equipment wherever
they went in the 1980s, the environment in the
1990s is a bit different. Yes, some assignments still
require an abundance of equipment. But by and large,
photographers are discovering that they must work
faster and simpler.

 This has certainly been my experience. While the
majority of my assignments in the 1980s were corpo-
rate jobs, most of my work now is editorial, specifi-
cally travel, or in the educational field, producing
viewbooks for colleges and universities. Overall, the
locations I work with now are much nicer than they
used to be. I'm not required to go into factories and
offices, but into restaurants, hotels, inns, museums,
and classrooms. Equally important, I don't have a
whole or even a half day any more to spend on one
picture. Often I have only a few days to shoot an
entire region or city or university.

 Although I can work with available light more
now than I was able to in my corporate days, I'm still
required to use auxiliary lighting, not so much to
transform a location, but to enhance it. More often

than not, clients don't have a budget for an assistant
or even a willingness to pay for excess baggage
charges! I've had to teach myself to work more simply
with less equipment. Like the backpacker who cuts
the handle off his toothbrush to save a couple of
ounces, I've trimmed my equipment to a minimum,
seeking out the smallest, lightest, and most portable
version of whatever piece of equipment I need. I've
learned to do more with less.

 I've been helped in my quest by the equipment
manufacturers themselves. One of the quietest
aspects of the autofocus revolution has been the
number of incredible improvements in the flash sys-
tems of the major camera manufacturers. While pho-
tography magazines are largely interested in whose
autofocus camera is faster or better—a big concern for
sports and possibly wildlife photographers—the
working "photographer in the street" is probably
more interested in the flash system. Focusing a cam-
era has always been a far less complicated affair than
calculating flash exposures and fill-flash ratios. The
new flash systems have made these previously
tedious operations fully automatic, and thus, have
made photographers' lives simpler. And simplicity is
a primary tenet of any location-lighting philosophy.

HOW TO USE THIS BOOK

SHORE TEMPLE,
Mahabalipuram, India. Nikon
8008S, Angenieux 28-70mm
AF zoom lens, tripod,
Fujichrome Velvia exposed
for 2 seconds at f/4.

*I needed a dramatic image of
the Shore Temple for a story
on southern India that I was
shooting for Travel/Holiday
magazine. Unfortunately, the
days were hazy during my
trip. But I knew that the tem-
ple was illuminated at night,
and getting this shot was sim-
ply a matter of waiting until
dusk when the temple would
stand out against the color of
the sky.*

Throughout this book, the text deals with general principles of lighting and lighting equipment. However, my intention isn't to make this book an "Intro to Lighting Theory 101" course. I briefly discuss basic principles, such as guide numbers, lighting ratios, and the dreaded Inverse Square Law, which seems imposing at first. But the main thrust of the book consists of specific lighting solutions for a variety of situations, as well as nuts-and-bolts tips on what gear to use and how to pack and transport it. You'll find most of this information in the captions and lighting diagrams that accompany the photographs.

Keep in mind that my use and mention of specific brands of camera and lighting equipment aren't meant to be an endorsement. They merely result from the fact that I use the equipment in the field, and it works for me. I'm not sponsored or subsidized by any manufacturer of cameras, lighting gear, film, or accessories. I've either purchased or rented at market rates every piece of equipment I use.

If you already have a good handle on lighting basics, you can cut to the pictures, captions, and side-bars to pick up a few new additions to your bag of tricks. But if you're just starting out, first read the text for the fundamental principles of lighting, and then check the pictures and captions to see how these rules are applied in the real-world jungle that is location photography!

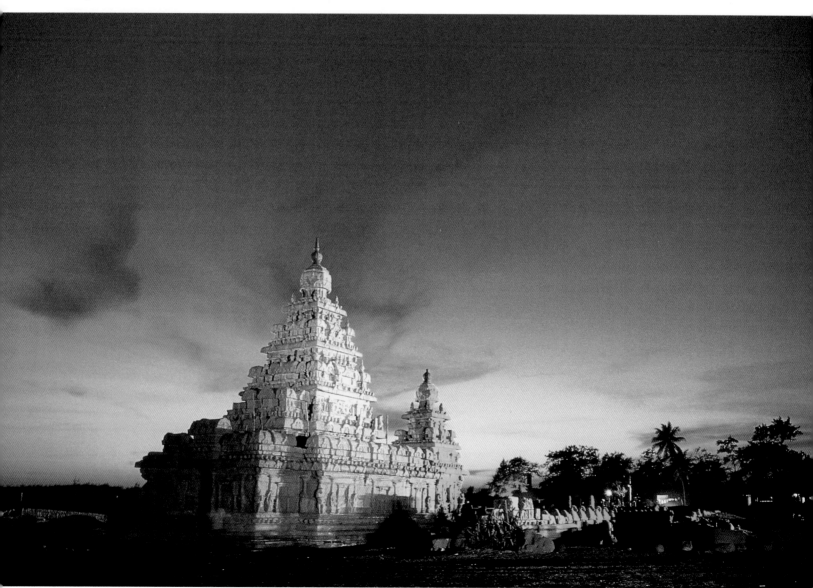

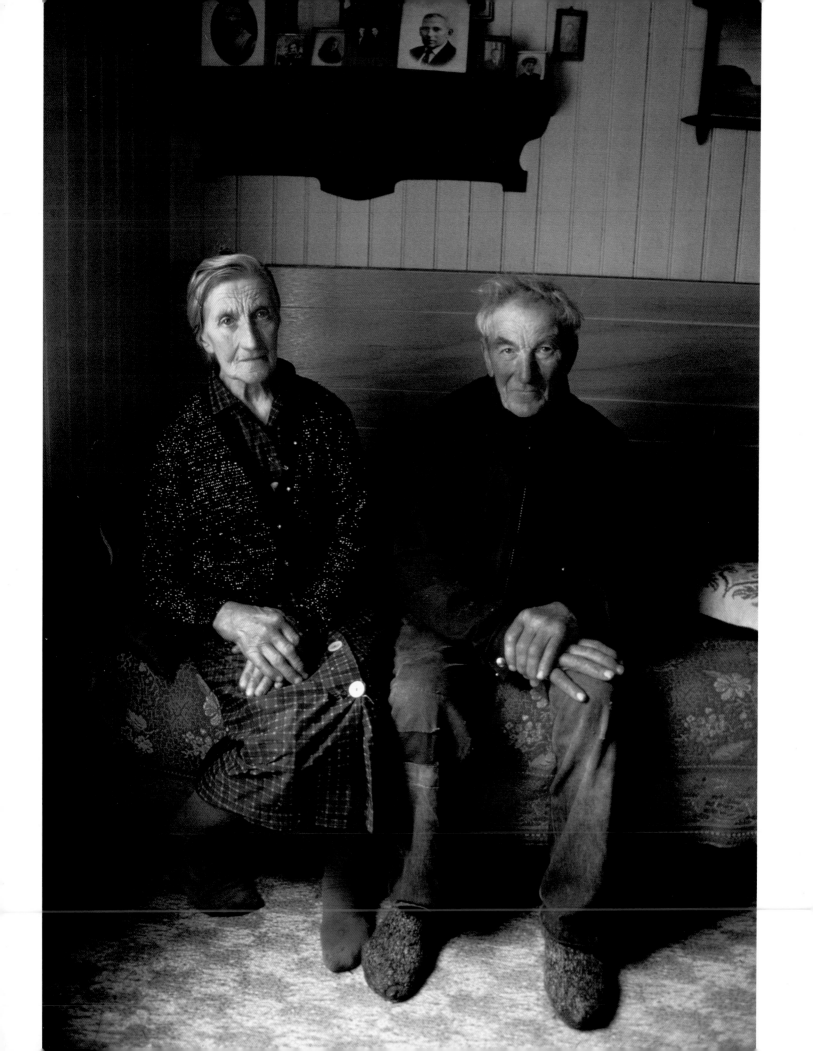

AVAILABLE LIGHT

Windowlight is one of my favorite sources for portrait work. Here, its classic style, reminiscent of a van der Meer painting, is well suited to the rugged features of this couple, who live on a farm in a remote portion of northwestern Iceland. Working on an assignment for National Geographic, I asked the couple to sit next to a window that was just off camera on the left, and they struck their own stoic pose.

Over the years, the term "existing light" or "available light" has become synonymous with low-light photography. For the purposes of this book, however, I'm going back to a broader understanding of existing light as being the light on location that is available—be it from the sun or from artificial sources already in place at the location, such as light bulbs, candles, headlights, flashlights, and campfires.

You could fill a library with books about shooting with available light. But I don't intend to provide a comprehensive treatment here. I simply discuss the basics of the main types of natural light and how to modify them.

The first and best option for any location-lighting situation is natural light. Why? Because you can readily see and measure the sun's effects, you don't have to be concerned about voltage and power sources, and unless the weather is changing rapidly, you don't have to worry about it shutting off in the middle of a shoot. The myriad incarnations of natural light are fascinating, something a careful, observant photographer can almost always put to good use.

The keys to working with natural light are recognizing its basic types—frontlight, sidelight, toplight, and backlight—and knowing which subject matter is well suited to which type of light. When I look at the portfolios of beginning photographers at some of the workshops I teach, I'm always amazed by how little attention they pay to light; few have a true feel for light. Their subject matter may be interesting and their compositions acceptable, but often awful lighting ruins their pictures.

The trick is to understand the advantages and disadvantages of the light you have on hand, and then work to maximize the opportunities it offers. For example, if you're shooting a portrait outdoors at midday, you'll probably want to position your subject in bright shade rather than photograph the face with deep shadows filling the eye sockets. The angle of the direct, overhead sun produces these unappealing shadows.

Another problem is that many photographers don't realize that their film can't "see" the light the same way we do. The eye perceives countless shades between a burnt-out, glaringly bright highlight and a black, impenetrable shadow, but film sees only a few. For the film to register an image so that it looks like what you see, you have to make sure that what you record falls within the film's limited contrast range. So, in addition to recognizing different types of light and purposes for each, you must also be able to modify that light in order to make it readable on film and better suited to the subject matter.

IDENTIFYING DIFFERENT KINDS OF LIGHT

Learning to recognize various types of natural light is really about understanding the angle of the sun in relation to your subject and how diffused that light source is, as well as how the time of day affects light quality. Photographers commonly refer to four different angles of light: frontlight, sidelight, backlight, and toplight. They also distinguish between direct sunlight, overcast, and open shade, and they know that the color of light changes throughout the day, from rosy warm at sunrise, to cool and bright at noon, and then warms up again in the afternoon until sunset. Photographers must also know how to shoot in the illumination that comes from such light sources as candles and campfires. As you become more aware of and familiar with how light changes as the sun moves through the sky and around your subjects, you'll be able to take advantage of the unique opportunities each kind of light offers.

Frontlight. Somehow, the Celtic warning to "keep the sun behind your left shoulder" managed to work its way into our collective photographic unconscious. During the era of the Brownie and Instamatic cameras, with their rudimentary optics and slow-speed film, this was basically good advice. But this guideline has probably misled more fledgling photographers into taking bad pictures than any other piece of photographic lore.

GIRL WITH BATIK BUTTERFLY MATERIAL, Penang, Malaysia. Nikon 8008S, Nikkor 80-200mm AF zoom lens, Fujichrome Velvia exposed for 1/125 sec. at f/2.8.

I was shooting an assignment in Malaysia for Travel/Holiday magazine when I came upon this young girl. She was standing outside her family's fabric shop. I like the way the last rays of the setting sun hit the material.

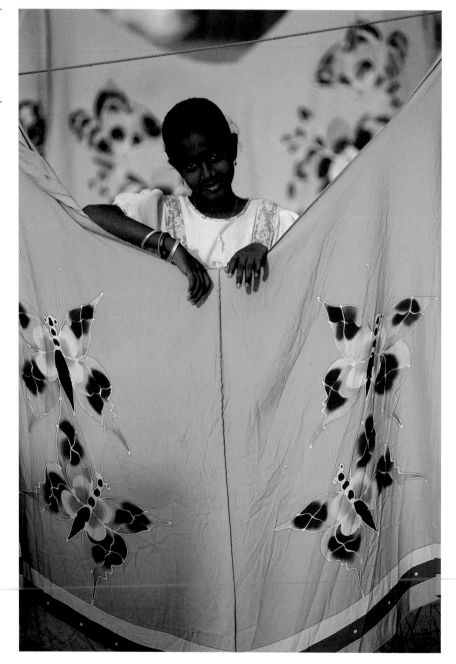

COUPLE ON HORSEBACK IN SURF, Bermuda. Nikon 8008S, Nikkor 20mm AF wide-angle lens, Fujichrome Velvia exposed for 1/125 sec. at f/5.6.

I photographed this couple for a potential cover for a Travel & Leisure article about Bermuda. All I needed to make this shot was the warm sidelight and an ability to walk backward through the surf.

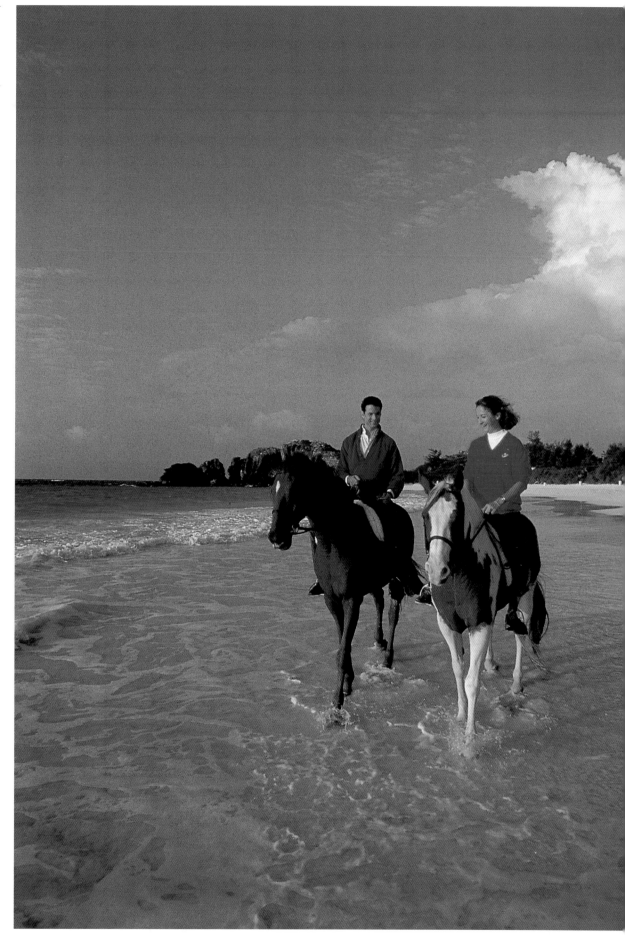

PROFESSIONAL MODELS
AT OUTDOOR CAFE, Berlin,
Germany. Nikon 8008S,
Nikkor 80-200mm zoom lens,
Fujichrome 100 exposed for
1/250 sec. at f/4.

*My shooting schedule was so
tight when I was photograph-
ing models in Berlin for a
Lufthansa brochure that I
often had to work in the
harsh midday sun. Fortunate-
ly, I found a table where I
was able to turn the models
away from the sun. I then
used the white side of a 38-
inch gold/white Flexfill to
bounce some additional light
into the scene.*

As its name implies, frontlight hits the subject squarely in front of it, casting shadows only behind it. So, frontlight is largely featureless and one dimensional. Because it hits the subject from the same angle as the camera sees it, pictures exposed with it lack the sculpting shadows that can create a sense of depth on film, an otherwise two-dimensional medium. While this type of light adequately records a scene, it rarely imparts any magic.

There is an exception, however: frontlight that originates from a low-hanging, early-morning or late-afternoon sun. Its warm color and softer, more diffuse light make frontlight a viable option for portraiture or architectural work. But generally, for most times of the day, I don't seek out frontlight on location because it usually doesn't add any drama.

Sidelight. The best kind of light for capturing the mood and the majesty of landscapes on film occurs in early morning or late afternoon, when the sun angles into the scene from the side. The interplay of highlight and shadow that this produces, which is known as *chiaroscuro* in painting, brings out both the texture and the depth of a landscape, and the golden tones of the sun at these times of day further infuse scenes with a special glow.

While sidelight is superb for landscapes, the sculpting shadows it creates make it a bit too severe for portraiture. Unless you want to emphasize wrinkled or craggy features with dramatic shadows, other kinds of light are more suitable for people.

Backlight. Nothing surpasses the soft glow of backlight for evoking a feeling of romance. In landscapes, backlight accentuates the highlights in sea spray, fog, and smoke. In portraits, it creates a halo around the subject's hair and shoulders, which separates the person from the background and helps suppress unflattering facial details. People react so strongly to this type of light that it has become a standard in any movie scene or still picture meant to elicit feelings of nostalgia, warmth, or general well-being. Despite backlight's frequent use, its dramatic effectiveness never diminishes.

Backlight does have drawbacks, however. It tends to wash out colors, rendering the subject or landscape in monochrome. So you must take great care to prevent the light from shining directly into the lens so that *halations*, which are bright, glowing areas around objects, and *flare*, which consists of reflections of the interior glass elements of the lens, don't appear in the photograph. Also, the volume of light coming from behind the subject often fools a camera's through-the-lens (TTL) light meter. This will result in underexposure unless you compensate for this condition.

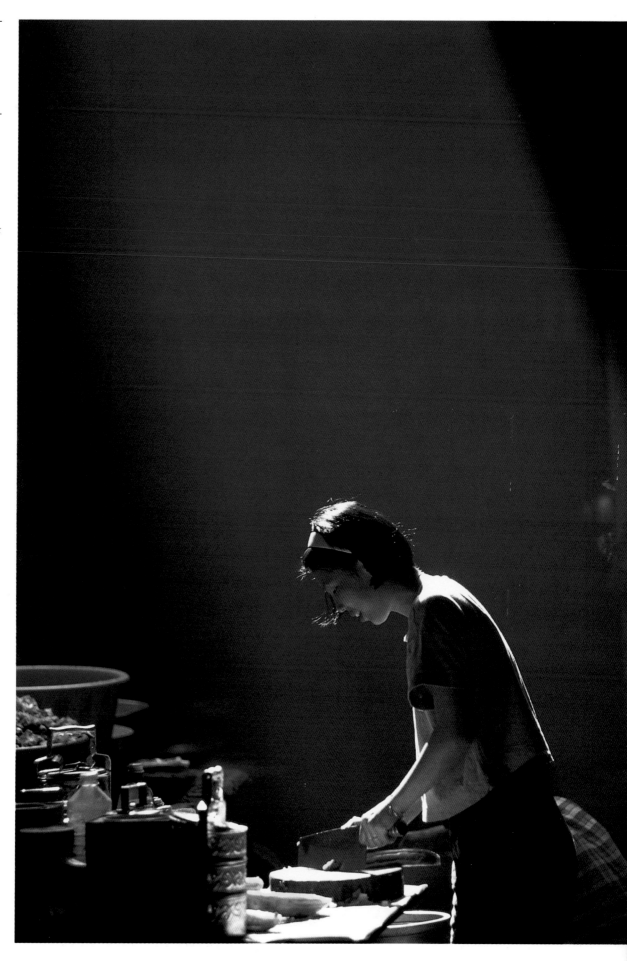

RESTAURANT WORKER
CHOPPING FOOD, Malacca,
Malaysia. Nikon 8008S,
Nikkor 80-200mm zoom lens,
Fujichrome 100 exposed for
1/250 sec. at f/4.

A shaft of sunlight streaming down from a skylight into a courtyard was the only light source in this picture, shot on assignment for Travel/Holi-day *magazine. The sunlight provides a rimlight, and the table top bounces enough light back into the subject's face to register detail.*

Penang, Malaysia. Nikon
8008S, Nikkor 80-200mm
zoom lens, Fujichrome Velvia
exposed for 1/30 sec. at f/2.8.

Overcast conditions are perfect for people photography. A light rain was falling when I photographed these two young girls under their umbrella on the island of Penang in Malaysia. I made this shot during an assignment for Travel/Holiday magazine.

Toplight. A cousin to frontlight, toplight is produced when the light falls from overhead, as it does during the middle of the day when the sun is high in the sky. Toplight offers more sculpting shadows than frontlight; however, with human subjects, those shadows fall in all the wrong places. For example, eye sockets block up, and strange shadows appear under the nose from the harsh, specular, and bluish light of the sun at high noon.

If you can avoid these ugly drawbacks, toplight can be an effective tool in your lighting kit. As you can probably tell, I'm not a great fan of either frontlight or toplight. This isn't to say that you can't take good pictures in these two types of light, but I think that more pleasing alternatives exist.

Overcast and Open Shade. Amateur photographers probably misunderstand this type of light the most. In fact, they usually put the camera away when they see a light cover of clouds. This is unfortunate because a number of common subjects in travel photography, such as people, landscapes, and street scenes, actually require the soft light of overcast or open shade.

Although this kind of illumination may seem lackluster, it perfectly matches the compressed range of film's tone recognition, which can't render shadows and highlights at the same time. The low-contrast light of overcast and open shade reveals details and makes colors come alive with increased saturation. The key to using overcast and open shade effectively is to find compositions that don't include the sky, which will be bald, or featureless, and gray. You should also look for subjects with strong colors or with striking graphic elements that don't need shadows in order to register on film.

Twilight and Dusk. Photographers have a number of pet names for dusk or twilight, the hour or so after sunset when the sky is still a rich blue before it turns black. They refer to this as the magic hour, the blue hour, and the afterglow. This is the best time to shoot skylines, monuments, fountains—almost any outdoor scene illuminated by artificial light. In fact, most

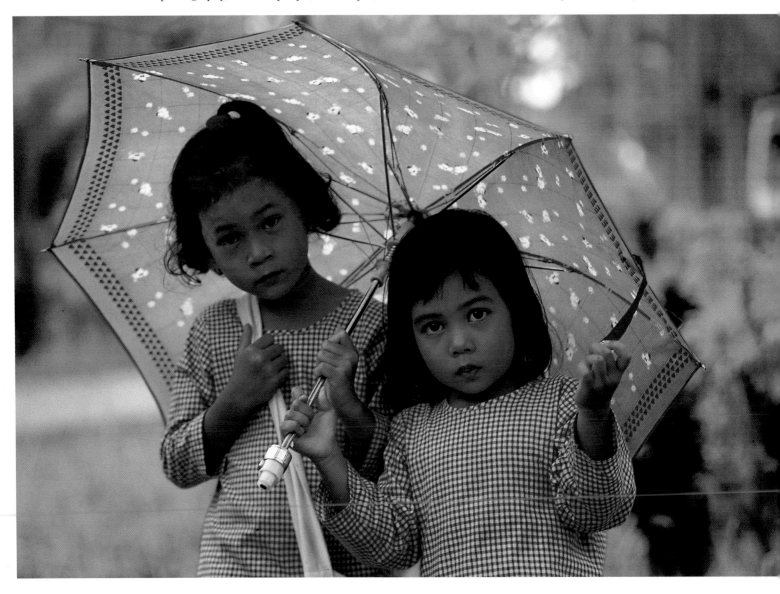

MOUNT ORGUEIL CASTLE, Jersey, Channel Islands. Nikon 8008S, Nikkor 80-200mm zoom lens, tripod, Fujichrome Velvia exposed for 2 seconds at f/5.6.

What is great about dusk is that no matter how bad the weather is, the sky will eventually turn blue for awhile after sunset. Shooting a story on the Channel Islands for Islands *magazine, I'd been battling gray, rainy skies all day on Jersey, and I was scheduled to move on to another island the next day. Despite the drizzle, I set up my tripod across the harbor from the castle and waited for dusk. I knew that the town's neon signs and streetlights would glow nicely, but I was pleasantly surprised by how wonderful the castle, illuminated with floodlights, looked.*

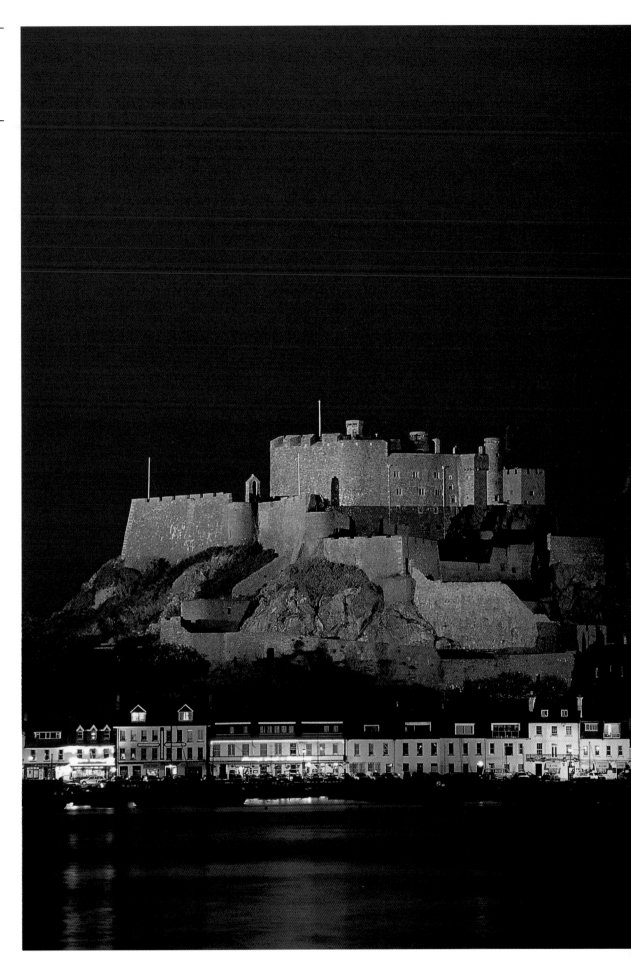

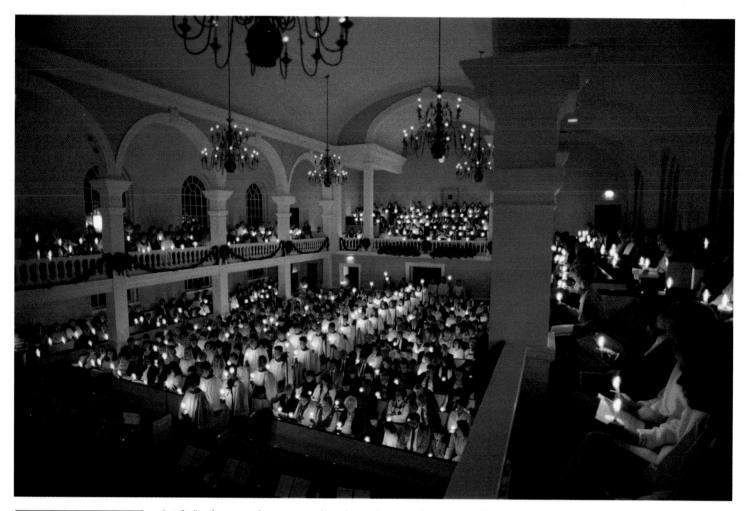

At Bucknell University, the candlelight Christmas service is a big winter event on campus. Near the end of the service, candles are lighted from person to person, and the whole congregation is illuminated by only the candlelight for a few moments before the candles are extinguished. To cut down the contrast, I'd arranged with the chaplain earlier to have the overhead chandeliers turned down, not shut off entirely, once the candles were lighted. I took an incident-light reading from the face of the person next to me once her candle was lit since I knew that the hotspots would throw off a TTL reading. I bracketed as many shots as time allowed.

"night" photography is actually done during this period. In true nighttime, not enough ambient light exists to separate buildings and other subjects from the black sky on film. In the resulting photographs, bright lights often look like nothing more than bright spots floating in darkness.

Besides the rich, moody feel twilight lends to pictures, professional photographers like this light because it is basically weatherproof. No matter how gray and gloomy the day, the sky will glow royal blue during the magic hour. So even a cloudy or rainy day, which you might otherwise write off for shooting skylines and buildings, can yield fine pictures.

Windowlight. Since Rembrandt's time, portraitists have enjoyed the diffused quality of windowlight. Soft enough to flatter yet directional enough to add shadow and a three-dimensional effect, windowlight is nature's perfect illumination for portraits and still lifes. When true windowlight isn't available, photographers go to great trouble to mimic its special quality by diffusing their artificial lights with umbrellas, softboxes, and light panels.

Only soft, indirect light qualifies as windowlight. A shaft of direct sunlight, even if it comes through a window, is considered sidelight and, as such, is too harsh and *specular*, or mirror-like, for portraits.

Candles and Campfires. On occasion, you may find yourself shooting with some unusual light sources, such as candles and campfires. When this happens, you must first consider that the color temperature of these sources is much warmer than daylight and even most incandescent sources. Presumably, however, since you're using these light sources, you are more interested in the atmosphere than the proper color rendition.

Often, you'll want to include these atmospheric light sources in the picture. Be aware that this is where many photographers run into trouble. Despite the best efforts of today's ultra-sophisticated, multi-segmented TTL camera meters, the inclusion of one or more bright light sources in a picture will invariably fool these meters into underexposure. The result might not be as severe as the underexposure center-weighted TTL meters produce, but it will be underexposure all the same.

You can avoid this in two simple ways. One is to take a closeup or spot-meter reading of the person or object that the candle or fire is illuminating, making sure that you don't include the light source. Your other option is to take a reading from the subject's position with an incident light meter. Either way, the excessively bright light source won't mislead you as you shoot.

PUB SINGER, Banagher,
Ireland. Nikon 8008S,
Angenieux 28-70mm AF zoom
lens, Tiffen 85C filter, tripod,
Fujichrome 100 exposed for
1/8 sec. at f/4.

*Shooting a story about cruis-
ing on the Shannon River for*
Islands *magazine, I came
across Mick Hough warming
up for an evening perfor-
mance of traditional Irish
music at JJ Hough's Singing
Pub in the little village of
Banagher. The overcast light
coming in from the window
was beautiful but very blue,
so I warmed it up with an
85C filter. As Hough
crooned, I made a series of
bracketed exposures using
only the windowlight for
illumination.*

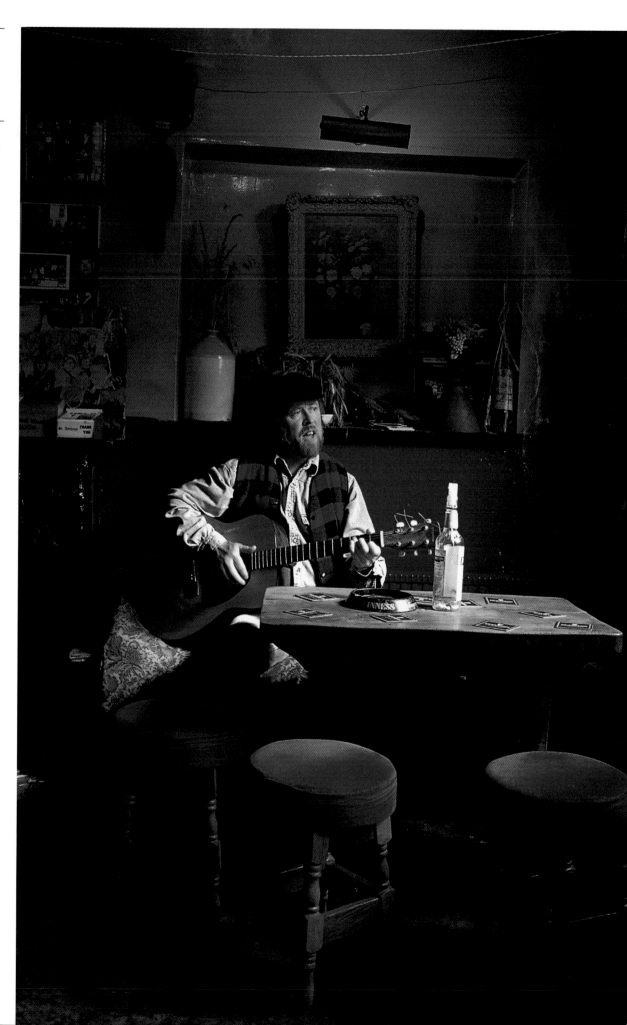

WHAT IS COLOR TEMPERATURE?

BOY IN PALM TREE AT
SUNSET, Western Samoa.
Nikon 8008S, Nikkor 20-35mm
AF zoom lens, Tiffen 85C filter,
Tiffen ND.6 graduated neutral-
density P filter, Fujichrome
Velvia exposed for 1/250
sec. at f/4.

The clouds and the composition looked good in this scene, which I shot in Western Samoa for Islands magazine, but the color was lacking. I knew that if I waited until the sun was lower in the sky and the color became richer, both the clouds and the boy might be gone. I decided to warm up the color with an 85C filter and to make the clouds dramatic by darkening the sky with a graduated ND filter. The sandwiched filters help to bring out the most in the scene.

Throughout this book, I use the terms "warm" and "cool" to describe the quality of the light. This has nothing to do with the actual heat generated by the light, but rather its color. The color of light is measured in Kelvin degrees (see the chart below). High-noon sunlight, which is kind of bluish, is about 5500K. An incandescent light bulb, which emits a much warmer, orangish light, has a lower Kelvin temperature; this is generally around 3200K. Tungsten and quartz lights, which are also orangish, have a slightly higher temperature, usually 3400K.

In some branches of photography, you have to be a stickler for accurate color. For example, if you're shooting a clothing catalog, you'll want the colors in the photograph to match the colors of the actual clothes as closely as possible. Some color-temperature meters help you to precisely determine the color of the light you're working with, so you can correct the illumination with filters if necessary in order to get the proper color.

Color-temperature meters work like light meters, but they read the color rather than the intensity of the light. They have a flat, white disc, which is similar to the flat port available for many incident light meters and is used in much the same way. You read the light falling on the subject, not reflecting off of it. You enter the type of film you're using, daylight or tungsten, and then when you take the reading, the meter makes two calculations.

The light-balancing (LB) reading deals with the yellow/blue color spectrum and tells you how much blue (82-series blue filters) or yellow (81-series amber filters) to add to achieve a neutral balance. The color-correction (CC) reading deals with the magenta/green spectrum and recommends how much magenta or green color correction is needed to bring that spectrum to a neutral balance. Color-correction filters typically come in strengths of 5, 10, 20, 30, or 40. A 10CC magenta filter is weaker than a 30CC magenta filter. You need to experiment a bit with both your color-temperature meter and your favorite film to arrive at what you consider to be a "neutral" color balance in your images.

Assuming that you're using the same film, once you make the filtration corrections for both readings, you'll have a neutral color balance that you can attain no matter what the existing color temperature. Unfortunately, the one place that most photographers need their color-temperature meter is the one place that it is least effective: with vapor lights, such as fluorescent lights, mercury-vapor lights, and sodium-vapor lights. Because these lights actually pulse, they send out spikes of light that a color-temperature meter finds difficult to read. As a result, the meter's recommendations can be either accurate or way off, depending on what part of the spike it reads. Minolta is the pioneer of color-temperature meters, and its latest, the Colormeter IIIF, can read the color temperature of flash as well.

For most location-lighting situations, you don't need to be that precise in terms of color balance. In fact, in most cases I am more concerned with making the color of the light appear pleasing than I am with rendering it accurately. To do this, you need to remember a few basics about color temperature and how it affects your photographs—or more specifically, the people who look at your photographs. Orange/red tones suggest a sense of warmth and well-being, while blues connote cold and foreboding.

One reason why everyone seems to prefer photographs shot in the early morning or late afternoon is the lovely golden tone of the sunlight at those times. For the most part, I use warming filters (81A, 81B, 81C, 85, 85B, and 85C) on my lenses to emphasize or recapture this warmth (see page 26). Because I always prefer having a subject look good to looking accurate, occasionally I have to break some rules.

For example, slide film is balanced for either daylight (5500K) or artificial incandescent light (3200K). If you're shooting a scene that is primarily illuminated

SOURCES OF ILLUMINATION AND THEIR COLOR TEMPERATURES

SOURCE	COLOR TEMPERATURE (K)
Sunlight (mean noon)	5400
Skylight	12,000 to 18,000
Photographic daylight	5500
Crater of carbon arc (ordinary hard-cored)	4000
White-flame carbon arc	5000
Blue flashbulbs	5400
Flashcube or magicube	5500
High-intensity carbon arc (sun arc)	5500
Clear zirconium foil-filled flash	4200
Clear aluminum foil-filled flash	3800
500-watt 3400K photolamp (approximately 34.0 lumens/watt)	3400
500-watt 3200K tungsten lamp (approximately 27.0 lumens/watt)	3200
200-watt general service (approximately 20.0 lumens/watt)	2980
100-watt general service (approximately 17.5 lumens/watt)	2900
75-watt general service (approximately 15.4 lumens/watt)	2820
40-watt general service (approximately 11.8 lumens/watt)	2650

Courtesy of Eastman Kodak Company.

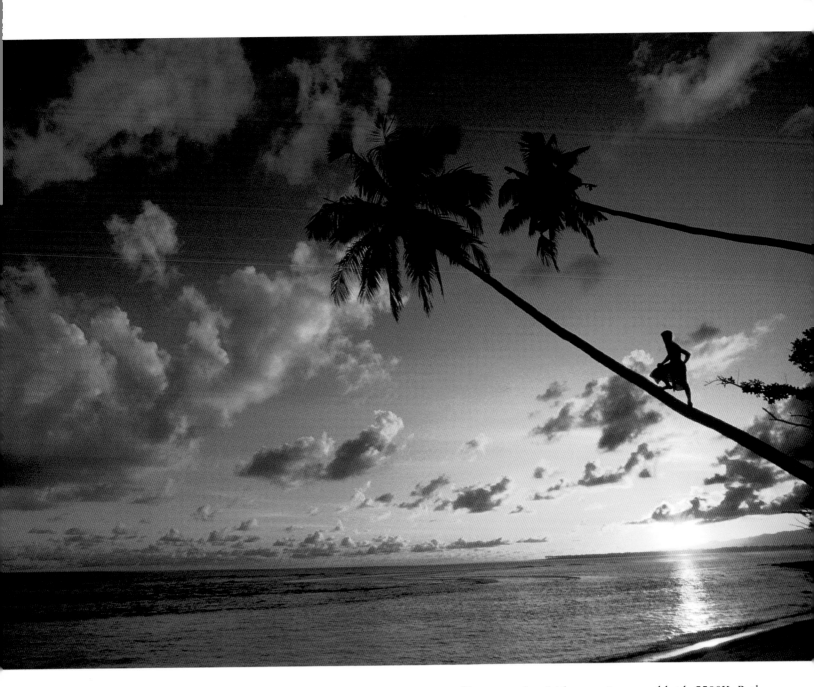

with incandescent light, using a Type B tungsten film will give you a more accurate rendition of the scene. If you use daylight film in such a situation, the scene will take on a warm, orangish tint. If the subject is a cafe or restaurant with candles on the table or a room with a blazing fire in the fireplace, this orange rendition and the subsequent feelings of warmth and well-being are just what you want. Technically, the image isn't correct, but emotionally it works.

One of the most glaring examples of a slavish devotion to technical accuracy at the cost of good results occurs in the world of electronic flash. Flash is supposed to be balanced for daylight, which mea-

sured at high noon is a very bluish 5500K. Rather than acknowledge that the bluish light of high noon is probably the ugliest natural light available, flash manufacturers prefer to be "correct." So they produce flashtubes that emit a color close to the blue tone of 5500K illumination instead of "warming" up their reflectors to the more pleasing color of early-morning or late-afternoon sunlight. As a result, when most professional photographers shoot with flash, they put some kind of warming filter on the light, the lens, or both in order to obtain a more appealing color rendition in their photographs (see page 42 for suggestions on filtering flash).

MODIFYING NATURAL LIGHT

Generally, the best way to work on location is to seek out or wait for the natural-light conditions that are ideal for the subject matter you want to shoot. Most of the time, however, you can't wait for perfect light, so you have to do what you can to modify the color and quality of the existing light. The only practical way to transform available light in a large scene is through the addition of filters. I keep several filters in my kit and use them whenever I need to improve a location's lighting.

WARMING FILTERS

Photographers turn to warming filters for several compelling reasons when they work. Consider the

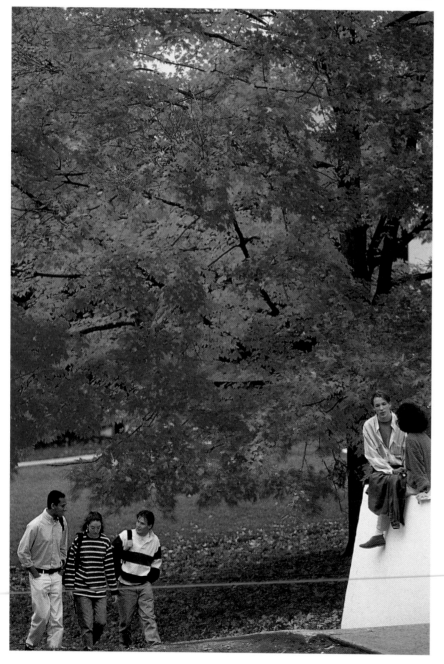

following two scenarios. You want the look of the gold light of late morning or early afternoon, but your timing isn't quite right, or you're shooting a portrait in the cool bluish light of open shade or overcast. To achieve the desired effect, you need a warming filter. These filters come in various colors and strengths. The 81-series filters are amber; in ascending order of strength, they are the 81A, 81B, 81C, and 81EF filters. The 85-series filters are orange; in ascending order of strength, they are the 85C, 85B, and 85 filters. Each stronger filter raises the color temperature by a certain number of Kelvin degrees and has a specific function when you mix various films and light sources (see the chart on page 28).

These recommendations, which photographers use to "correct" light temperature, are very helpful. But I tend to work with warming filters in order to enhance rather than to correct the color of natural light. It is safe to say that most of the time my use of warming filters results in Kelvin temperatures that are technically wrong. But since the final images look so great, I'm not too concerned about being wrong. Keep this in mind as you read my "real-world" recommendations that follow.

The 81A and 81B filters are so mild that many of my colleagues leave these on their lenses all the time instead of a skylight or an ultraviolet (UV) filter. I prefer the Tiffen 812 filter, which is a lovely combination of the pink of a skylight filter and the warmth of an 81A filter. The 81C and 81EF filters are great for shooting in overcast or open shade. Remember, don't be swayed by the "right" and "wrong" ways to use warming filters; what matters is what looks good to you. You have to experiment a bit to know which one to use when.

Unless I'm shooting tungsten film outdoors in daylight conditions and need the heavy orange correction, the only 85-series filter I find useful is the 85C. I consider it to be the warmest you can go before subjects start looking overfiltered and too orange. Also, the 85C can add an extra hour of natural-looking golden light in the morning or late afternoon. It is also superb for warming up the light of a heavily overcast day. The 85C is undoubtedly one of my favorite and most frequently used filters, yet I don't think I've ever used it for its "proper" purpose: to lower the color temperature 200K when you shoot tungsten film under photofloods.

POLARIZING FILTERS

These filters, which are also called *polarizers*, are often misunderstood and have generated their own set of myths among photographers. I recall standing on a scenic overlook near the city of Salzburg on a cloudy day watching a woman shooting picture after

Opposite page:
STUDENTS WITH FALL
FOLIAGE, New Jersey. Nikon
8008S, Nikkor 80-200mm AF
zoom lens, Tiffen 85C filter,
Fujichrome Velvia exposed for
1/250 sec. at f/2.8.

I photographed this scene for Rutgers University; my assignment was to highlight the autumn foliage. I found a great tree and some attractive students, but the clouds rolled in. The resulting overcast light was quite cool and blue. An 85C warming filter restored the students' skin tones and really made the foliage pop.

STUDENTS IN GYM LOBBY
WITH SHADOWS,
Chattanooga, Tennessee. Nikon
8008S, Nikkor 20-35mm AF
zoom lens, Tiffen 85C filter,
Fujichrome Velvia exposed for
1/30 sec. at f/2.8.

The McCallie School in Chattanooga, Tennessee, hired me to get graphic, colorful coverage of the school's new athletic complex. While taking advantage of the late light to shoot exteriors, I poked my head into the lobby out of curiosity to see what the light was doing. I saw these great shadow patterns. I commandeered a couple of students, ran up the stairs, and got off a few frames with my camera braced against the railing before the sun faded. The 85C filter accentuated the warmth of the setting sun.

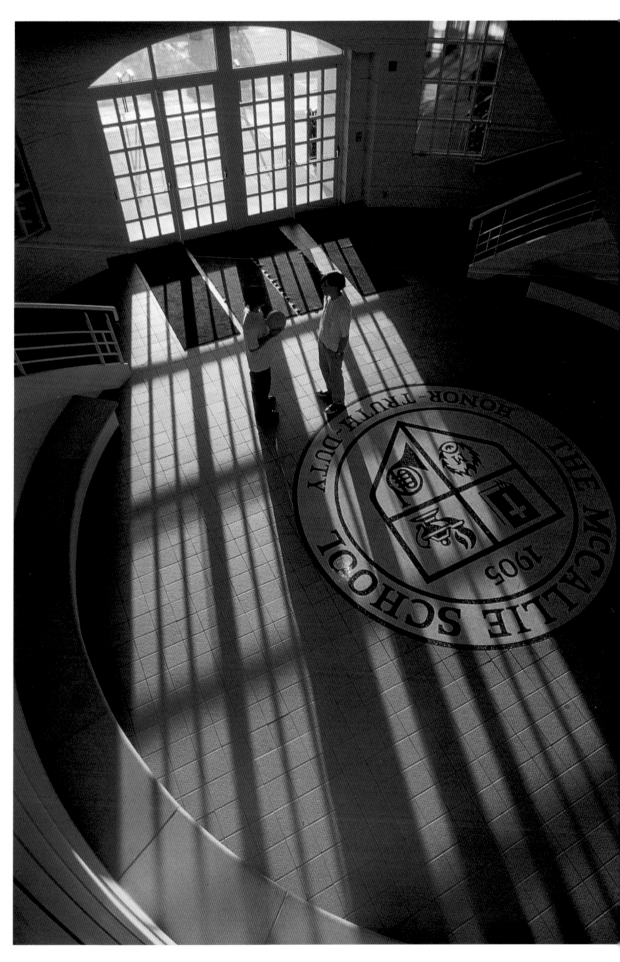

COLOR PHOTOGRAPHY IN MIXED LIGHTING

Exposure and filter starting points with fluorescent and high-intensity discharge lamps

Type of Lamp	Kodak Films With Daylight Balance [c]		Films with Tungsten Balance
	VERICOLOR III Professional Type S VERICOLOR HC Professional VERICOLOR 400 Professional KODACOLOR GOLD 100, 400 KODACHROME 25 and 200 Professional EKTAPRESS GOLD 100, 400, 1600 Professional	EKTACHROME 64, 100, 100 PLUS, 200, P800/1600 Professional EKTACHROME 100 PLUS KODACHROME 64 Professional	EKTACHROME 160 Professional EKTACHROME 50 Professional EKTACHROME 64T Professional VERICOLOR II Professional, Type L KODACHROME 40
Fluorescent			
Daylight	40M + 40Y + 1 stop	50M + 50Y + 1 1/3 stops	85B [d] + 40M + 30Y + 1 2/3 stops
White	20C + 30M + 1 stop	40M + 2/3 stop	60M + 50Y + 1 2/3 stops
Warm White	40C + 40M + 1 1/3 stops	20C + 40M + 1 stop	50M + 40Y + 1 stop
Warm White Deluxe	60C + 30M + 2 stops	60C + 30M + 2 stops	10M + 10Y + 2/3 stop
Cool White	30M + 2/3 stop	40M + 10Y + 1 stop	10R + 50M + 50Y + 1 2/3 stops
Cool White Deluxe	20C + 10M + 2/3 stop	20C + 10M + 2/3 stop	20M + 40Y + 2/3 stop
Unidentified [e]	10C + 20M + 2/3 stop	30M + 2/3 stop	50R + 1 stop
High-Intensity Discharge			
High Pressure Sodium [f]	70B + 50C + 3 stops	80B + 20C + 2 1/3 stops	50M + 20C + 1 stop
Metal-Halide [f]	30M + 10Y + 1 stop	40M + 20Y + 1 stop	60R + 20Y + 1 2/3 stops
Deluxe White Mercury	40M + 20Y + 1 stop	60M + 30Y + 1 1/3 stops	70R + 10Y + 1 2/3 stops
Clear Mercury	50R + 30M + 30Y + 1 2/3 stops	50R + 20M + 20Y + 1 1/3 stops [g]	90R + 40Y + 2 stops

Filter [a] and Exposure Adjustment [b] for KODAK Color Films

Note: It should be noted that exposure times will probably be long and that any filter recommendations determined by practical test will include some correction for Reciprocity Law Failure and will be correct only for similar exposure times.

For television newsreel work where tests cannot be made in advance, use an artificial light film and a CC40 red filter with any fluorescent tubes. This will not always give perfect results but if the picture content is sufficiently interesting and newsworthy, the color quality will be adequate.

a. KODAK Color Compensating Filter over the camera lens. Red or blue filters are recommended in some cases to limit the total number of filters required to three.

b. Exposure increase required to compensate for the filter.

c. Daylight films are divided into two groups for filter recommendations.

d. KODAK WRATTEN Gelatin Filter No. 85B.

e. Fluorescent lamps that are inaccessible or unmarked. Use of these filters may yield less than optimum correction.

f. Starting filters were established with data from Lucalox and Multi-vapor lamps manufactured by General Electric Company. Other sodium vapor and metal-halide lamps may have substantially different spectral outputs.

g. For KODAK EKTACHROME 400 Film, use 25M + 40Y filtration and increase exposure by 1 stop.

Courtesy of Eastman Kodak Company.

picture of the scene, all the while explaining to her companion how her "Polaroid (sic) filter will make the sky blue!"

No filter currently on the market can make a cloudy sky blue. Rotating the two pieces of polarized glass that make up a polarizer will, however, concentrate the scattered light rays in a blue sky, thereby rendering the sky a deep, rich blue. It will also cut the reflection off nonmetallic surfaces like water and foliage, making them appear rich and deep in color as well. The effect varies; you can see it become more or less intense as you rotate the filter's front element.

There are two types of polarizers, linear and circular. These terms don't describe the shape of the filters, just the way they achieve polarization. The results are the same with either type, but certain camera metering systems won't work properly with the "wrong" type of polarizer. Most of the metering systems of the autofocus cameras on the market today require a circular polarizer. Check your camera manual before you buy a polarizing filter.

Polarizers work best when used at a 90-degree angle to the sun. So they come in quite handy during the middle of the day when the sun is high in the sky; almost any point on the horizon will receive the maximum effect. An easy way to tell which portion of a scene will be polarized is to make a 90-degree angle with your thumb and forefinger; this is the "toy-gun" configuration popular with children. Next, point your forefinger at the sun. Wherever your thumb points (and you can rotate your hand, provided the forefinger is aimed at the sun) is where the polarization effect will be the most intense.

So far, the polarizer sounds like the panacea of filters. In a way this is true, but you have to consider a few caveats when using this filter. First, the light loss is around 1 1/2 to 2 *f*-stops when you rotate the filter for maximum polarization. This is no small decrease when you're working with slow, fine-grained ISO 50 film. Second, polarizers tend to "cool" things down, neutralizing any warm light in the scene.

For decades, filmmakers have had access to polarizing-and-warming-filter combinations. Finally, a couple of filter manufacturers realized that still photographers could probably utilize these and now make a

THE BATHS, Virgin Gorda, British Virgin Islands. Nikon 8008S, Nikkor 20-35mm AF zoom lens, B&W circular polarizing filter, Fujichrome Velvia exposed for 1/125 sec. at f/4.

Unless I shoot during the early morning or the late afternoon when I am in the tropics, I usually have a polarizer on my lens. This filter helps to emphasize the blues in the tropical water and sky.

CONVERSION FILTERS FOR COLOR FILMS

Wratten Gelatin Filter No.		Increase in Exposure	For Changing in Stops
85B	Amber filter for exposing Type B (tungsten) color materials in daylight	2/3	5500K to 3200K
85C	Amber filter sometimes preferred for exposing Type L and tungsten materials in daylight. Also for Type L film with electronic flash. Paler than 85B	1/3	5500K to 3800K
80A	Blue filter for exposing daylight-type color materials in 3200K tungsten illumination	2	3200K to 5500K
80B	Blue filter for exposing daylight-type color materials in photolamp 3400K illumination	1⅔	3400K to 5500K
80C	Blue filter for exposing daylight-type color materials, to clear aluminum-filled flashbulbs	1	3800K to 5500K

Courtesy of Eastman Kodak Company.

combination polarizer/slight warming filter. Tiffen offers this combination filter, but only with a linear polarizer. B&W, the German filter manufacturer, is the only company currently offering a circular polarizer/warming filter combination. The company's circular polarizer/KR3 (which is about equal to an 81B filter) combination filter is an expensive special-order item, but I consider the results to be worth the investment.

A few more points about working with polarizers. When you use them with wide-angle lenses, it is possible to include so much sky that only a portion of it will be polarized; this results in a sky characterized by uneven tones. Also, since polarizers tend to be thicker than ordinary filters because of their rotating mounts, they can cause vignetting in the corners of your picture. An easy way to check for this is to mount the polarizer on your lens, focus to infinity, stop down to the lens' minimum aperture, and press the depth-of-field preview button. Your screen will now be dark, but if you aim the camera at a light bulb or some other bright source, you'll be able to check for vignetting. If you can focus the lens from infinity back to its closest focusing distance with no darkening of the corners, the filter and the lens are a good match.

Finally, it is possible, especially in tropical areas, to overpolarize a sky so that it becomes almost black.

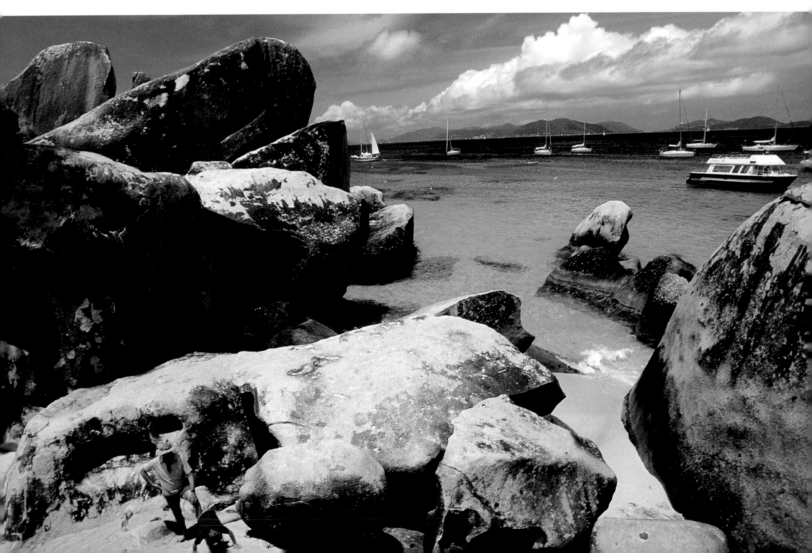

TOBAGO CAYS, the Caribbean. Nikon 8008S, Angenieux 28-70mm AF zoom lens, B&W circular polarizing filter, Fujichrome 100 exposed for 1/500 sec. at f/4.

The swirl of blues that surrounds these small islands in the eastern Caribbean created this arresting aerial view. To cut through the haze and make the most of the blues, I used a polarizer while shooting from the open window of a small plane.

You can easily check this effect in your viewfinder. If the sky looks too dark, slightly reduce the amount of polarization.

GRADUATED NEUTRAL-DENSITY FILTERS

Like warming-and-polarizing-filter combinations, graduated neutral-density (ND) filters come from the world of filmmaking. All that these often misunderstood filters do is reduce the amount of contrast in a scene. They are dark at the top and feather gradually to clear at the bottom. Their primary function is to maintain adequate detail in both a bright sky and a dark foreground area. However, many photographers find it difficult to know when to use a graduated ND filter because the naked eye can readily hold detail in sky and shadows. It is only when you train yourself to "see" subjects the way film, with its severely limited tonal recognition, does that the use of these filters becomes second nature to you. Apparently, this skill is harder to develop than you might think: you often see grossly overfiltered images written about in some photography magazines.

Graduated ND filters come in different strengths, but filters that are two stops (ND.6) and three stops (ND.9) darker at the top are the most popular choices of still photographers. These filters are available in rotating mounts in various sizes, as well as in rectangular CR39 resin plastic "system" filters, such as those made by Cokin and HiTech. Tiffen offers graduated ND filters in glass in its "P" and "P-XL" series, which are designed to fit the large Cokin P filter holder.

I use the Tiffen P filters in a Cokin holder because this arrangement enables me to stack two or more filters. One combination that I often use is an 85C warming filter and an ND.6 graduated filter. The resulting warmth often improves landscapes, and the neutral density darkens the sky, thereby increasing the drama in a scene. Recently, I've started using the HiTech filter system because it offers a wider array of filters; the system also provides such combinations as an 81EF and an ND.6 graduated in one filter.

PEMAQUID POINT LIGHTHOUSE, Maine. Nikon 8008S, Nikkor 20-35mm AF zoom lens, Tiffen ND.6 graduated neutral-density P filter, Fujichrome Velvia exposed for 1/60 sec. at f/4.

Whenever I teach my travel-photography class at the Maine Photographic Workshops, I take my students to Pemaquid Point for a sunrise shot. To hold detail in both the sky and the rocks, I used a graduated ND filter. The warm light of sunrise did the rest.

SHOOTING PORTRAITS IN NATURAL LIGHT

GRANDFATHER WITH
GRANDCHILD AND KID, Jersey,
Channel Islands. Nikon 8008S,
Nikkor 80-200mm AF zoom
lens, Fujichrome Velvia exposed
for 1/125 sec. at f/2.8.

*Here, I had only to position
the farmer, his granddaughter,
and his kid in the fields of his
farm on Jersey in the Chan-
nel Islands. The overcast light
did the rest. I made this por-
trait while on assignment for
Islands magazine.*

You can't do too much to actually modify the quali-
ty of the existing light in a large-scale landscape or
other outdoor situation. Although filters can help
somewhat, for the most part you simply have to work
with what nature provides. But the same isn't true of
natural-light portrait situations. With the exception
of a very large group portrait, you usually won't have
any problem altering the existing light for a portrait.
Generally, you need to do two things to the illumi-
nation: change its quality and lower its contrast.

Altering the quality of the light typically means
making it less specular and harsh. To achieve this, you
must diffuse the sunlight the same way that the
clouds diffuse it in overcast conditions. You have to
put some kind of translucent surface between the
sun and your subject. This can be as simple as a white
bedsheet or a commercially made diffusing panel.

The problem with using diffusers to modify nat-
ural light for portraits is basically one of size. In order
to diffuse sunlight for a 3/4-length portrait of a single

CLASSICAL DANCE TROUPE,
Bali, Indonesia. Nikon FE2,
Nikkor 180mm telephoto lens,
tripod, Kodachrome 64 exposed
for 1/125 sec. at f/2.8.

*Shooting in Bali on assign-
ment for Travel & Leisure
magazine, I had an oppor-
tunity to go to a full dress
rehearsal of a dance troupe
that was preparing for a tem-
ple festival. The dancers
rehearsed in the village
square, under a roof in a
completely open-sided market
building. During rehearsal
breaks, I was able to steer one
or two dancers near the edge
of the makeshift stage, where
the sunlight was streaming in
from the side and bouncing
off the light-colored floor. I
asked a village boy to hold a
38-inch gold Flexfill reflector
to redirect some of the bounc-
ing light into the dancers'
faces. I made this shot entirely
with this mix of natural front-
light and bounced sidelight.*

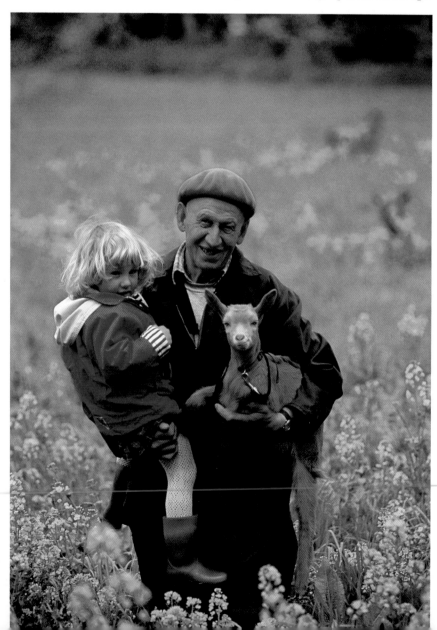

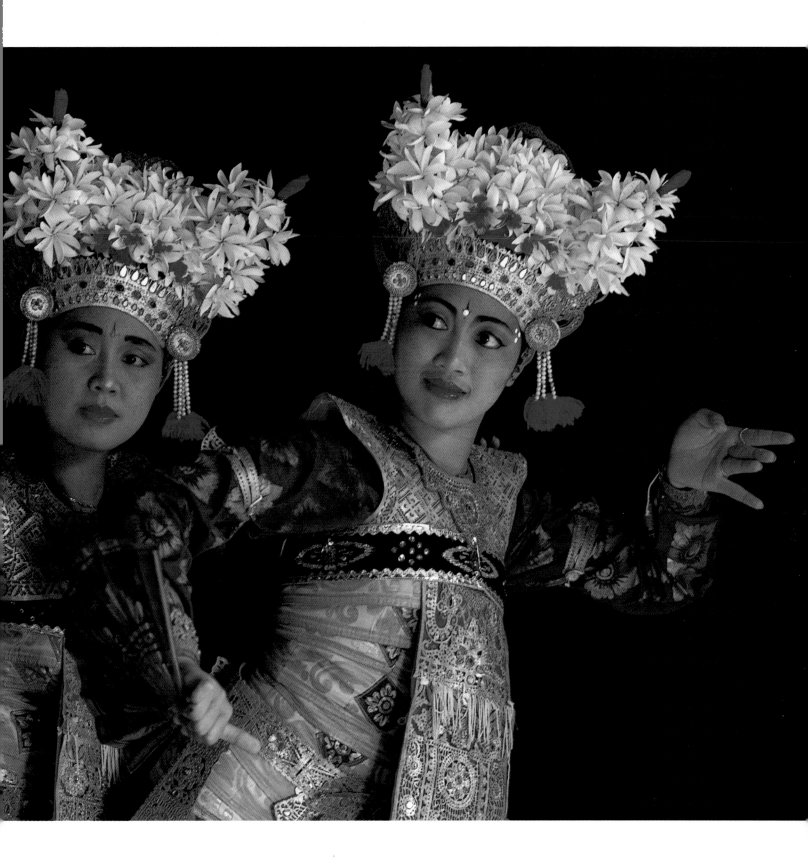

TRUMPETER UNDER LAMPPOST, New Orleans, Louisiana. Nikon 8008S, Nikkor 80-200mm zoom lens, tripod, Fujichrome 100 exposed for 1/8 sec. at f/4; Fujichrome 64 tungsten film exposed for 1/4 sec. at f/4-5.6.

For a story about New Orleans's French Quarter for Travel/Holiday magazine, I was working with Ken Terry, a local jazz musician who posed for me in various locations throughout the region. For this picture in Pirate's Alley, I needed to throw a little light on my subject as he played under a lamppost. To cover my bases, I made the shot two ways, with two color balances. To light Terry initially, I set up an Armatar 300 at half-power with a Roscolux #02 bastard-amber gel on a lightstand, and then aimed the flash at a 45-degree angle to him from about 12 feet away and out of camera frame (left). I used a Wein XL slave on the unit, and had a Wein SSR infrared transmitter in the hotshoe of my camera, which I'd mounted on a tripod 50 or 60 feet down the alley. The overall ambient reading was about 1/4 sec. at f/4 on Fujichrome 100. I underexposed that by one stop and set the strobe to give me f/4. Next, I did a Polaroid test and fired away. To make sure that I captured the feeling of "the blues," I decided to shoot the whole scene on tungsten film as well (right). I knew that this would render the daylight blue; however, I also knew that unless I gelled the flash, the blue tone that resulted would look sickly and unappealing. So I added a Roscolux #18 flame gel to the flash, increased the flash power to full, and switched to Fujichrome 64 tungsten film.

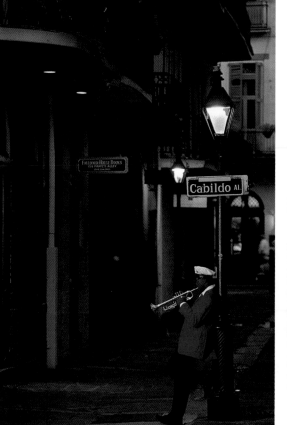

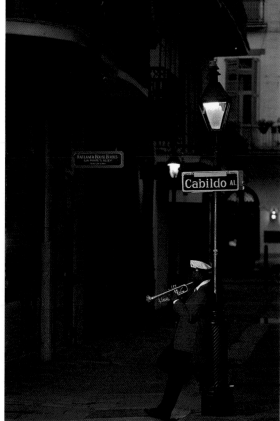

person, you need a panel that is at least the same size as the subject. Several portable 6 x 4-foot diffusing panels are available, like those made by Lightform, Domke, and California Sunbounce. Keep in mind, however, that even collapsed and folded, these panels are still 4 feet long. And once you need to photograph larger subjects, such as groups of people or a car, the diffuser must be comparably larger as well. Trying to prop up two or three of these panels outdoors is quite problematic, especially if a breeze is blowing. For most location-shooting situations, I don't find diffusing panels to be a viable option for modifying light outdoors (although I do like to use them indoors—see page 106).

REDUCING CONTRAST

Most of the time, when I'm trying to photograph people and the light is specular sunlight, I try to turn the subjects away from the light and to bounce some light back into the scene by using a reflector. This reflector can be a portable, commercially made one, like popular Flexfills. It can also be something you find by chance on location, such as a patch of light-colored ground or even a sheet of newspaper. Working in the tropics as much as I do, I often look for a patch of shade next to a sunny, sandy open area. I position my subject just inside the area of the shade and use the light reflecting off the sand to illuminate my subject. This approach might seem crude, but it is very effective at reducing contrast.

Even overcast conditions can produce contrast problems, so don't put away the reflector when the sun ducks behind a cloud. You'll still have shadowy eye sockets to deal with. By using the reflector at about a 45-degree angle under your subject's face, you open up the shadows both in the eye sockets and under the chin, as well as add a bit of sparkle to the light. Generally, you need to work with another person in order to use a reflector; this individual can be an assistant or someone you recruit on the spot. Since you can easily see the effects of the reflector, you don't need much training to use one. And it is a great way to keep a client occupied and feeling useful on a shoot! If no one else is around and you're shooting only a head-and-shoulder portrait, you can often ask the subject to hold the reflector.

Round, pop-open reflectors, like the Flexfills, come in a range of sizes. Since these reflectors fold up to a third of their open diameter, you can carry a good amount of reflecting surface in a relatively small package. My 38-inch Flexfill folds into a flat, 13-inch case that I can fit and store in the back pocket of my large camera bag. I can also clip the case to the strap of my smaller shoulder bag via a rock climbing carabiner. Reflectors come in different surface colors; white, silver, gold, and translucent are the common choices. You usually can get a combination of two colors, one on each side of the reflector. I find the silver to be too specular and cold, so I use the gold/white combination.

FLUORESCENT LIGHTING

SURGEONS AT WORK,
Pennsylvania. Nikon 8008S,
Nikkor 80-200mm zoom lens,
Tiffen FLD filter, tripod,
Kodachrome 64 exposed
for 1/15 sec. at f/4.

I made this shot for a Merck & Co. annual report. The host hospital gave me two choices: I could shoot a surgical procedure from a gallery position and not be able to move around, or I could set up a shot. I selected the latter option and wheeled in quite a bit of lighting gear. Three surgical nurses posed as two surgeons and a nurse to keep the image authentic. When I had them demonstrate typical surgery positions, I noticed that the illumination from the high-intensity surgery lamp was quite dramatic. It was also fluorescent, but I could easily correct this. Since I had only a limited time to shoot in the operating room, I decided to go with the available light rather than try to reconstruct something with my lights. I chose a tight composition because it looked graphic and eliminated the need for a patient. The only other adjustment I made was to lay a piece of red seamless paper on the operating table, so that the reflections in the surgical instruments would look realistically red. I bracketed extensively, thereby getting a whole series of different effects as the exposures changed. I preferred a dramatic dark exposure; the client used a lighter one in its annual report.

Fluorescent lights and other vapor lights, such as the sodium- and mercury-vapor lights found in many large industrial sights, are the bane of location photographers shooting color-slide film. Why? These light sources don't emit the full spectrum of light; they usually register as green on film. In addition, they aren't technically continuous light sources—they pulse rapidly. As a result, they often confound color-temperature meters, which may provide far-from-accurate advice on how to filter them. Moreover, the color temperature of these lights can vary from manufacturer to manufacturer, and even from bulb to bulb within the same make and model. To help photographers handle this potential problem, the Eastman Kodak Company has come up with specific combinations of film types, bulb types, and suggested filtrations.

For most films, I think that a 40CC magenta filter does a good job of correcting the green glow of fluorescent lighting. If I find myself shooting daylight spilling in with fluorescent lights, such as in many offices with windows, I use a Tiffen FLD filter, whose magenta color is somewhat weaker than that of the 40CC filter.

As the concern about conserving energy grows, so will the use of fluorescent lights, which are cheaper to run. I'm now seeing these "energy-saving" fluorescent bulbs screwed into the fixtures of lamps in some of the posh hotels and offices that I have occasion to photograph. But the sickly light that they emit is the very antithesis of the warm, cozy atmosphere that most hotels aspire to. I've heard of many nonphotographer travelers and office workers who now bring their own light bulbs instead of putting up with the cold light quality of fluorescents! To these discerning individuals, I say bravo.

Mercury-vapor light sources are gas lamps that seem to emit a white light. These lights call for a different tactic, one that isn't correct, but is useful all the same. It is nearly impossible to get decent results when you shoot under these lights, but I find that if I shoot tungsten-balanced film with a 40CC magenta filter, I can shift the overall color from an unappealing green to a cool blue. I then use complementary filtered flash to highlight certain people or other subjects in a scene.

Sodium-vapor lights, which are an ugly yellow color, call for a completely different approach. My advice is to add as much magenta filtration as you can while you shoot and hope for the best. Another option is to shoot color-negative film and hope that it can be corrected in the lab. I confess that I've never been able to get a truly decent picture in this type of light.

FLASH BASICS

During the summers in the charming town of Ebeltoft in Denmark, nightwatchmen make the rounds in traditional costume, stopping and singing out their "All's Well." The streetlamp didn't put out enough light to adequately illuminate the men, but I liked the idea of making them look as if it did. To achieve this effect, I plugged my Nikon SB-24 flash into an SC-17 TTL extension cord modified to stretch up to 12 feet. Then I mounted the flash on a lightstand that my Danish Tourist Board client held. This way, the illumination it produced seemed to come from the same angle and direction as the streetlight. Finally, I set my off-camera flash on -1 stop on matrix-balanced, fill-flash mode, which successfully blended the flash and the available-light exposures.

That electronic flash has become the first choice in auxiliary lighting for still photography shouldn't surprise anyone. Since the days of flash powder, which eventually evolved into flash bulbs and today's computer-controlled units, the brief burst of light known as flash or strobe has proven its merits again and again. Using flash offers several basic advantages. The color temperature of the light is balanced to daylight, so you don't have to switch films when you head indoors. The sheer light output per the size and weight of the unit is unequaled in continuous sources, as is the action-stopping ability of that burst of light. With the advent of thyristor control, the electronic flash is even able to determine proper exposure—by measuring the flash output either through the lens or via a sensor eye in the flash unit itself—and quench itself when the light output is sufficient for the chosen *f*-stop chosen. This is a neat trick that continuous light sources have yet to match.

Working with flash does, however, have a few shortcomings. The primary one is that the burst of light is so fast that it is impossible to determine exactly what the light will look like in the final photograph. Fortunately, you can minimize this problem by shooting Polaroids. While you can control continuous light sources via both the shutter-speed and aperture settings on your camera, you can control electronic flash using only the aperture setting. This is because of the flash's quick burst. Once you make sure that the shutter will be fully open when the flash goes off by choosing your camera's top *sync shutter speed* or slower, the shutter speed doesn't enter into your flash calculations. The only exception is when you blend flash with available light.

GUIDE NUMBERS

One of the most confusing aspects of working with electronic flash is the jargon that describes the power of a given unit. Terms like "watt-seconds," "joules," and "foot-candles" are all used at one time or another to indicate the flash unit's output, yet none are really an accurate way to compare the output of one unit to that of another. Both "watt-seconds" and "joules," a European term, describe the power output of a unit, but not the light output. The actual light output of two 400 watt-second units made by different manufacturers might vary widely according to the efficiency of the units' designs.

The only way to judge the light output of various units is to compare their *guide numbers* (GNs). Guide numbers are determined in the following way. Set up a flash unit exactly 10 feet from a subject, most likely a person. Using an ISO 100 film (which is the unofficial standard for GN ratings), make a series of exposures in one-stop increments from *f*/2.8 down to *f*/22. Be sure to keep careful records of which picture you shot at which aperture. An easy way to do this is to have your subject hold up an index card with the appropriate aperture written on it. Then when the film comes back, decide which exposure looks best to you. Suppose that you prefer *f*/11. To arrive at the corresponding GN, multiply the f-stop by the distance. Here, *f*/11 x 10 feet = 110, so your flash unit has a GN of 110.

Don't be surprised if the GN you determine for a particular flash unit differs from the GN the manufacturer provides. Ordinarily, the manufacturers' GNs are on the optimistic side. This is because the manufacturers might test their units under different conditions than you might find on an average assignment.

Despite these slight variations in actual and suggested light outputs, GNs are the only real way to compare the light outputs of different flash units. GNs serve another function as well. Even in today's world of flash meters, Polaroids, and computer and thyristor controls, knowing your unit's GN can save you in the event that any or all three of these devices fail while you're working in the field.

THE INVERSE SQUARE LAW

Unfortunately, when you use flash, you can't possibly get around the Inverse Square Law. Basically, this complicated-sounding rule states that light falls off as the square of the distance from the light source to the subject. In other words, this law describes how quickly light decreases as it moves farther away from the subject because it covers a greater area as its beam spreads. Since the light falls off rapidly in a geometric progression, you need to use either a background light or a long shutter speed in order to burn in the background of any picture that has some depth to it (see the excerpt below).

THE INVERSE SQUARE LAW

"*Light falls off as the square of the distance.*" This elementary rule of physics is perhaps one of the most basic principles in lighting and a factor in large-group photography, background illumination, and portraits of couples and families, to name just a few. By your reviewing the concept, the next time you find yourself confronting the Inverse Square Law in *depth of light*, you can use a more knowledgeable approach to solve the problem.

The "inverse" in the law refers to the fact that the *remaining* amount of light (illuminating the subject) is equal to the inverse square of the distance from the light to the subject. In other words, if you place a light source 5 feet from the subject, the amount of light remaining to illuminate the subject equals the inverse square of 5 feet, or $1/(5)^2$. This is 1/25 of

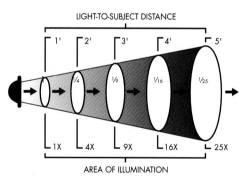

LIGHT-TO-SUBJECT DISTANCE

AREA OF ILLUMINATION

DOUBLE THE DISTANCE = OPEN 2 *F*-STOPS

DOUBLE THE LIGHT INTENSITY = CLOSE 1 *F*-STOP

the amount of light measured at the source. If the distance is doubled by moving the light back to 10 feet, the remaining

light on the subject is calculated as $1/(10)^2$ or 1/100 of the intensity at the source. Therefore, the light making up your film exposure is only 1/4 of that available at a 5-foot distance and requires 2 *f*-stops to compensate for the loss.

F-stop numbers are also an inverse value. The greater the *f*-stop number gets, the smaller the lens aperture becomes. Using this relationship, you can also interpret another comparison that becomes a handy reference.

Also, by your doubling the light-to-subject distance in feet, the effective exposure changes by two *f*-stops. A one *f*-stop change is made when you move the light from the subject to a distance equal to 1.4 times its previous distance. This relates exactly to the *f*-stop scale for quick and easy calculations.

Courtesy of Norman Enterprises, Inc.

THE HOTSHOE-MOUNT FLASH

MONARCH BUTTERFLY, the Caribbean. Nikon 8008S, Nikkor 80-200mm AF zoom lens, Fujichrome Velvia exposed for 1/125 sec. at f/4.

A shoe-mount flash is great for closeups. The unit's quick burst of light helps to freeze motion and brighten colors. For this closeup shot of a monarch butterfly, I set my Nikon SB-24 flash on -1 stop on matrix-balanced, fill-flash mode. At this setting, the flash also retained the natural-looking background.

MAN WITH RED GATE, Grand Turk Island, British West Indies. Nikon 8008S, Nikkor 20-35mm AF zoom lens, Fujichrome Velvia exposed for 1/250 sec. at f/5.6.

Bright sunlight, whitewashed masonry, and dark skin tones can spell disaster in a photograph. Fortunately, the contrast-lowering capabilities of a shoe-mount flash can save the day. For this portrait, I set my Nikon SB-24 flash on -1 stop in matrix-balanced, fill-flash mode, and held it off camera via an SC-17 TTL cord. The unit provided a burst of flash just bright enough to open up the detail on the man's face and put catchlights in his eyes.

For many years, the basic hotshoe-mount flash was the lighting accessory everyone loved to hate. Sure, you could go into a dark room, set the sync speed on your camera (usually 1/60 sec.), turn on your flash unit, figure out the proper f-stop using the GN or distance scale on the flash, aim the flash at your subject (checking to see if the person was still awake), and shoot away. The results were predictable: a harsh, stark, flat light falling on a startled-looking subject floating in a sea of darkness. But at least you got the picture.

Later on, when thyristor and TTL exposure controls were introduced, photographers were relieved of these complicated exposure calculations. You could simply select any one of your flash unit's recommended f-stops and fire at will. Unfortunately, for most flash users, this made it easier to make ugly pictures; the light quality, or actually the lack of it, remained the same.

Not surprisingly, then, many less technically oriented photographers avoided working with flash at almost any cost. They felt that if a picture couldn't be done with available light, it wasn't worth doing. And who could blame them? There is hardly an uglier form of available light than direct, on-camera flash. Fortunately, you have better ways to use on-camera flash to produce beautiful, publishable photographs at your disposal.

INCREASING YOUR FLASH'S EFFECTIVENESS

Most electronic flash units are balanced for high-noon daylight, which is 5500K or higher. Many photographers consider this light to be cold and blue. To produce a more flattering skin tone, some photographers "warm up" their flash by taping a light amber filter, such as a Roscolux #02 bastard-amber filter, to the front of their flash unit's reflector. The inexpensive Roscolux swatch book provides perfectly sized filters for most shoe-mount flashes.

You can improve the quality of your flash pictures other ways, too. If you do rely on fill flash a great deal, try to use a camera with a top sync speed of 1/250 sec. This higher sync speed enables you to use wide-open apertures, which are often needed when you work with small, battery-powered strobes.

You can refine the quality of your bounce flash by taping a 3 x 5-inch white index card to the back of your flash unit, so that it peeks above the flash reflector when you aim it at the ceiling (see page 45). This card redirects some of the light heading for the ceiling and opens up the eye-socket shadows that sometimes occur with bounced light. You can also use commercially manufactured fill cards, such as Domke's Sommers Fill Card; these are made of white plastic and attach to the strobe via a hook and loop fastener.

ARTIST WITH VOTIVE CANDLES, New York City. Nikon 8008S, Nikkor 20mm wide-angle lens, tripod, Kodachrome 64 exposed for 1 second at f/4.

I made this shot for the United States Information Agency for a story about an iconographer who was restoring a Russian Orthodox church in Manhattan. The artist, who had created this small shrine in memory of his mother, lit votive candles at the end of each day's work. Although the candlelight alone wasn't enough to illuminate him, I wanted to make it look as though it was. So I attached an SB-24 flash covered with Roscolux #18 flame gel to a small 20-inch white umbrella via a Domke twin-flash bracket. I connected this to my camera with an SC-17 cord that I've had modified to accept extensions. Here, I used a 12-foot extension. I placed the rig on the floor in front of the artist, so that the light would shoot through the umbrella and come from the same basic direction as the candlelight. The available-light reading was 1 second at f/4. I used matrix-balanced fill flash, dialed a -1 stop compensation factor into the strobe, and proceeded to fire away, confident that the flash would blend in a natural-looking way and not overpower the scene.

USING YOUR FLASH OFF CAMERA WITH A CORD

The single most important way that you can enhance the quality of your single-flash pictures is to take the flash unit off the camera. The only good part about the flash sitting in the hotshoe when you shoot is that you don't need a hand to hold the unit; this arrangement does absolutely nothing to improve the quality of the light. The resulting illumination is featureless and straight on, and as such has the same drawbacks that natural frontlight does. By moving the flash off the camera and aiming the unit at about a 45-degree angle to the subject, you create the sculpting, well-placed shadows that impart a·three-dimensional sense of depth to your picture. You have several options to choose from.

First, invest in one of the optional off-camera cords that nearly every camera and flash manufacturer offers. These cords enable you to retain full use of your flash unit, including TTL exposure control (if your flash offers this feature). Many older units, like the venerable Vivitar 283, have remote cords that use the flash unit's own sensor. You unplug the cord from the camera body and attach it to the end of the cord that sits in the hotshoe. You then plug the other end of the cord into the flash itself, thereby permitting you to point it anywhere while the sensor in the hotshoe remains aimed at the subject. Then simply hold the flash in your hand off to one side in order to create dramatic shadows.

These off-camera cords often come in different lengths, and a longer one will give you the flexibility of moving farther away from the light source, as you might do when shooting with a telephoto lens. Of course, when you use the flash this way, you must mount it on a lightstand or have someone else hold it for you. If your flash or camera manufacturer offers only one cord length, check the manual to see if you can gang together two or more to get extra distance. For example, Nikon's SC-17 cord is about 5 feet long when uncoiled, but the instructions say you can use three of them together for an additional 10 feet or so of extension. Similarly, some after-market outlets, like Andrews Photographics (see Resources on page 142), "chop" an SC-17 cord in two, put connecting hardware on either end, and offer extension cords of various lengths to connect the two ends. I had this done with my SC-17 cord and now have 12- and 25-foot-long "extension cords." And I've actually ganged these cords together for more than 40 feet of extension, retaining full TTL control of my Nikon SB-24 flash while shooting with a 300mm telephoto lens!

MAN SCOOPING PILLS, New Jersey. Nikon 8008S, Nikkor 18mm wide-angle lens, Kodachrome 64 exposed for 1/60 sec. at f/8.

I shot this picture of a pill-coating machine for the Schering Plough annual report. Once I opened the coater's back hatch and positioned my camera near the pills, I didn't have much room for a light in the machine, which resembles a large, tumbling-action clothes dryer. I needed a single light source that would do it all, so I clamped an Armatar 300 flash, with the reflector removed for bare-tube lighting, right above the camera to the top rim of the hatch. The 360-degree light bouncing around the brushed metal interior did the trick, and I maneuvered as best I could to put the hotspot reflection into a position where it would be least offensive.

TIRED FIREFIGHTERS, New Jersey. Nikon FE2, Nikkor 85mm telephoto lens, Kodachrome 64 exposed for 1/60 sec. at f/8.

I made this shot for a Johnson & Johnson annual report. My goal was to show how people who "haven't got time for the pain" cope with their aches with one of the company's medications (notice the little bottle in the upper-right-hand corner of the frame). For the basic lighting setup used here, I bounced a Dyna-Lite 1000 watt-second head into a Photek 51-inch umbrella and through a Domke 4 x 6-foot white panel to the left of the camera.

HAND WITH DNA GELS, Pennsylvania. Nikon 8008S, Nikkor 85mm telephoto lens, tripod, Kodachrome 64 exposed for 10 seconds at f/4.

To read these DNA gels, you need the aid of an ultraviolet (UV) lightbox, which didn't cast enough light to illuminate any other element in the scene. So to highlight the scientist's rubber-gloved hand, my assistant used a small penlight that I carry in my camera bag. Since the weak illumination from the UV lightbox required a long exposure, the light from the small flashlight was a perfect match; I couldn't have predicted that the light would look so red. I "guesstimated" exposure times, took a couple of Polaroid tests, and bracketed heavily. The scientist, my assistant, and I all wore two sets of protective goggles during the shoot because we were spending a great deal of time looking at the UV light.

If retaining TTL control isn't important, a long PC cord can also do the trick. With this setup, you'll probably need to put the flash on "Manual" and take a flash-meter reading from the subject's position to guarantee an accurate exposure. If your flash has automatic rather than TTL exposure control, you can aim the sensor at the subject and shoot at the selected aperture. Keep in mind that this method is far less accurate than the meter-reading approach. Here, because of the distance between the flash and the camera, the lens may be "seeing" a different portion of the subject than the flash unit's exposure sensor.

To make using your shoe-mount flash off-camera with an extension cord more convenient, try Photak's small velcro wriststrap (see Resources on page 142). This strap attaches to your flash by means of a hotshoe or 1/4-inch #20 screw and enables you to dangle the flash on your wrist while you reload or make other camera adjustments. This accessory is like having an extra hand in the field. You can also use a flash off-camera without a corded connection (see page 81).

BOUNCE FLASH

As a rookie newspaper photographer in the mid-1970s, I carried the standard-issue flash of the time: a big, powerful, all-manual "potato masher" with a handle. This flash could have illuminated the front of a three-story apartment building during a nighttime fire—once you figured out the right aperture by using the calculator dial on the back of the flash. (Of course, by this time, at least in the beginning, the fire would almost be out). I eventually got the hang of the flash, but I hated to use it because of the harsh quality the direct light gave my pictures. Finally, one of the more experienced staff photographers took me aside and asked me why I didn't bounce the thing. I told him that I would be happy to as soon as I found a better unit to replace mine. He then initiated me into the mysteries of bounce flash.

Basically, bounce flash involves aiming the flash at a broad, light-toned (preferably white), neutral-colored surface—usually a ceiling or a wall—to diffuse the light before it hits the subject. This eliminates the harsh shadows and hard, specular light of direct flash. And in its place, you have a soft, natural-looking light that appears, for all intents and purposes, to be available light.

You need to remember several points when shooting bounce flash. Because the light is traveling farther

WAITRESS IN CAFE TOMASELLI, Salzburg, Austria. Nikon FE2, Nikkor 24mm wide-angle lens, Kodachrome 64 exposed for 1/30 sec. at f/5.6.

I needed a shot of Salzburg's historic Cafe Tomaselli for a National Geographic Traveler story. I'd shot some candids of people in the cafe with high-speed film and available light, but I wanted to cover myself with some insurance shots of the waitresses and the pastry on a finer-grained stock. Although the women were basically cooperative, they wouldn't interrupt their busy routine to pose, so I had to shoot on the run. I decided to use my Armatar 300 watt-second flash in the automatic mode. With the remote sensor sitting in the hotshoe, the Vivitar SC–1 remote sensor cord enabled me to aim the unit at the 10-foot ceiling. I attached a small, white bounce card with velcro to the reflector in order to redirect a little of the illumination. The flash's extra power allowed me to work at a medium aperture, f/5.6, with relatively slow film, Kodachrome 64, using bounced light. Since the waitresses wouldn't stay still for me to do a Polaroid test shot, this automatic rig permitted me to follow them as they worked and shoot quickly and unobtrusively.

FERTILITY GODDESS STATUE,
Malta. Nikon FE2, Nikkor
20mm wide-angle lens,
Kodachrome 64 exposed
for 1/250 sec. at f/8-11.

These statues of the fertility goddesses, the so-called Fat Ladies, were found throughout the Bronze Age stone temples on the island of Malta. I wanted a shot of one among the rocks near a temple for the National Geographic story I was working on. The National Museum staff wouldn't let me move an actual statue out to the temple, but they provided me with a replica. I took the statue to the Hagar Qim temple late on a cloudy afternoon and placed it on some of the rock formations there. I wanted a dramatic sky behind the statue. I knew that I could underexpose the clouds enough to accomplish my goal. I simply had to set a 1/250 sec. sync speed on my camera and pump in enough flash to require a small aperture. I turned on an Armatar 300 flash at full power and used an Armato umbrella bracket to attach the flash to a small, 20-inch white umbrella. I then connected all of this to the camera using a long PC cord. Holding the umbrella at a 45-degree angle to the statue with my left hand, I took readings and did a Polaroid test shot. Then I made a series of exposures with my motordriven camera with my right hand.

and being diffused, bounce flash uses more power than direct flash. With an average 8- or 10-foot-high white ceiling, you can expect to lose two to three stops of light. Modern thyristor and TTL flash units with swivel heads correct for this light reduction because they measure the light reflecting off the subject (automatic exposure) or off the film plane (TTL exposure). Nevertheless, if you are used to apertures in the f/8 to f/11 range when shooting direct flash, be prepared to use wider apertures, f/2.8 to f/5.6, when bouncing the flash.

Photographers who shoot in color must also be aware of the color of the surroundings when they bounce flash. For example, a light green ceiling make your subject look seasick, while orange walls provide an "instant-sunburn" look. If you find yourself shooting in a room with dark or off-color walls and ceilings, don't give up—just improvise. Taping together several pages of a broadsheet newspaper and then taping them to the wall or ceiling will produce a nice bounce surface. Rosco sells 56 x 48-inch sheets of gold, silver, and white reflective material that fold into a pocket-sized plastic pouch, weigh only a few ounces, and provide 18 square feet of bounce surface. These sheets are called Roscopaks, and you can attach them to anything.

PHARMACEUTICAL LAB, Rome, Italy. Nikon FE2, Nikkor 20mm wide-angle lens, tripod, Kodachrome 64 exposed for 2 seconds at f/8-11.

To successfully shoot this lab, I turned off the fluorescent lights, and set up my Bowens 500 watt-second flash at full power (above). After covering it with a blue gel, I bounced the flash off the ceiling to produce a wash of blue light with a reading of f/5.6, knowing that I would eventually be shooting at closer to f/11. Underexposing the blue illumination gives it a deep, shadowy tone. Next, I set my Armatar 200 watt-second, battery-operated unit at full power and fitted it with a gridspot. I hid this flash between the computers on the scientist's desk and aimed the flash at him to require an aperture between f/8 and f/11. Then I dialed down a second Armatar 200 flash to quarter power, fitted it with a red gel, and aimed it so that it raked across the side of the foreground computer and the lab bottles (right).

DIFFUSING THE FLASH

CAT ON A FOUR-POSTER BED,
Maine. Nikon FE2, Nikkor
20mm wide-angle lens, tripod,
Kodachrome 64 exposed for
1/4 sec. at f/8.

Working on a story on New England inns for Travel & Leisure magazine, my assistant and I came across this cat sleeping peacefully on the bed in a room in the Captain Lord Mansion. It was a great situation, but we didn't know how long the cat would cooperate. While my assistant built a quick fire, I set up a Dyna-Lite M500x powerpack with one head bounced off the ceiling to the right of the camera. I wanted to open up the foreground while keeping the feeling of natural light. The available-light reading was about 1/4 sec. at f/8 on Kodachrome 64. I turned down the power down on the light so the strobe reading would be about a stop less, f/5.6; I wanted to open up the shadows. Concerned about time, I didn't even do a Polaroid test. I shot a bracketed sequence with the camera on a tripod. The cat slept the entire time.

When you work with on-camera flash, you sometimes find that no suitable bounce surfaces are available. Fortunately, you still have some alternatives to direct flash to choose from. In recent years, several manufacturers have come up with compact, inexpensive, portable diffusion devices for on-camera flash. Although these accessories are preferable to direct flash, their small size limits their diffusion power.

And no matter what the advertising copy might promise about these diffusers, one truth regarding lighting can't be circumvented: the larger the light source (in relation to the size of the subject), the softer the light. So while a small, clip-on softbox may provide a soft, wraparound light for a macro subject like a butterfly, a light source as big as a king-size bedsheet would be required to achieve that same light quality for a group portrait of five or six people. But this is a case when diffusing the flash with something is better than doing nothing at all.

The most compact of these diffusion devices is the Sto-Fen OmniBounce. This translucent plastic dome fits over the reflector of the flash, creating a 360-degree spread of light, similar to bare-tube lighting (see page 115). This is the accessory to use when you have a wide-angle lens on your camera. It can even cover the 180-degree, full-frame perspective of a

16mm fisheye lens. Like a bare tube, the OmniBounce works best when the scattering light can bounce off light-toned surfaces. Light loss from this device is about two stops.

LumiQuest makes a series of "Pocket Bouncers" that are essentially small bounce surfaces that attach to flash units with velcro. The softest and largest of these is called the Big Bounce. The bounced light passes through this sheet of frosted vinyl, which provides a bounce surface of about 8 x 10 inches. The Big Bounce is a bit unwieldy, but the smaller Pocket Bouncer works well for on-camera flash. These devices cause a light loss of 1½ to 3 stops.

Westcott makes a small softbox called the Micro Apollo that attaches to your flash by means of spring-tensioned arms and velcro. You can mount the unit quite quickly. The front panel, which measures approximately 5 x 7 inches, does a good job of diffusing with a minimal light loss, usually about 1 1/2 stops.

All of these diffusers do an adequate job of softening up the light from an on-camera flash. Be aware, though, of the possibility of light bouncing back into the automatic thyristor eye on many flashes. These diffusers work better with units that offer TTL exposure control.

WOMAN WITH DOGS, New Orleans, Louisiana. Nikon 8008S, Angenieux 20-70mm zoom lens, tripod, Fujichrome Velvia exposed for 1/15 sec. at f/4.

For a story about the French Quarter of New Orleans for Travel/Holiday magazine, I wanted an appealing environmental portrait of Rebecca Lentz, a former ballet-school head and a fixture of the Quarter. Lentz loves the color purple, and all her clothes and even her house are painted a lavender hue. I set up a chair in her back garden and posed her with two of her dogs. To add a little zing to the overcast illumination, I used my SB-24 flash, set for -1 stop in matrix-balanced, fill-flash mode, with an SC-17 remote cord. I aimed the flash through a small white umbrella. With my camera on a tripod, I took a meter reading through the lens and fired away.

STILT WALKERS, Singapore.
Nikon 8008S, Nikkor 20-35mm
zoom lens, Kodachrome 200
exposed for 1/4 sec. at f/4.

I was shooting a story on Singapore for Islands magazine and was covering the annual Chingay parade, which celebrates the Chinese New Year. As is my habit at parades, I roam the assembly area before the parade starts to look for portraits. I found these stilt walkers and chose a low angle in order to eliminate a busy background. I used my SB-24 flash set on -1 stop on matrix-balanced, fill-flash mode and went with the camera's meter reading for the available-light exposure.

BLENDING FLASH AND NATURAL LIGHT

THE ATLANTA UNDERGROUND,
Georgia. Nikon 8008S, Nikkor
20-35mm zoom lens, tripod,
Fujichrome 100 exposed for
1 second at f/4.

*Shooting for the Insight Guide
to Atlanta, I wanted to cap-
ture the activity of a busy
weekend night at the Atlanta
Underground, a complex of
bars, clubs, and shops. With
all of the available light in
the scene, all I needed was a
pop of strobe to open up the
foreground. This was a perfect
situation for my on-camera
flash, which I set at -1 stop on
matrix-balanced, fill-flash
mode.*

One of the most important techniques a location photographer needs to learn is how to work with the light available and not necessarily to overpower it. The light from flash units falls off quickly. It doesn't go far, and as the Inverse Square Law states, its power diminishes geometrically as it travels away from the source. This is especially true of small, shoe-mount flash units. The best you can do with these is to illuminate a small area right in front of the camera.

What happens, though, when you have a dark scene with some depth to it? No matter how you modify the light from your flash—by bouncing or diffusing it, for example—if you shoot at the camera's normal sync speed (1/60, 1/125, or 1/250 sec. depending on the make and model), you'll still end up with either a well-lit subject or subjects swimming in a pool of darkness. There is an easy and obvious way to remedy this.

While you determine a flash exposure by the aperture setting alone, you can control an available-light shot via two control options, the aperture and the shutter speed. No law requires you to shoot at your camera's top sync speed; these speeds are important when you're mixing flash with bright sunlight (see page 55). In low-light settings, you can actually *burn in* the background by using a slower shutter speed with your flash. Instead of shooting a flash picture at 1/125 sec., try shooting the same image at 1/8, 1/4, or 1/2 sec. Suddenly, details in the background become visible, thereby creating a much more natural-looking picture: lamps look lit, computer screens are no longer blank, and candles and fireplaces emanate their expected glow.

How important is this technique? I shot most of the photographs in this book with flash and a slow shutter speed. There is no better way to achieve natural-looking yet effectively illuminated pictures than by combining flash and available light. In fact, blending has become such a widespread technique that camera manufacturers have built this function into their autofocus flash systems. Nikon's matrix-balanced fill-flash mode, Minolta's slow-sync flash mode, and Canon's evaluative TTL (ETTL) mode all automatically utilize this technique.

But what if you don't own one of the new Smart-flash systems? Can you blend available light and the flash from your older, automatic thyristor unit? The answer is yes, with a little practice. The key is to

PILOTS IN JET, New Jersey.
Nikon 8008S, Nikkor 300mm
AF telephoto lens, tripod,
Kodachrome 64 exposed for
1 second at f/5.6.

I photographed these pilots for Allied Signal's corporate-magazine story about "Corporate Angels," a program through which corporate jets provide free transportation for transplant patients and organs. I needed a strong opening shot with the pilots clearly recognizable. I arranged to shoot on an unused runway at a small, corporate airport in New Jersey. I taped a bare-tube Armatar 300 flash with a Roscolux #18 flame gel to the control panel. Dialing down the flash to quarter power, I got a reading of f/5.6. I planned to set off the strobe with a radio remote. I set up down the runway, mounting my camera and 300mm lens on a tripod and attaching the radio transmitter. When I tried to take a Polaroid, however, the strobes wouldn't fire. For some reason, the radio signal didn't penetrate the plane's metal fuselage. Luckily, I had an assistant and a pair of powerful walkie-talkies. Since I used a long exposure to register the dusk light, I was able to tell my assistant to manually fire the flash via the walkie-talkie. He used a long PC cord, so he was able to sit out of sight in the plane's passenger compartment. Because a thunderstorm was rapidly approaching, the control tower wanted me off the taxiway, so I couldn't shoot another Polaroid. In the next three minutes, I squeezed off a series of bracketed exposures and hoped one would work. Fortunately, this one does.

*In this shot for a Schering
Plough annual report, a safe-
ty inspector uses a hanging
safety light to check the seams
of a large-scale, pharmaceuti-
cal production tank. I knew
that the safety light would
provide enough illumination
for him, but would leave the
rest of the tank dark. I had
only one place to put a light
where it wouldn't show:
beneath the agitator blade
behind the inspector. I
clamped an Armatar 300
watt-second flash set at full
power to the blade. I took off
the reflector in order to expose
the bare tube, which a
Roscolux #18 flame gel cov-
ered. I then plugged a Wein
XL slave into the light, which
I controlled with a Wein SSR
infrared trigger. I used a long
exposure in order to register
the lamplight on the inspec-
tor's face. The bare-tube lit the
rest of the tank's interior.*

prevent the flash or the available-light exposure from overpowering and washing out the subject. Basically, you want to underexpose each source slightly, so that together they don't overexpose the subject when they blend.

You can achieve this in a variety of ways. Suppose that you're using an automatic thyristor flash unit and ISO 100 film, and that one of the apertures available to you is f/5.6. After you set this aperture on the camera, meter the existing light. Assume that you get a reading that indicates a corresponding shutter speed of 1/4 sec. at the f/5.6 aperture. Next, under-expose the reading about one stop by setting 1/8 sec. on the camera. Then close down the aperture by half a stop to f/6.3 (remember, your flash is set to f/5.6, so in effect you're underexposing).

Now fire away. The result should be an exposure with both the foreground subject and the back-ground rendered nicely. This technique calls for a lit-tle experimentation until you find the formula that works best for you. For example, you may prefer the effect achieved when you shoot one full stop under the flashes' recommended aperture, or two shutter speeds faster than the available-light reading. The dis-tinct improvement in your flash pictures will be worth the investment of a few rolls of film to nail down this technique. (If you use a manual flash unit, see "Using Polaroid Tests" on page 66.)

Blending natural light and flash does have a down-side, however. The first and most obvious drawback is that since you're using a slow shutter speed, you need a tripod to ensure sharpness in both the back-ground and the foreground. Any movement by your

flash-lit subject in the foreground will result in blur-ring and ghosting. Nevertheless, many photographers prefer to do a great deal of their blending with hand-held cameras; they think that the blurring of the background and the ghosting of the flash image actu-ally add a sense of movement and excitement to the photograph. Shutter speeds of 1/4, 1/8, and 1/15 sec. are particularly effective for achieving this look.

When blending flash and available light, make sure that the color temperatures of the sources are matched or compatible. If you like the warm glow of incandescent or tungsten light sources shot on day-light film, you will need to make a corresponding cor-rection on your flash. And if you're using tungsten-balanced film, you must warm up your flash to a sim-ilar color temperature. An orange 85B gel filter, such as the Roscolux #18 flame filter, taped to the front of your flash will work well.

You can blend natural light and flash under fluo-rescent lights, too. Using a magenta-colored Tiffen FLD filter on your lens when you shoot Kodachrome 200, a film that corrects beautifully under fluores-cents, takes care of the available light. But the unfil-tered flash will look strongly magenta. To solve this problem, try taping a Roscolux #87 light window green gel over your flash to produce approximately the same color temperature as that of the fluores-cents. If you prefer a heavier correction of 40CC magenta in fluorescent situations—which is often necessary with films other than Kodachrome 200—add a second Roscolux #87 light window green gel to your flash. This technique is known as *complemen-tary filtration* or *color back*.

FILL FLASH

KITTY COLE BANG, Palm Springs, California. Nikon 8008S, Nikkor 20-35mm AF zoom lens, Fujichrome 100 exposed for 1/250 sec. at f/4.

Kitty Cole Bang was the most flamboyant in a field of colorful politicians running for mayor of this desert town. This self-described ultra-glamorous drag celebrity agreed to pose for a profile I was shooting about Palm Springs for Private Clubs *magazine. I chose a low angle to isolate Bang and the Rolls Royce against the blue sky. I mounted my SB-24 flash on a lightstand, connected it to a custom-extended Nikon SC-17 cord, and set it at -1. I used fill flash so that Bang wouldn't be rendered in silhouette.*

No flash technique has been more misunderstood and subject to misinterpretation than fill flash, which is also sometimes called *synchro-sunlight flash.* Basically, this technique is the same as blending. The major differences are that with fill flash, the primary light source is the sun, and you're using the flash only to open up shadows in the scene. Again, film's limited perception range—its inability to hold details in both shadow and highlight areas—necessitates the use of fill flash. If film could see details in shadows the way the human eye can, you wouldn't need to lighten up those shadows. When making prints from negatives, you can eliminate some of this blockage by *dodging,* or lightening, the shadows. Photographers who shoot slide film, which is still the standard choice for most professional applications, don't have this option.

Essentially, when you use fill flash, you use a two-light setup (see page 61). The sun is the primary source of illumination. The flash is your fill light; its job is to open up, but not entirely eliminate, any shadows the sun casts. If you use too much fill and eliminate the shadows entirely, the result will be a stark, unnatural-looking picture. If you really go overboard with the fill light, you'll create a second main light. This, in turn, will produce a second set of shadows, which is entirely unnatural. After all, there is only one sun, so people are used to seeing only one set of shadows. Double shadows are usually unacceptable for still lighting: you see multiple shadows in some television- and film-lighting situations, but this is acceptable only because the image is moving.

To use fill flash, you must first make an available-light reading. Suppose that you're shooting ISO 100 film on a sunny day, and the reading is 1/125 sec. at f/16. Suppose, too, that your camera has a top sync speed of 1/250 sec., your flash has a GN of 110, and your subject is 10 feet from the camera. The object of fill flash is to open up the shadows. Most photographers find that keeping the shadows 1 to 1½ stops darker than the highlights provides a natural-looking open shadow. If you divide the distance, 10 feet, into the GN, 110, you come up with an aperture of f/11. Since you're shooting at f/16, the flash will be underexposing by a stop, and you'll have opened up, but not washed out, the shadows.

TENNIS COACH, Long Island, New York. Nikon FE2, Nikkor 105mm telephoto lens, Kodachrome 64 exposed for 1/125 sec. at f/11.

I photographed Tony Palafox, a famous tennis coach who has worked with John McEnroe and other players, for a cover profile in Boys' Life magazine. Since the story was to include a series of how-to sequence shots as well, I had to do the shoot at Palafox's home, which had a tennis court. I set up the cover shot in his garage, using a 9-foot-wide roll of blue seamless paper as a backdrop. I then positioned a medium Chimera softbox with a Dyna-Lite 500 watt-second head covered with a blue gel on the floor behind my subject. I aimed this assembly up at the background. Another medium Chimera, with a Dyna-Lite 1000 watt-second head, provided the main light from the left of the camera. A 38-inch Flexfill on the opposite side of the subject provided some bounce fill. I suspended the tennis balls from the garage rafters with clear, monofilament fishing line.

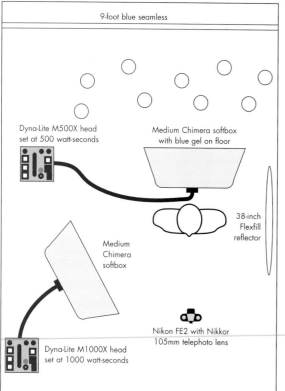

9-foot blue seamless

Dyna-Lite M500X head
set at 500 watt-seconds

Medium Chimera softbox
with blue gel on floor

38-inch
Flexfill
reflector

Medium
Chimera
softbox

Nikon FE2 with Nikkor
105mm telephoto lens

Dyna-Lite M1000X head
set at 1000 watt-seconds

DRAGON DANCE, Kuala
Lumpur, Malaysia. Nikon
8008S, Nikkor 20-35mm zoom
lens, Fujichrome 100 exposed
for 1/2 sec. at f/4.

*Shooting in Malaysia for
Travel/Holiday magazine, I
came across this temple festi-
val outside Kuala Lumpur
during the Chinese New Year
celebrations. I wormed my
way close to the stage and
panned with a slow shutter
speed as the dancers swirled
past. I mixed a long exposure
with a pop of strobe, setting
my SB-24 on -1 stop in
matrix-balanced, fill-flash
mode.*

This technique sounds pretty simple so far. Prob-lems arise when you use a manual strobe without any automatic or ratio functions: it doesn't allow you to vary the flash output by choosing, for example, the 1/2, 1/4, or 1/8 power settings (if you have an old strobe like this, do yourself a favor and get rid of it— unless you have a strong urge to use antique technol-ogy!). In this case, you must physically move the flash closer to or farther away from the subject, while keeping the camera at the same distance, until you are able to achieve the requisite 1 to 1½ stops less light. If your flash has power controls, such as "half-power," "quarter-power," and "eighth-power" designa-tions, you can vary the output this way without hav-ing to physically move the strobe.

Suppose that you're shooting once again with basi-cally the same parameters. The only difference is that your flash has a GN of 80. At 10 feet, you'll be able to pump in only f/8's amount of flash, which is two stops less light than that of f/16, your shooting aper-ture. You can either move the flash closer or, more conveniently, increase the shutter speed to 1/250 sec. You would then have to open the aperture to f/11 for the available-light reading. The flash's f/8 setting pro-vides a perfect balance for fill flash.

AUTOMATIC FLASH UNITS

A camera with a sync speed of 1/250 sec. and an automatic (not a TTL) flash can combine for rela-tively hassle-free fill flash. Most flash units offer a choice of two or more apertures per film speed at which you can shoot. When using the flash as a main light, you simply select one of those apertures, turn on the flash, and fire away. The flash will put out only the light needed for that aperture. When using the flash as a fill light, you can "fool" it into underex-posing simply by setting the aperture one stop below the strobe's recommendation.

For example, you're shooting an ISO 100 film in full sunlight, and your reading is 1/250 sec. at f/11. Suppose that your strobe offers three automatic aper-tures for ISO 100 film: f/4, f/8, and f/16. Select the f/8 setting, even though your lens is set at f/11, and fire away. The flash will automatically put out enough light for f/8, which is about one stop less than the available light, and perfect fill. The thyristor will put out f/8's worth of flash no matter where you move as you shoot (assuming, of course, that you stay within the flash's operating range). For most small units, this means about 3 to 15 feet. The shadows will be open but won't be overexposed.

You may need to slightly juggle the shutter-speed/f-stop combination in order to come up with a setting that will mesh with your flash's aperture choices. Before the advent of the autofocus Smartflashes, which do all these fill functions automatically, I selected my hotshoe-mount strobes by the auto apertures they offered. In those days, I shot mostly Kodachrome 64. In full sunlight, its exposure was 1/250 sec. at f/8. As a result, I needed a flash that offered an automatic aperture setting of f/5.6, and the Sunpak 444D fit the bill.

SMARTFLASH

The new Smartflash units that were a byproduct of the autofocus generation of SLRs have revolutionized the way many photographers work. These units offer all the traditional bells and whistles, such as a choice of automatic thyristor exposure control or TTL exposure control, power ratios, zoom heads, and built-in diffusion panels.

Before this, however, an electronic flash's exposure system, whether automatic or TTL, only controlled the unit as the main light. If the flash was the main source of lighting in the picture, these units worked perfectly. The Smartflash units can do all this, but they have a mode that enables them to read the contrast range in a scene and put out only enough light to lower the contrast. In other words, a Smartflash unit can also function as a fill light, with the available light serving as the main source of illumination. When working in tandem with sophisticated multisegment camera meters, these Smartflash units are uncannily accurate in their ability to provide per-

fectly balanced fill flash in a number of situations. Different camera manufacturers have various names for this function. Nikon calls it a matrix-balanced fill flash; Minolta, a slow-synch flash; and Canon, an ETTL fill flash.

Initially, this might not sound too impressive. But in practice, the ability to put out absolutely seamless, worry-free, perfectly balanced fill flash without complicated calculations or Polaroid tests is a tremendous boon. You can create well-lit, professional-caliber photographs in far less time than previously required. As a result, you can cover a higher number of situations in a given amount of time. In many cases, the skillful blend of flash and available light eliminates the need to set up multiple lights.

The best Smartflash systems still permit some input from photographers. For example, many professional photographers find the fill flash that the factory settings of their Smartflash units are a little "hot" when they shoot transparency film. In other words, the units provide a slightly too much flash in the fill mode. Fortunately, in many units, you can program in an override of plus or minus up to two stops. For example, with my Nikon SB-24 flash and Nikon 8008s camera body, I like the results of the matrix-balanced fill flash when I have my SB-24 set to minus one stop. The Nikon factory default setting for matrix-balanced fill flash is minus 2/3 stop. By adding a minus one stop on top of that, I'm essentially telling the flash to underexpose the fill flash by 1⅔ stops from the available-light reading, a balance that looks great to me (for more on Smartflash technique, see "How I Use the Nikon SB Flash System" on page 80).

MULTIPLE FLASH

STAFF AT GRISWOLD INN BAR, Connecticut. Nikon FE2, Nikkor 24mm wide-angle lens, Kodachrome 64 exposed for 1/15 sec. at f/5.6.

To illuminate this shot of the staff behind the bar at the historic Griswold Inn, I worked with two Domke 4 x 6-foot light panels with white diffusion material. Behind each panel, I bounced a Dyna-Lite head into a Photek 51-inch umbrella. Since the light had to bounce into the umbrella and then travel through the panel's diffusion, it became very soft. The diffusion, however, also ate up a great deal of power. I had 1000 watt-seconds of power going through one head and 500 watt-seconds through the other. In the background, I put another Dyna-Lite 500 watt-second head through a square Bowens Bowflecta umbrella.

There comes a time in all photographers' lives when one light just isn't enough for the job, no matter how ingeniously they use it or how many reflectors they employ. Beginning to work with multiple light sources is a daunting prospect for many photographers because the pitfalls they encounter seem to increase geometrically with every added source. However, regardless of the complications involved, a multiple-source lighting setup is still composed of the same fundamental building blocks as a single-source setup. When you're confronted by a situation that requires multiple lights, it is worthwhile to take it step by step, applying the basic principles of multiple lighting covered in this chapter. The pitfalls will still be there, but the approach to multiple lighting described below can keep you from getting trapped.

Every lighting situation starts with a *main*, or *key*, *light* that illuminates the primary subject, determining its shadows and shape. A *fill light* is used to lighten the shadows and reduce contrast so that the film's compressed tonal recognition can still read detail in the shadows. The fill may actually be a second light, or it may take the form of a reflector; either way, its job is to lighten shadows and lower contrast. A *background light* is used to illuminate the background in a scene and separate the subject and the background. The background light can be another electronic flash or even ambient light. The blending techniques discussed in the previous chapter essentially use the available light. Finally, a *rim light*, sometimes called a *kicker*, is a light directed from the back or side of the subject that rims or edges it; this light also helps separate the subject from the background.

These four basic lights are the building blocks that constitute almost any lighting setup that involves people, from a simple portrait to a large interior. You probably won't use all four in every setup; often all you need is a main light and a fill light, or a main light and a background light. In practice, when I'm confronted with a multiple-flash situation, I like to "build" the setup one light at a time rather than throwing together a bunch of lights somewhat randomly. By taking a Polaroid after setting up each flash head, I can see how each light affects the picture.

The jump from using one light to using two or more lights is really a quantum leap. There is a saying about raising children that applies to using lights as well: "One is like none, and two are like ten." Actually, this is a bit of an exaggeration. But you can't deny that in addition to increasing the light, using multiple flashes increases the number of mistakes you can make. Working with more than one light doesn't have to be a hardship, however. Read on to discover how to make the move into multiple lighting a pleasant experience.

DETERMINING EXPOSURE IN MULTIPLE-FLASH SETUPS

Using a flashmeter is the best way to determine exposure for multiple-light setups. Flashmeters generally measure incident light, which means that they measure the light falling on the subject and not the light reflected off the subject (as TTL and automatic-thyristor meters do). The best flashmeters also have a mode to measure available light, and some, like Minolta's Flashmeter IV and Flashmeter V, measure incident and reflected light at the same time, thereby giving you accurate readings when you blend strobe and available light.

To measure for flash, hold the small, white dome on the flashmeter in front of the subject and pointed toward the camera. When you pop the flash, the flashmeter determines the proper *f*-stop for the given film speed. Because the dome on the flashmeter reads the light coming from all angles, you can easily get a reading for the combined output of all the lights. However, it is difficult to determine the output of each individual light.

You can get around this problem two ways. One method is to replace the dome in the flashmeter with an accessory flat port. Doing this, however, can make your overall readings less accurate since it is possible that the flat port won't "see" the output of lights coming in from an angle. The other way is to point the dome at each individual light and take separate readings, using your hand to block the light coming from the other sources. This way, you can get an idea of how much light is coming from each flash head, so you can determine the lighting ratio between them.

UNDERSTANDING LIGHTING RATIOS

A *lighting ratio* is simply a way to describe the difference between the light and dark portions in a photograph. For example, it can indicate the difference in the illumination level between the main light and the fill light. The reason why many photographers begin to quake when any discussion of lighting ratios starts is that, like many other aspects of photography, the obvious explanation isn't the correct one!

For example, many photographers find that, in order to create an appealing, open portrait, the shadow side of the subject's face should be about one *f*-stop darker than the highlight side. Now logic would tell you that this is a 2:1 ratio because the highlight side (the main light) is getting twice as much light as the shadow side (the fill light). But in the arcane jargon of lighting ratios, that relationship is a 3:1 ratio, not a 2:1 ratio.

In order to understand the way lighting ratios are expressed, you should try to think in terms of units of light. In the above-mentioned portrait with a 3:1 ratio, the main light provides two units of light on the highlight side of the subject's face. Because of the placement of the key light, it doesn't illuminate the shadow side, so a fill light is necessary. At one *f*-stop less than the main light, the fill light in this setup provides half as much light, or one unit of light. But because it is a fill light, it illuminates not only the shadow side but the highlight side as well. So the fill light adds an extra unit of light to the highlight side as well as to the shadow side. This means that the highlight side is now receiving three units of light—two from the main light, and one from the fill light—while the shadow side is receiving only one unit from the fill light. The resulting ratio, then, is 3:1, not 2:1. According to this formula, a two-stop difference between the highlight and shadow sides of a portrait produces a 4:1 ratio, and so on.

How worried should you be about precise ratios? Not too, unless you are in photography school and your homework assignment is to shoot portraits at different lighting ratios. In all my years of shooting, I've never had clients tell me that they would like a nice 3:1 ratio on an executive portrait. However, when I photograph heavyset, jowly executives, I know that a higher ratio—in other words, a deeper shadow—may help to slim them down or add a bit of drama. For a glamour portrait, you might keep the ratio so low as to be nearly nonexistent because the shadows and the mood they create aren't appropriate. Lighting ratios are simply photographic shorthand for describing lighting effects that you can often see and judge better with a Polaroid in the case of flash, or with your own eyes in a continuous-light situation.

PHARMACEUTICAL LAB, West Point, Pennsylvania. Nikon FE2, Nikkor 20mm wide-angle lens, tripod, Kodachrome 64 exposed for 1/2 sec. at f/8.

The key here was to isolate the elements of the scene, each with its own light, rather than to produce a wash of light (right). After turning off the overhead fluorescents, I aimed a Dyna-Lite head with a grid spot at the scientist and covered the white computer monitor with black velvet so that it wouldn't burn out (below). Next, I highlighted the machine behind him with another Dyna-Lite head with a grid spot. I then placed an Enertec NE-1 bare-tube head connected to a Dyna-Lite powerpack and covered with a blue gel inside the cage-like structure behind the scientist's head. Its omnidirectional illumination highlights several different areas of the cage. Finally, a small, low-powered, red-gelled Sunpak 444D lights the computer keyboard, simulating the glow from the screen.

Dyna-Lite 250 watt-second head Enertec NE-1 bare tube

Equipment bank

Dyna-Lite 500 watt-second grid spot

Dyna-Lite 500 watt-second grid spot

Sunpak 444D with red filter set at 50 watt-seconds

Computer monitor draped in black velvet

Nikon FE2 with Nikkor 20mm wide-angle lens

SCIENTIST WITH LASERS
AND COMPUTER, New Jersey.
Nikon 8008S, Nikkor 20mm
wide-angle lens, tripod,
Kodachrome 64 exposed for
10 seconds at f/11.

*The tiny room I had to work
in to get this laser shot for a
Bellcore annual report was
the least of my problems. To
highlight the laser and make
it visible, my assistant
wrapped his arms in black
velvet, so they wouldn't regis-
ter on film. Next, he traced
the path of the laser with a
nozzle from a tank of liquid
nitrogen that the lab had. The
cold smoke of the frozen gas
made the beam itself visible.
To illuminate the scene, I
bounced a blue-gelled Dyna-
Lite head from an M1000x
powerpack set at 500 watt-
seconds off the ceiling.
Although the exposure read-
ing was f/5.6, I shot at f/11 to
produce an overall wash of
deep blue. Next, I aimed a
Dyna-Lite head with a tight
grid spot, using the remaining
500 watt-seconds from the
M1000x powerpack, at the
scientist's face. To separate
him from the back wall, I put
a third Dyna-Lite head, with
a red-gelled grid spot and set
for 500 watt-seconds from an
M500x powerpack, behind
him and aimed it at the wall.
By bracketing and doing
Polaroid test shots, I found
that 10 seconds at f/11 was
the right exposure for balanc-
ing the computer screen, the
laser, and the strobes.*

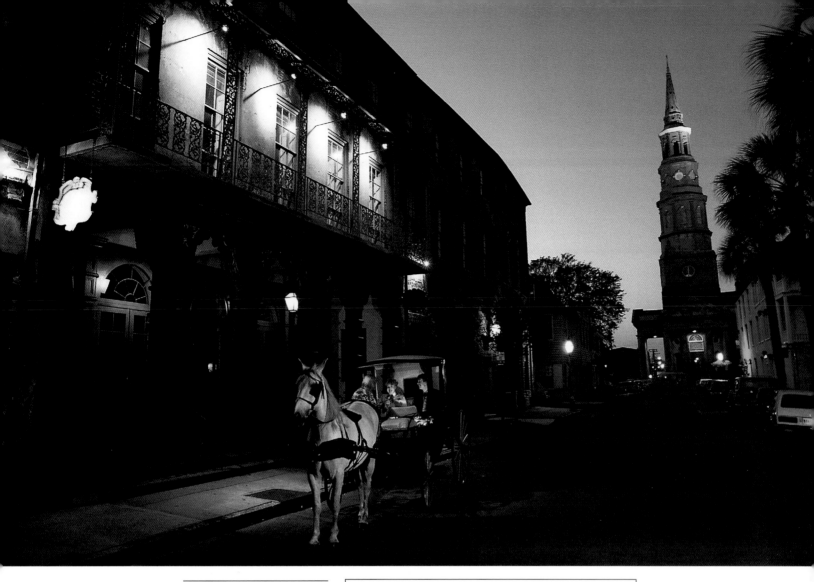

COUPLE IN CARRIAGE, Charleston, South Carolina. Nikon FE2, Nikkor 24mm wide-angle lens, Tiffen 85B filter, Tiffen 85C filter, tripod, Kodachrome 64 exposed for 1 second at f/4.

Shooting a carriage in front of the Dock Street Theater in Charleston, South Carolina, for Travel & Leisure *magazine, I needed to boost the level of available light. I used a direct Armatar 300 flash at full power, covering it with an 85B filter in order to simulate warm, incandescent available light. I aimed the flash at the carriage and triggered it via a Wein SSR infrared transmitter. Inside the carriage, I placed a low-powered Armatar 200 flash, with the reflector removed and the bare tube covered with an 85B filter, to illuminate the couple.*

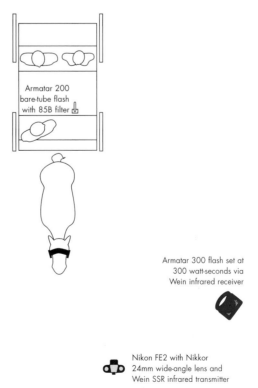

Armatar 200 bare-tube flash with 85B filter

Armatar 300 flash set at 300 watt-seconds via Wein infrared receiver

Nikon FE2 with Nikkor 24mm wide-angle lens and Wein SSR infrared transmitter

USING POLAROID TESTS

CHEF AND MAITRE D', Connecticut. Nikon FE2, Nikkor 24mm wide-angle lens, tripod, Kodachrome 64 exposed for 1/4 sec. at f/5.6.

On assignment for Travel & Leisure magazine, I wanted a warm, soft light to match the classic decor of this New England restaurant. To achieve this effect, I bounced two Dyna-Lite heads, one with 1000 watt-seconds of power

No matter how familiar you are with lighting ratios, or how accurate and sophisticated your flashmeter is, there is no better way to determine the "look" of your lighting than to see it with your own eyes. Unfortunately, with the lightning-quick burst of electronic flash, that is impossible to do. So, the advent of Polaroid film gave photographers the chance to preview their flash pictures instantly. You no longer have to shoot, send the film for processing, wait for it to come back, all the while hoping for the best. Shooting a Polaroid of your flash-lit subject, you simply wait a minute or two and peel off the backing. You then have a proof that gives you a reasonable idea of

what the flash illumination was going to look like on film and what light to adjust.

At first, this technology was available only to photographers who used medium- and large-format cameras with interchangeable backs. These individuals had no problem snapping on a Polaroid back to do the test shot, taking it off, and putting the real film-back on for the final shot. Until recently, users of 35mm cameras had fewer, less optimal choices.

The first option was to locate a Polaroid camera that had user-selected shutter speeds and apertures similar to those of a 35mm camera. The venerable Polaroid 180 and 195 cameras, originally designed to be used by insurance adjusters and the like, quickly became cult items as proof cameras. The method is still viable. You simply load one of these cameras with a Polaroid film that has a film speed similar to that of the film you're shooting. For example, when I shoot Kodachrome 64, I use Polaroid 664, both of which are ISO 64. And when I shoot an ISO 100 E6 film like Fujichrome or Ektachrome, I use Polaroid 100 Plus film. The next step is to set the same shutter speed and aperture, and then fire away. In 90 seconds, you have a Polaroid proof that gives you a good idea of how the flash will look in the final images.

This method has some drawbacks, however. Since Polaroid didn't make any interchangeable lenses for its 180 and 195 series cameras, they produce shots through a standard lens for these formats, a 115mm lens. If you're using a wide-angle lens on your 35mm camera, you have to shoot a couple of Polaroids and lay them side by side to get the total effect. Similarly, you would have to lay a loupe on a portion of the Polaroid

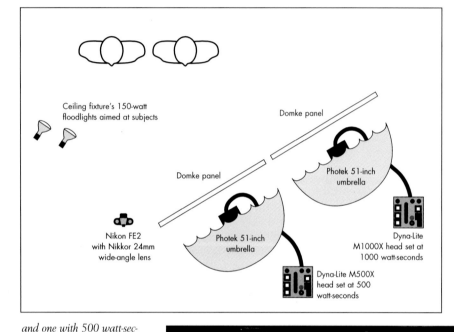

Ceiling fixture's 150-watt floodlights aimed at subjects

Domke panel

Domke panel

Photek 51-inch umbrella

Nikon FE2 with Nikkor 24mm wide-angle lens

Photek 51-inch umbrella

Dyna-Lite M1000X head set at 1000 watt-seconds

Dyna-Lite M500X head set at 500 watt-seconds

and one with 500 watt-seconds, into two Photek 51-inch umbrellas coming from the right. To further diffuse the light, I placed a Domke 4 x 6-foot light panel with translucent material in front of each umbrella, creating, in effect, a large banklight or softbox. I aimed a couple of the reflector floodlights in the ceiling fixtures at the subjects to open the shadows slightly.

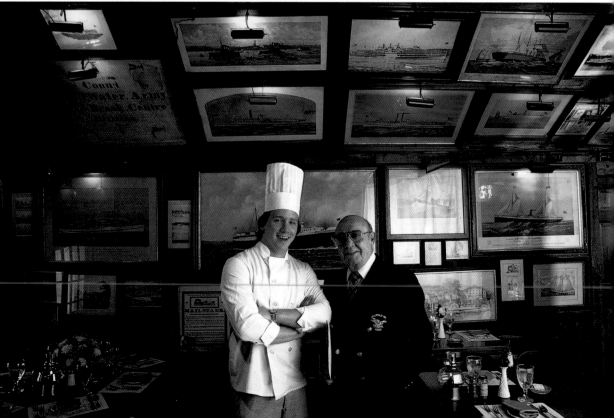

DAY FOR NIGHT IN A
RYOKAN, Kyoto, Japan. Nikon
FE2, Nikkor 20mm wide-angle
lens, Kodachrome 64 exposed
for 1/125 sec. at f/11.

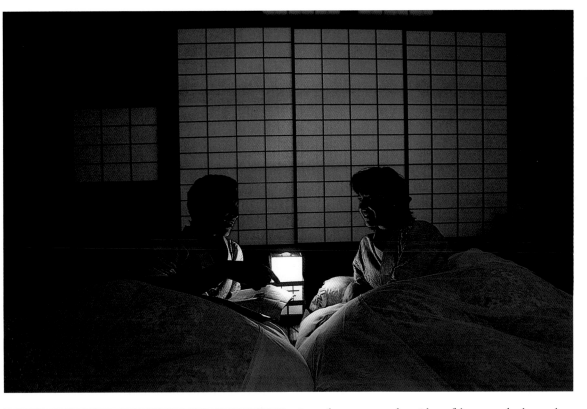

On assignment in Japan for National Geographic Traveler magazine, I was shooting a story on traditional inns, called ryokans. One of the photo editor's requests was to shoot a sequence with a Western couple, showing bedtime. My models were only available from 1:00-3:00 p.m. That made the bedtime shot a problem. Solution: Because my camera had a sync speed of 1/250 sec. and I had a couple of fairly powerful Dyna-Lite M500x powerpacks, I knew I could "overpower" the daylight and make the shot look like a night scene.

I put one pack and one flash head, bounced into an umbrella, behind the shoji screen behind the couple and covered the head with a Roscolux deep blue gel. In the room itself, I set up the other pack so that its flash head bounced off the ceiling, similarly covered with blue gels.

I was planning to shoot the scene at about f/11 for 1/250 sec., knowing that this would, in effect, "neutralize" the available light by severely underexposing it, and that the 1½-to-2-stop underexposure of the blue-gelled strobes would create a dark, nighttime feel yet still be readable on film. But that exposure would also underexpose the light from the little shoji lamp, which I was going to use to illuminate the couple.

I took the flashtube out of my Armatar 300 battery-operated unit and put it on the end of an Armatar-made flashtube extension cord (sometimes known as "strobe on a rope"). The other end of this cord plugs into the flashtube socket on the strobe itself. To simulate warm, incandescent light, I wrapped the flashtube in a Roscolux #18 flame

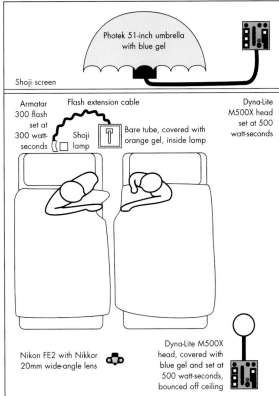

gel. Because it was just the tube and not the whole flash unit, I was able to fit it inside the shoji lamp, hiding the cord, the body of the flash unit, and the battery pack behind the man's mattress. With the Armatar 300 flash

dialed up to full power, I got a reading of f/11 from the couple's faces. I shot a Polaroid to make sure that the effect was working and fired away, confident that broad daylight would look like night in the final chrome. And it does.

in order to get a clear idea of how a telephoto shot would look.

Nevertheless, using a Polaroid 180 or 195 camera remains an inexpensive way to get into Polaroid testing. Because these cameras haven't been manufactured for several years, they're becoming quite rare. But a company named Four Designs takes current Polaroid folding cameras and modifies them so that they have user-selected shutter speeds and apertures (see Resources on page 142).

During the 1970s, repair-and-customization guru Marty Forscher began creating Polaroid "backs" for 35mm cameras. He was able to graft regular camera backs to Polaroid backs by using a block of fiber optics to transfer the image from the camera's film plane to that of the Polaroid back. This revolutionized the way 35mm photographers worked because they were able to see Polaroid previews with the exact same lens and perspective as those used in the final image. Photographers were no longer unpleasantly surprised by, for example, an umbrella reflected in the corner of their 20mm wide-angle shot that didn't show up on the 115mm Polaroid.

Currently the NPC Company markets these 35mm Polaroid backs (see Resources on page 142). They are also available for medium-format cameras, such as the Pentax 67 and the Mamiya 6, that don't feature interchangeable backs. The fiber optics used in these backs make them rather expensive, costing between 600 and 900 dollars. If, however, you're shooting a great deal of multiple-flash setups, you'll find that these backs are worth the investment.

BATTERY-POWERED FLASH UNITS

CASINO PENTHOUSE, Atlantic City, New Jersey. Nikon FE2, Nikkor 24mm wide-angle lens, Kodachrome 64 exposed for 1/125 sec. at f/5.6.

Plenty of light poured into the windows of the high-rollers' penthouse at Trump Casino when I was shooting a story Travel & Leisure magazine. Naturally, the farther I moved away from the windows, the more the light dropped off. So I decided to supplement but not overpower the window-light. I bounced three Dyna-Lite 500 watt-second heads, two from an M1000x power-pack and one from a M500x powerpack, off the ceiling to fill this huge room.

Once you find yourself headed on the road to multiple-flash ownership and use, you have to make several decisions. First, you have to choose between battery-powered and alternating-current (AC) flash units. Naturally, both types have useful features, and in truth, you'll eventually end up needing some of each for a complete lighting kit.

The primary advantage to working with battery-powered strobes is the independence they afford you when it comes to power sources. You don't have to worry about the availability or the voltage of the power; you simply set up your units and fire away. In addition, battery-powered units are generally smaller and cheaper than their AC-powered counterparts. Many photographers' battery-powered systems consist of two or three of their favorite shoe-mount flash units, along with some high-voltage battery packs for quick *recycling times*. This is the length of time that the batteries need to return to full power after being discharged. Waiting for four AA batteries to recycle

your lights in multiple-flash setups is like watching grass grow.

Unfortunately, you must pay a hefty price for the independence of battery-powered flashes. They are generally less powerful and slower to recycle than AC units. Fast flash recycling is important when you're photographing people and you need to catch fleeting expressions and/or interactions. Nothing is more frustrating than seeing a great moment in the viewfinder before the flash has finished recycling.

Most battery-operated units run in the 100 to 400 watt-second range, although a few systems are more powerful (and more expensive). When you work with high-power battery units, like the 1200 watt-second units, you get only about 50 full-power shots from a battery with a multi-second recycle time. (This is the manufacturer's estimate. I've never owned a battery-powered strobe that delivered much more than about 50 percent of the manufacturer's claims about the number of shots a fully charged battery will provide in the real world of actual use. This isn't to say that the companies are dishonest; they are just incredibly lucky when they run their tests!) So unless you carry a bagful of heavy and expensive spare batteries, you may find yourself out of juice by the time you finish taking readings, tweaking lights, and shooting Polaroids.

Another important point to consider is the type of battery your strobe systems use. Although nickel-cadmium (NiCad) batteries have been greatly improved during the last few years, the typical NiCad

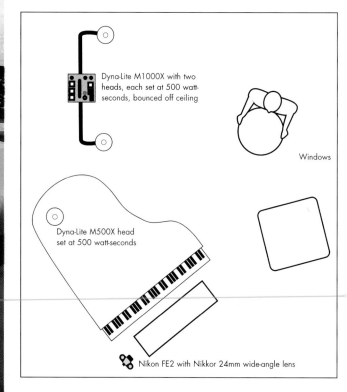

Dyna-Lite M1000X with two heads, each set at 500 watt-seconds, bounced off ceiling

Windows

Dyna-Lite M500X head set at 500 watt-seconds

Nikon FE2 with Nikkor 24mm wide-angle lens

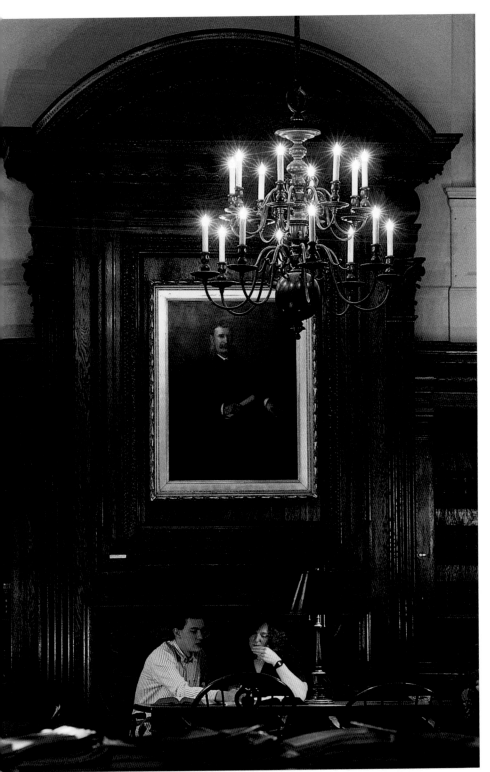

rechargeable battery is subject to the effects of *memory*. These batteries must be fully discharged before you recharge them. If you routinely use only a portion of the battery's power, say half, before recharging, soon the battery will deliver only half of its power. The term "memory" describes this tendency.

You can combat battery-memory effects two ways. One approach is to use batteries that aren't subject to memory effects, such as *gel cells*; these are sealed lead acid batteries. The batteries I use to power the HS 350 High-Voltage modules, which run both my Armatar 300 and my Nikon strobes, are gel cells, and I find them convenient to use. I don't have to worry about the discharge cycle; I simply recharge and go on to the next location. Your other option is to use a conditioning charger with your NiCads, which fully discharges a battery before beginning the recharging cycle. Unfortunately, not every battery manufacturer offers a conditioning charger, so photographers are left to their own devices to find ways to fully discharge their batteries.

Nevertheless, I know many working professionals who use nothing but battery-powered strobes and are quite happy with the arrangement. Ian Lloyd, who is based in Asia, is often called upon to shoot in out-of-the-way locations like logging camps and remote villages, as well as in more mundane locations like offices and factories. Danny Turner is a medium-format, location-portrait specialist. He carries several 1200 watt-second battery units and does most of his work with one 4 x 6-foot softbox. He rarely makes more than 50 exposures per sitting, so the battery capacity is fine. And he never has to worry about extension cords, portable generators, or inverters when he wants to shoot out of range of AC power.

If you want to bounce or diffuse your lights and shoot at *f*/8 or higher on a medium-speed film, you'll be out of luck with most battery systems. The high-voltage battery packs required to run even 100 to 400 watt-second strobes are heavy, especially when you consider the weight of the battery chargers you must carry in order to recharge them. A bag of battery-powered strobes, with rechargers and spare batteries, can easily outweigh an AC system that has the capacity for far greater light output.

PROFESSOR WITH STUDENT, Massachusetts. Nikon 8008S, Nikkor 80-200mm zoom lens, tripod, Kodachrome 64 exposed for 1/8 sec. at f/4.

Initially, I set up two Dyna-Lite heads bounced into umbrellas to illuminate this scene in the faculty lounge of Williams College. While I used the modeling lights to focus, I noticed what a nice quality they had. Because Kodachrome 64 has an appealing golden glow when exposed under tungsten lights, I decided to shoot using only the available light from the windows, lamps, and modeling lights. The professor and the student were engrossed in their conversation, so I was able to shoot a fair amount of film. I knew that I would lose some frames to lack of sharpness due to movement, but I didn't want to interrupt my subjects' interaction by popping off the strobes.

AC-POWERED FLASH UNITS

I made this shot of two teenage scouts wrestling while photographing the Explorer Olympics for Boys' Life magazine. I needed a great deal of

The most compelling reason to use an AC-powered unit is the unlimited number of flashes available—once you locate a power source and connect the unit to it. If you're shooting 15 to 20 rolls of film a day on location assignments, an AC-powered system will probably be the better choice for you. This also holds true if you like to diffuse your lights, shoot at apertures of f/8 or smaller, or shoot with medium-format film, which requires small apertures for sufficient depth of field.

Another advantage of AC strobes is their modeling lights. These built-in, continuous lights give you a preview of what the flash itself will look like in the final photographs. Modeling lights come in handy when you want to check for reflections but no Polaroid testing is possible. These lights also increase the general available-light level, which, in turn, makes focusing easier.

Although the lights sound great on paper, a couple of real-world considerations make modeling lights less useful than you would initially think. First, in all but the darkest locations, there is usually enough available light to make it difficult to see the effects of the modeling lights. So in the end, you can't be completely sure of what the flash will look like unless you shoot a Polaroid. Also, the heat that the modeling lights generate can cause problems in enclosed diffusion devices, such as softboxes. And if you're blending flash and available light, you should turn off the modeling lights off unless you specifically need them. If you don't, the modeling lights will affect your reading since you're using a slow enough shutter speed to register the ambient light. Despite their shortcomings, however, modeling lights are good to have.

The downside of AC units is finding the sometimes elusive wall plug. Carrying long, bulky extension cords is inconvenient, and the units lose some power when you use them. The alternative is to rent and carry either a gas-powered, voltage-regulated gen-

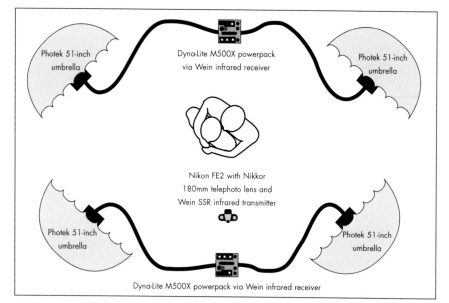

Photek 51-inch umbrella

Dyna-Lite M500X powerpack via Wein infrared receiver

Photek 51-inch umbrella

Nikon FE2 with Nikkor 180mm telephoto lens and Wein SSR infrared transmitter

Photek 51-inch umbrella

Photek 51-inch umbrella

Dyna-Lite M500X powerpack via Wein infrared receiver

flash power that could recycle quickly in order to catch the action. I set up four Dyna-Lite heads, one in each corner of the mat, and bounced each one into a Photek 51-inch white umbrella. I ran two heads, each with 250 watt-seconds of power, off one Dyna-Lite M500x pack, and another two heads with 250 watt-seconds of power each off another. This broad-lighting arrangement enabled me to shoot the action from any side of the mat with main, fill, and background lights. Using a long ED lens made out of extra-low-dispersion glass toned down the flare from the backlights. To minimize the number of wires, I used a Wein SSR infrared transmitter to trip the built-in slave eyes of the Dyna-Lite M500x powerpacks.

ANTIQUES DEALER, Stow-on-the-Wold, England. Nikon 8008S,
Nikkor 20-35mm AF zoom lens, tripod, Kodachrome 64 exposed
for 1/2 sec. at f/5.6.

*I made this shot while working on an assignment about the
Cotswolds for* Travel & Leisure *magazine. The antiques shop
just glowed with brass and warm light, and I wanted to capture
this in my picture. I decided to use a long shutter speed to burn
in all the little lamps placed around the shop; however, I still
needed to "clean up" the light with some strobe. I positioned my
main light, a Bowens Monolight Voyager bounced into a Photek
51-inch umbrella covered with a Converta Bank and set at 200
watt-seconds, to the left of the dealer. I placed another Voyager
with a similar umbrella setup to his right, adjusted to 100 watt-
seconds and slightly farther away than the one on the left. After
carefully checking my Polaroid test, I fired away.*

erator, which is a heavy and expensive option, or an
inverter, which can convert the power from a car bat-
tery to AC. Both power sources can do the trick, but
at substantial cost and inconvenience. (For an in-
depth, nuts-and-bolts discussion of generators, invert-
ers, flash systems, batteries, and other lighting hard-
ware, read Jon Falk's superb book, *Adventures in
Location Lighting*. The book doesn't contain any pic-
tures, but lighting guru Falk makes up for it with a
wealth of solid technical information.)

Another disadvantage of AC strobes manifests
itself when you travel overseas in countries with stan-
dard voltage that differs from the one you're accus-
tomed to. Here in the United States, the standard
voltage is 110 to 120 volts at 60 cycles. In large parts
of the rest of the world, the standard voltage is 220 to
240 volts, and sometimes even 250 volts, at 50 cycles.
Plugging a 110-volt unit into a 220-volt outlet will
lead to disaster.

You can handle this problem two ways. One solu-
tion is to carry a voltage transformer. These heavy
units plug into the wall and step down the voltage so
the powerpack you plug into it won't fry its circuits.
Because transformers must be large enough to handle
the powerpack's voltage, you must always check with
the strobe manufacturer about recommended trans-
formers for your particular unit. For example, my
Dyna-Lite M1000X requires a 500 watt-second trans-
former, which weighs about 8 1/2 pounds. This is
more than two pounds heavier than the pack itself. I
would rather have root-canal work done than carry
several extra 8-pound hunks of metal around in my
already heavy lighting kit.

My distaste for working with transformers goes
beyond the weight consideration, however. On a cor-
porate shoot in England, I used two transformers with
two of my Dyna-Lite powerpacks during an afternoon
of rapid-fire people photography. My assistant and I
had to do setup after setup of people talking and relat-
ing to one another in an office setting. After we fin-
ished the shoot and were breaking down to head to
the airport for a flight to France, we started to unplug
the transformers. We realized that they'd gotten so
hot that they were nearly molten. The rapid firing had
strained them to the limit, and we literally couldn't
touch them. We missed our flight waiting for the
transformers to cool down and nearly jeopardized the
rest of the shoot. I swore then and there that I would
never deal with transformers again.

At that time, photographers seeking dual-voltage
flash equipment that could be operated on either
current without the need for heavy transformers had
few equipment choices. I decided to pick up three
Bowens Monolite Voyagers, which are 500 watt-sec-
ond monolights. These units are so advanced that I
didn't even have to manually flip a switch from 110
to 220; they automatically seek out any voltage out-
put from 90 to 250 volts and adjust themselves.

SLIP-ON ADAPTOR PLUGS

A. Flat, parallel blades. Used in Western Hemisphere, North and Central Pacific. Good for adapting European plugs to North American sockets, and polarized plugs to nonpolarized sockets found throughout the world (e.g., Japan).

B. Round pins, shorter and closer than D (below). Common in Great Britain, parts of Africa, Far East, and Middle East, primarily as bathroom "shaver" plug.

C. Three rectangular prongs. Generally found in Great Britain and in its former and present colonies.

D. Thin, round pins. The most common plug pattern around the world. Also serves as an extension for step-down converters in recessed sockets.

E. Flat, angled blades. Encountered throughout the South Pacific, Australia, New Zealand, and China.

F. Three round prongs. Found in Hong Kong, Indian Subcontinent, some of Africa, former British colonies.

H. Three large, round, widely spaced prongs, used almost exclusively in South Africa. Extremely difficult to find in North America.

Courtesy of Magellan's.

GUIDE TO WORLD OUTLETS AND ELECTRICITY

Listed next to each country below is the shape of the wall socket you are likely to encounter as a visitor. If more than one pattern is shown, the most common pattern, if any, is listed in bold type.

Voltage around the world is primarily 220 volts. Those countries that use 110 volts, totally or partially, are marked with an asterisk (*).

Afghanistan-D/**F**
Albania-D
Algeria*-D/**F**
Andorra-D
Angola-D
Antigua-A/B/**C**
Argentina-D/**E**
Armenia-D
Australia-E
Austria-D
Azerbaijan-D
Azores-D/F
Bahamas*-A
Bahrain-B/**C**/F
Balearic Islands*-D
Bangladesh-D/**F**
Barbados*-A
Belgium-D
Belarus-D
Belize*-A
Benin-D/**F**
Bermuda*-A/**C**/E
Bhutan-C/D/**F**
Bolivia*-A/D
Bosnia-Herzegovina-D
Botswana-B/**C**/F
Brazil*-A/D
Brunei-B/**C**
Bulgaria-D
Burkina Faso-D
Burundi-D
Cameroon*-D
Canada*-A
Canary Islands-D
Cape Verde, Rep. of-D
Cayman Islands*-A
Central African Rep.-D
Chad-D/F
Chile-D
China, Peo. Rep.-C/D/**E**
CIS-D
Colombia*-A/**D**
Comoros-D
Congo-D
Cook Islands-E
Costa Rica*-A
Croatia-D
Cuba*-A
Cyprus-B/**C**
Czech Republic-D
Denmark-D
Djibouti-D
Dominica-B/**C**
Dominican Rep.*-A
Ecuador*-A/**D**
Egypt-D
El Salvador*-A

England-B/**C**
Equatorial Guinea-D
Eritrea-**D**/F
Estonia-D
Ethiopia-**D**/F
Fiji-E
Finland-D
France-D
French Guiana-D
French Polynesia*-A/**D**
Gabon-D
Gambia, The-B/**C**
Georgia-D
Germany-D
Ghana-B/**C**/D/F
Gibraltar-B/**C**/D
Greece-D
Greenland-D
Grenada-B/C/D/F
Grenadines-D
Guadaloupe-D
Guam*-A
Guatemala*-A
Guinea-D
Guinea-Bissau-D
Guyana*-A/B/**C**/D/F
Haiti*-A
Honduras*-A
Hong Kong-**C**/F
Hungary-D
Iceland-D
India-C/D/**F**
Indonesia*-D
Iran-D
Iraq-B/**C**/D/F
Ireland, Northern-B/**C**
Ireland, Rep. of-B/**C**
Israel-D
Italy-D
Ivory Coast-D
Jamaica*-A
Japan*-A
Jordan-B/**C**/D
Kampuchea-D
Kazakhstan-D
Kenya-B/**C**/F
Kiribati-E
Korea, North*-A/**D**
Korea, South*-A/**D**
Kuwait-B/**C**/D/F
Kyrgyztan-D
Laos-**A**/D
Latvia-D
Lebanon*-D
Lesotho-D/**H**
Liberia*-A/B/C
Libya*-**D**/F

Liechtenstein-D
Lithuania-D
Luxembourg-D
Macao-D/F
Macedonia-D
Madagascar*-D
Madeira-D/F
Malawi-B/**C**
Malaysia-B/**C**
Maldives-D/**F**
Mali-D
Malta-B/**C**
Martinique-D
Mauritania-D
Mauritius-B/**C**/D
Mexico*-A
Micronesia*-A
Moldova-D
Monaco*-D
Mongolia-D
Montserrat-A/B/**C**
Morocco*-D/F
Mozambique-D
Myanmar-B/**C**/D/F
Namibia-D/**H**
Nauru-E
Nepal-B/D/**F**
Netherlands-D
Neth. Antilles*-A/**D**
New Caledonia-D
New Hebrides-E
New Zealand-E
Nicaragua*-A
Niger-D
Nigeria-B/**C**/F
Norway-D
Okinawa*-A
Oman-B/**C**/F
Pakistan-D/**F**
Panama*-A
Papua New Guinea-A/**E**
Paraguay-D
Peru*-**A**/D
Philippines*-**A**/D
Poland-D
Portugal-**D**/F
Puerto Rico*-A
Qatar-B/**C**/F
Romania-D
Rwanda-D
Russia-D
St. Kitts-Nevis-B/**C**/F
St. Lucia-B/**C**
St. Maarten*-D
St. Vincent-B/**C**
Samoa, American*-A/D/**E**

Samoa, Western-E
San Marino-D
Sao Tome and Principe-D
Saudi Arabia*-**A**/D
Scotland-B/**C**
Senegal*-D
Seychelles-B/**C**/F
Sierra Leone-B/**C**/F
Singapore-B/**C**/D/F
Slovakia-D
Slovenia-D
Solomon Islands-E
Somalia-D
South Africa, Rep. of-**C**/H
Spain*-D
Sri Lanka-D/**F**
Sudan-B/**C**/D
Surinam*-D
Swaziland-D/**H**
Sweden-D
Switzerland-D
Syria-D
Taiwan*-A
Tajikistan-D
Tanzania-B/**C**/F
Thailand-A/**D**
Togo*-D
Tonga-D/**E**/F
Trinidad & Tobago*-A/B/**C**/F
Tunisia*-D
Turkey-D
Turkmenistan-D
Turks & Caicos Islands*-A
Tuvalu-E
Uganda-B/**C**/F
Ukraine-D
United Arab Emirates-B/**C**/F
United States of America*-A
Uruguay-D/**E**
Uzbekistan-D
Vanuatu-C/D/**E**
Venezuela*-A
Vietnam*-A/**D**
Virgin Islands (British)-B/**C**
Virgin Islands (US)*-A
Wales-B/C
Yemen-A/B/**C**/D/F
Yugoslavia-D
Zaire-D
Zambia-B/C
Zimbabwe-B/**C**/F

Courtesy of Magellan's.

Although the monolights are about 10 years old, I still use them whenever my work takes me out of the United States. Today, many manufacturers, including Comet, Balcar, Norman, and Profoto, also offer dual-voltage equipment. Although this gear is generally a bit more expensive than mono-voltage equipment, I highly recommend it for all photographers who anticipate any overseas travel at all.

Whether you work with dual- or mono-voltage equipment, when you work abroad you'll need, at the very least, plug adaptors for dual-voltage units, and possibly voltage converters and plug adaptors for mono-voltage gear. Magellan's, a mail-order catalog filled with gadgets for travelers, has the most complete line of foreign voltage transformers and plug adaptors I've ever seen (see the chart on page 72). The catalog offers rare plug adapters, such as those used in South Africa, and is the only source of foreign plug adaptors for three-prong, grounded American-made plugs that I've ever found. Magellan's sells a lot of great adaptor gear for computers and modems, as well as general travel gadgets (see Resources on page 142).

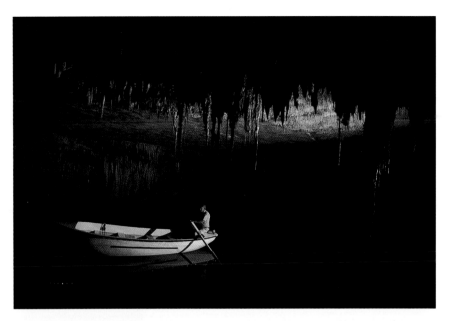

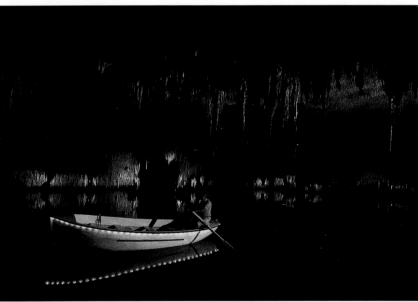

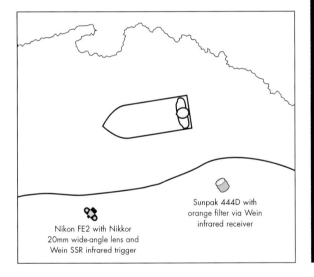

Sunpak 444D with orange filter via Wein infrared receiver

Nikon FE2 with Nikkor 20mm wide-angle lens and Wein SSR infrared trigger

THE DRAGON CAVE, Mallorca, Spain. Nikon FE2, Nikkor 20mm wide-angle lens, Tiffen 85B filter, tripod, Kodachrome 200 exposed for 4 seconds at f/4.

This cave, which I shot on an assignment for Travel & Leisure magazine, is fairly spectacular and features an underground lake. In the first picture, I illuminated the boatman with a single off-camera flash, my Sunpak 444D, which I'd covered with an orange gel (top). I used my Wein SSR infrared trigger, fitted with a Wein infrared receiver, to trip the flash, so I didn't have to worry about tripping over any cords in the dark. The sync speed was 1/250 sec., the highest speed the Nikon FE2 allows. But even this fast shutter speed didn't allow the spotlighting throughout the cave to register; only the portion of the frame that the flash illuminated registers. The second image shows what happened when I open the shutter to about 1/4 sec. (center). Here, the background lights are starting to burn in, but not enough. The third shot, which combines the burst of flash with a 4-second exposure, gets it right, with adequate illumination for both the boatman and the cave (bottom).

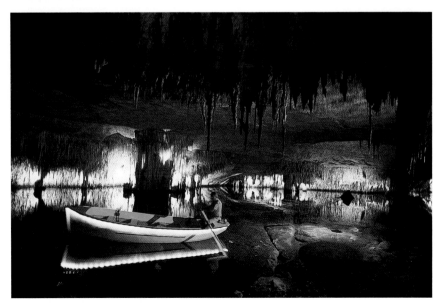

NEUSCHWANSTEIN CASTLE OFFICE INTERIOR, Bavaria, Germany.
Nikon 8008S, Nikkor 28mm PC wide-angle lens, tripod,
Fujichrome 100 exposed for 1/30 sec. at f/8-11.

*This ornate office in Bavaria's Neuschwanstein Castle posed
special problems, and not necessarily photographic ones! In order
to shoot a story about King Ludwig's castles for Travel/Holiday
magazine, I had to obtain special written permission to photo-
graph the castle interiors. I was allowed to shoot for only one
hour in the morning, as the workers arrived and before the cas-
tle opened to the public. Unfortunately, this was also the time
when the cleaners did their work, and I had to wait until the
vacuuming was finished in order to get access to electricity.
When I was finally able to proceed, I plugged in two Bowens
Monolite Voyagers, each at full power (500 watt-seconds) and
fitted with Photek 51-inch umbrellas. Next, I placed the lights in
two corners of the room. I used a Wein SSR infrared remote to
trigger the units.*

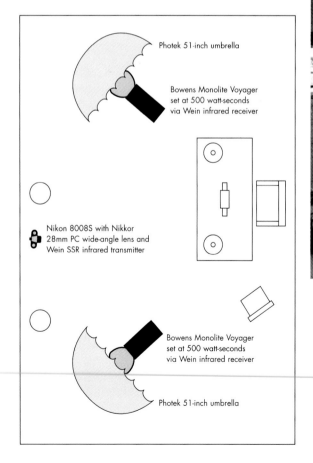

Photek 51-inch umbrella

Bowens Monolite Voyager
set at 500 watt-seconds
via Wein infrared receiver

Nikon 8008S with Nikkor
28mm PC wide-angle lens and
Wein SSR infrared transmitter

Bowens Monolite Voyager
set at 500 watt-seconds
via Wein infrared receiver

Photek 51-inch umbrella

74

SELECTING A FLASH SYSTEM

Deciding between monolights and a pack-and-head system is only one of the choices you'll have to make when selecting a flash system. You'll also have to consider price, power output, weight, and compatibility. Keep in mind that no rule states that your flash system must be all one type or another. If, however, you mix and match, naturally you must look for units that are at least a little compatible. For example, Dyna-Lite basically offers a pack-and-head system. But the manufacturer also makes the Uni-400, a small, 400 watt-second monolight that accepts all the other Dyna-Lite accessories. This monolight can even run off the company's JackRabbit battery if necessary.

First, you need to consider the importance of size and weight versus power and price. While it is convenient to have a half a dozen 2400 watt-second powerpacks with you on the road, ask yourself if you really need that many. More power means more weight and more expense. Look for ways around heavy power usage. For example, I've found that the current crop of outstanding ISO 100 slide films have made it unnecessary to shoot slower ISO 50 and ISO 64 slide films. As a consequence, I can often get the power I need from my Dyna-Lite M500x powerpack and don't have to carry my Dyna-Lite M1000x powerpack. The 500 powerpack is substantially lighter, smaller, and easier to carry than the 1000 powerpack. Next, you should think about recycle times. Since I'm often photographing people and looking for fleeting expressions, rapid recycling is critical to me. But if you shoot stationary objects, recycling time is less of a concern.

Another consideration is the difference between single-voltage and multi-voltage units. Multi-voltage units are generally more expensive and slightly larger than single-voltage units. If you never leave your country, stick to single voltage. If you travel overseas in your work, even to nearby places like the Caribbean, you might want to opt for a multi-voltage setup.

Finally, compare domestic- and foreign-made units. It is no secret that the American dollar is taking a beating on a regular basis these days. Consequently, anything purchased from overseas manufacturers with stronger currencies, such as Japan and Europe, is going to be much more expensive than its American counterpart. Generally, you'll get much more value with American-made equipment simply because you aren't required to buy it with a currency that is weaker than the one the manufacturer uses. Of course, in the end, you'll buy a unit because the features it has are the features you need.

MAN IN STERILE LAB, West Point, Pennsylvania. Nikon FE2, Nikkor 85mm telephoto lens, Kodachrome 64 exposed for 1/60 sec. at f/5.6.

Although recombinant DNA technology is on the cutting edge of pharmaceutical production, it looks like big jars in a meat locker! For a Merck & Company annual report, I had to come up with something clean and high-tech looking in what was essentially a large, walk-in refrigerator. To create a wash of blue on the gray back wall, I put a blue-gelled Dyna-Lite head on the floor behind the scientist and aimed it into a medium Chimera softbox set for 500 watt-seconds from a Dyna-Lite M500x powerpack. Next, I aimed another medium Chimera softbox with a Dyna-Lite head, set for 125 watt-seconds from another Dyna-Lite M500x powerpack, at the scientist from the left. I framed the shot through some tubes and jars in order to produce interesting foreground shadows.

PLAZA ATHENÉE LOBBY, New York City. Nikon FE2, Nikkor 24mm wide-angle lens, tripod, Kodachrome 64 exposed for 1/4 sec. at f/5.6.

I shot this lobby while working on an article about small, elegant New York City hotels for Travel & Leisure *magazine. I wanted a broad, open light that simulated the weak daylight coming in from the windows off to the left. To achieve this effect, I bounced three Dyna-Lite heads, one M1000x and two M500x powerpacks set at 500 watt-seconds, into three Photek 51-inch umbrellas. I positioned one unit off to the right of the camera. I then arranged for another Dyna-Lite to come in from the left, aiming it at the concierge and bellhop. Finally, I set up the third unit in the far rear of the lobby so that it too came in from the left. I used a long shutter speed to burn in the ambient light.*

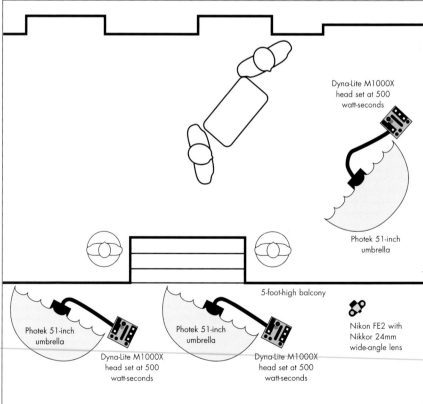

Dyna-Lite M1000X head set at 500 watt-seconds

Photek 51-inch umbrella

Photek 51-inch umbrella

Photek 51-inch umbrella

Dyna-Lite M1000X head set at 500 watt-seconds

Dyna-Lite M1000X head set at 500 watt-seconds

5-foot-high balcony

Nikon FE2 with Nikkor 24mm wide-angle lens

BARKSDALE HOUSE INN,
Charleston, South Carolina.
Nikon FE2, Nikkor 28mm wide-
angle lens, tripod, Kodachrome
64 exposed for 1/4 sec. at f/8.

I photographed this bed and breakfast as part of a story about Charleston for Travel & Leisure *magazine. The little available light coming into the room had to be boosted. I wanted to mimic the open quality of ambient illumination, so I placed one Dyna-Lite head with 500 watt-seconds of power to the right of the camera and bounced it off the white ceiling. Next, I bounced a second Dyna-Lite head off the ceiling near the bed with only 250 watt-seconds of power because I wanted the light to drop off slightly.*

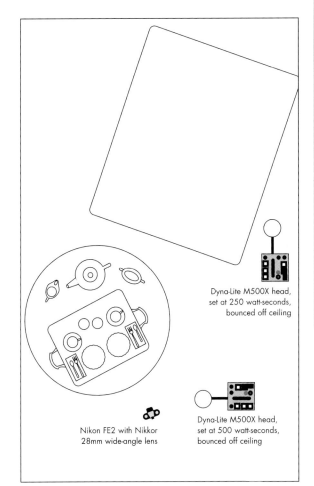

Dyna-Lite M500X head,
set at 250 watt-seconds,
bounced off ceiling

Nikon FE2 with Nikkor
28mm wide-angle lens

Dyna-Lite M500X head,
set at 500 watt-seconds,
bounced off ceiling

MONOLIGHTS VERSUS PACK-AND-HEAD SYSTEMS

AC strobe systems come in two basic incarnations. With monolights, the generator and the head are contained in the same housing, which sits on top of the lightstand and gets plugged into the wall. Pack-and-head systems feature generator packs that are separate from the flash heads. The generators are plugged into the wall, and the heads are plugged into the generator. Both systems have advantages and drawbacks.

Self-contained monolights eliminate the need to carry a lot of head extension cords. You can place them far away from each other without worrying about having to connect them to one another. If you have three or four monolights with you and one of them develops a problem, the others will continue to function unaffected.

One disadvantage of monolights is weight placement. Since they contain both the generator and the head, they tend to be heavier than regular flash heads. So having 5 to 10 pounds, plus an umbrella or softbox, sitting on top of an 8-foot lightstand isn't the most stable arrangement. The other disadvantage is power distribution. Even if you need only a small, low-powered pop of flash in a certain area of your setup, you must still dedicate an entire monolight to do the job.

Pack-and-head systems provide a little more flexibility than monolights in terms of power distribution. You can run three or four heads off one power-pack, sending different power levels to each head if necessary, or sending all the power through just one head. Flash heads tend to be smaller than monolights and are more stable on a lightstand.

In terms of the disadvantages of pack-and-head systems, a failure in a power generator can severely affect your ability to finish a job. This is especially troublesome if you're running multiple heads off one pack. In addition, since all of the flash heads must be connected to the packs, you need long extension cables if you want to place the heads far away from one another and the powerpack.

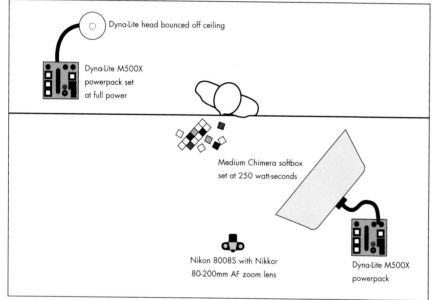

YOUNG BOY WITH BLOCKS, Ridgewood, New Jersey. Nikon 8008S, Nikkor 80-200mm AF zoom lens, Fujichrome 100 exposed for 1/125 sec. at f/8.

For a story about the importance of fantasy in children's play for Working Mother magazine, I photographed Jonathan, my youngest son, playing with his blocks. To light him, I set up a Dyna-Lite head in a medium Chimera softbox with 250 watt-seconds coming from a Dyna-Lite M500x powerpack to the right of my camera. I wanted to keep a high-key feeling, so I bounced another head from another Dyna-Lite M500x power-pack set at full power off the ceiling behind Jon. Because this was 1 to 1 1/2 stops brighter than the main light, it provided an appealing rimlight and hairlight on my son, as well as effectively illuminated the background.

TTL EXPOSURE

CARNIVAL QUEEN, Old San Juan, Puerto Rico. Nikon 8008S, Nikkor 20-35mm AF zoom lens, Kodachrome 200 exposed for 1/8 sec. at f/4.

The action at the Carnival Parade in Old San Juan moves quickly. Metering in manual mode, I selected a shutter speed that would slightly underexpose but still register the background. I've found that 1/8 sec. is a good shutter speed for effectively adding just a bit of blur to flash pictures. I panned with the queen as she walked past, confident that my Nikon SB-24 flash, set to -1 in matrix-balanced, fill-flash mode, would make the right exposure decision.

Nearly every camera manufacturer's electronic-flash system is designed so that you can gang together several flash units while maintaining TTL exposure control. On the surface, this seems to be a great boon to photographers, especially those without multiple-light experience and such paraphernalia as flashmeters and Polaroid backs. Although these types of systems do work, in real-world terms, they aren't practical for a number of situations.

The primary problem is the necessity of the hardwire connection. The main master flash must be either on the hotshoe mount or connected via an extension cord, and extra flash units also have to be hardwired together. The effect is one of a large spider web. And people seem inexorably drawn to walking into the cords and pulling the whole arrangement down! In addition, ratio control is difficult since, in most systems, whatever the main flash is set for, the extra units generally do the same.

Still, for a simple, two-light setup in a confined, low-traffic area, TTL multiple-flash systems can work successfully. You need the longest cord available to connect the secondary flash to the main flash, so you have flexibility in flash placement (see page 80).

What must be the quietest revolution in TTL flash is Minolta's unique cordless TTL flash system for its Maxxum Xi camera series. Using a small device that looks like an infrared trigger slipped into the hotshoe mount, you can control the output of up to 10 Minolta 5400HS flash units, without any hardwire connection whatsoever. In a two-light setup, the amazing Wireless Remote Flash Controller will even let you control lighting ratios. For example, you can get either a 2:1 or a 1:2 ratio between the main flash and the auxiliary flash. If you don't own the Controller, you can still have control, including the above ratio control, over a second off-camera flash when you use a 5400HS unit in your hotshoe mount.

When I used this system, I discovered that it works exactly as advertised. In fact, I found it impossible to "fool" the system into producing a bad exposure. If the system has a shortcoming, it is that you can control the flash units only up to a distance of 16 feet from the main unit or the Wireless Remote Flash Controller. This may prevent you from doing large-area TTL setups, but for most applications where small, battery-powered flashes will do the trick, a 16-foot limit is easy to live with.

I've found this system to be versatile and accurate, and I use it in a variety of ways. My kit currently consists of two of the older SB-24 units, and one of the latest units, the SB-26. The most appealing feature of this system is the matrix-balanced, fill-flash mode. In addition to the two usual flash-metering options, TTL and automatic thyristor, this impressive-sounding feature also calculates contrast in the multisegmented exposure reading and puts out just enough fill flash to open but not overpower the shadows. This is usually about 2/3 stop less than the available light. As a result, you don't have to do any complicated calculations for fill flash; you simply set the flash to the matrix-balanced mode and shoot.

If you find the factory setting of -2/3 stop to be a bit too much fill—and most photographers do—you can override it by up to +1 stop or -3 stops in 1/3-stop increments. In the matrix-balanced, fill-flash mode, I have my SB-24 flash set to -1, so, in effect, I have the flash underexposing 1 2/3 stops for fill flash, a balance that I find perfect. When I use my SB-24 as my primary source of illumination in regular TTL or automatic exposure modes, I don't make any exposure adjustments.

I carry one regular SC-17 TTL extension cord with a wrist strap in order to be able to take the unit off the camera and hold it in my hand. I have a small, 20-inch white umbrella and a Domke twin-flash bracket fitted with another wrist strap, which enables me to hold the SC-17 extended flash and bounce it into or through the umbrella with one hand while I shoot the camera with the other. In addition, I have one modified SC-17 cord, which Andrews Photographics cut and modified to accept one or both of the 12-foot and 25-foot extension sections the company also made for me (see Resources on page 142). With these extension cords, I can work much farther away from the subject and the light and still retain TTL control. This makes it easy for me to put the flash on a stand, as well as to use the matrix-balanced, fill-flash mode outdoors with long lenses.

I also have a choice of battery packs, depending on the demands of the assignment. For example, on a typical travel assignment that doesn't call for many interior situations, I carry only two flash units and two SD-8 battery packs, which are powered by six AA batteries and are very compact and lightweight. For heavy-duty shooting, my SB units run off the same Armato high-voltage HV 350 powerpacks that run my larger Armatar 200 and 300 units. I often take an Armatar 300, which is a 300 watt-second unit, to use as a main light in multiple-flash setups, along with the three SB flash units.

I also have a choice of triggering methods for the extra off-camera units. I have a modified SC–19 cord, which accepts my customized 12- and 25-foot extension cords, that permits me to connect a second flash to my main unit for corded TTL control. I use this method for small, two-light setups in low-traffic areas, where it is less likely that people will trip over the cords. For cordless work, I use Wein HS-XL slaves. These sensitive slave eyes have a hotshoe mount in which the flash sits.

The addition of the SB-26 flash unit offers another alternative for two-light setups. This flash has a built-in slave eye with a slight-delay circuit. When this unit serves as a second light, you can use the on-camera flash in TTL or automatic because the light from the secondary SB-26 won't affect the reading. Similarly, you can use the SB-26 on automatic (but not TTL) because the primary flash won't affect its reading. While this arrangement isn't quite Minolta's cordless TTL, it is a very workable cordless, two-light setup that enables you to work automatically.

When traveling with the lightweight, two-SB-flash setup, I carry a compact Bogen lightstand with Stroboframe umbrella bracket. I also carry a small bag with three other light-support options, a large Lowell alligator clamp fitted with a small Gitzo ballhead, and a hotshoe mount for attaching the flash to bookshelves, windowsills, etc. I also bring along a Cool-Lux putty knife with a stud for mounting the ballhead and flash, which allows me to wedge the flash in a closed doorjamb or under books in a shelf. My Lowell scissor clip, another essential tool, enables me to mount the flash on the bracework of a dropped ceiling. Between these clamps and the lightstand, I can always find a way to support the second flash in a two-light setup.

One of the many tasks that the Nikon SB-24 flash does superbly (as do the newer SB-25 and SB-26 units) is provide fill flash in outdoor situations. These flash units have eliminated the need to determine fill-flash exposures via a series of calculations; this slow, awkward process resulted in a high number of missed picture opportunities. Here, I first photographed this Caribbean native without any flash (left). For the second shot, I set my Nikon SB-24 flash on −1 stop in matrix-balanced, fill-flash mode (right). The flash and camera meter interface to read contrast ratios, and the flash puts out just enough light to lower the contrast by lightening up, but not eliminating, the shadow areas.

REMOTE-TRIGGERING DEVICES

You have several options when it comes to the remote triggering of secondary strobes in a multiple-light setup. Each approach has its strong points and weaknesses, and none is absolutely foolproof. Flash "gremlins," unexplained misfires, occur in any cordless connection system. The trick is to find the system that is best suited to the shooting situations in which you work.

The most common remote-triggering devices are the so-called *slaves*. These photoelectric eyes read the flash from the primary unit and use it in order to trigger the flash that it is attached, usually via a short PC cord or hotshoe. Slaves come in various sensitivity levels, and I've found that it is always wise to get the most sensitive slave you can afford. Like the flash manufacturers' GN and flashes per battery estimates, slave manufacturers' sensitivity ratings tend to be somewhat optimistic, too.

Good slave eyes, such as those Wein makes, work well. But the downside is that they'll work well with everybody's flash unit. So if you're using one to trigger a second strobe in a setting where other people may be using flash, such as at a wedding or a hotel floor show, the slave will trigger from their flashes as well. In these situations, you need a "closed" system to trigger your auxiliary lights.

One type of closed system is a channeled infrared setup, such as Wein's Pro-Synch PS-500-4 unit. Similar to the SSR, which is a nonchanneled infrared transmitter, the PS-500-4 features a small transmitter and a slave-eye receiver. But the infrared pulse this unit puts out is encoded, and the receiver is programmed to receive only those encoded signals. As a result, it is "blind" to the white light other strobe sources put out. The PS-500-4 model has four encoded channels, but less expensive channeled infrared setups have just two.

I've found that the channeled infrared system works well unless a lot of extra flashes are going off. When this happens, the system's infrared receivers are kept busy filtering out so many extraneous flashes that they are also temporarily "blind" to your channeled signal. This happened to me during a folk-dancing demonstration in Barbados. So many other flashes were popping that my two remote strobes with channeled infrared receivers were able to respond on only every third or fourth exposure I shot.

In situations like these, you need an even more secure closed system, such as a radio remote. Instead of an infrared transmitter, these systems use a small radio transmitter, similar to a garage door opener, that you trigger via a PC cord attached to your camera. The receiver is connected to the flash unit itself, and the radio signal sets the flash off. Since nothing but that assigned frequency will set off the receiver, you are safe from all outside influences—except the outside chance that someone nearby is operating on the same frequency. Some units, such as the Venca Radio Remotes, offer several different frequencies or channels, so if you find you're having a problem with one frequency, you can use another.

Be aware, however, that radio remotes aren't the panacea they might seem to be at first. They tend to be a little larger than an infrared transmitter and require a great deal of battery power. An infrared transmitter takes two AA batteries and the receivers are battery-less, while a radio transmitter commonly uses a 9-volt battery and the receivers use anywhere from four to eight AA batteries.

Because of FCC regulations, radio remotes can't operate with more than a 100-foot range, and that range will be even less if the batteries aren't fresh. When you consider that metal structures and other obstacles can interfere with the limited signal, you can readily understand how the occasional misfire or other frustration will arise with these units.

Is there a foolproof system for triggering remote strobes? Probably the most reliable setup would be a hardwire connection from one strobe to the other and then to the camera. This is what the sports photographers who shoot basketball and hockey in big arenas use; the possibility for interference and failure is too great with any other system. But sports photographers' lights are rigged in the rafters where there is little if any chance of someone tripping over them. You can rig an arrangement like this on a smaller scale, but if it is on ground level, you'll encounter the same problems that arise with a hardwired TTL system: too many wires for people to trip over. For most photographers, an occasional misfire is easier to live with than a crash and the loss of their lighting kit.

ARM WRESTLING IN MANUEL'S TAVERN, Atlanta, Georgia. Nikon 8008S, Nikkor 20-35mm AF zoom lens, Fujichrome 100 exposed for 1/15 sec. at f/8-11.

Manuel's Tavern, a famous Atlanta watering hole for journalists and politicians, is always lively, but because of the minimal available light and dark woodwork it is also quite dim. Shooting a story on the city for National Geographic Traveler magazine, I wanted to show a bit of the bar behind the bartender as he clowned and arm-wrestled with a customer. This required a broad-lighting setup. My solution was to use two Photek 51-inch umbrellas, each connected to a Dyna-Lite M500x head set at full power. I put one umbrella with a Converta Bank diffuser near the camera position, and the other down the bar a bit to illuminate the background.

Photek 51-inch umbrella

Dyna-Lite M500X head set at 500 watt-seconds

Nikon 8008S with Nikkor 20–35mm AF zoom lens

Photek 51-inch umbrella with diffuser

Dyna-Lite M500X head set at 500 watt-seconds

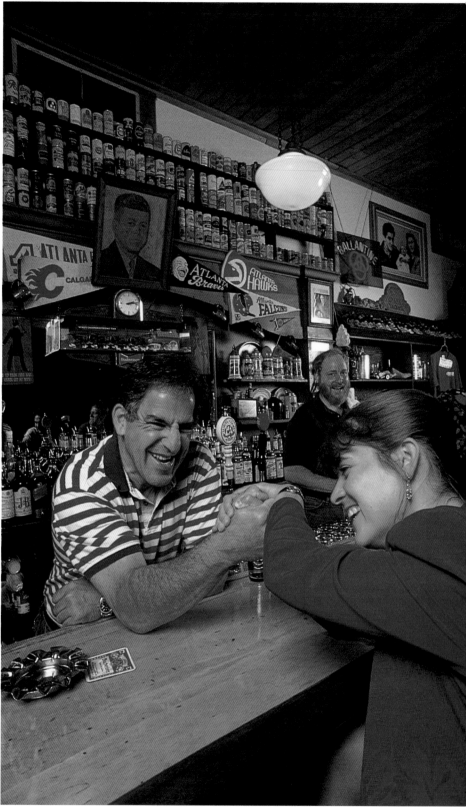

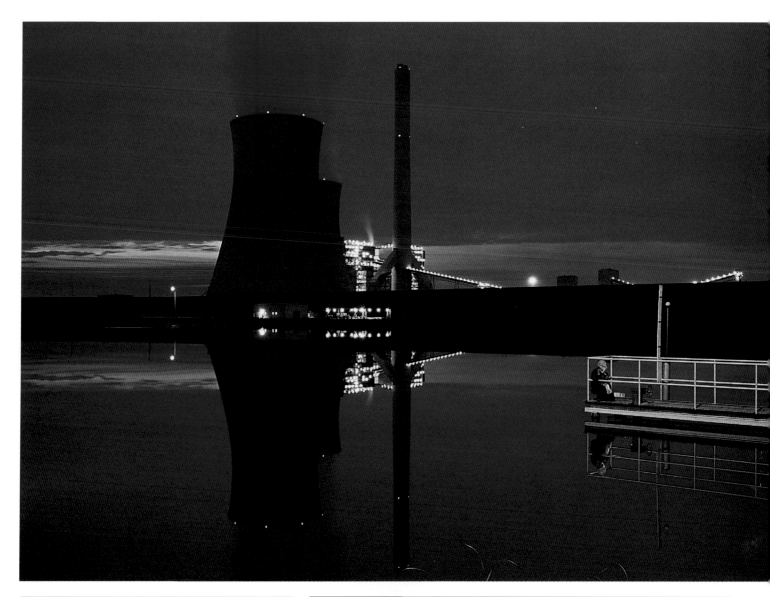

NIGHT SHOT AT POWER PLANT, Arkansas. Nikon FE2, Nikkor 20mm wide-angle lens, Kodachrome 64 exposed for 2 seconds at f/4.

Shot at a coal-fired power plant on assignment for Merck & Company's annual report, this photograph illustrates the round-the-clock monitoring that the company's water-treatment subsidiary provides. With the technician placed at the end of the bridge, my assistant put a Sunpak 444D, set on manual and dialed down to about 1/8 power, behind the standing valve just in front of the worker. The Sunpak's sync cord was connected to a Venca radio-control unit. Although this unit illuminated the technician, I still needed to light up the bridge. On the bank of the pool, about 40 feet to the left of camera position, I aimed an Armatar 300, set at full power and fitted with another Venca radio receiver, at the bridge. I pointed the flash slightly upward to feather the light and prevent too much of it from hitting the water in the foreground. Each strobe produced a reading of f/4 on Kodachrome 64. A 2-second exposure burned in the ambient dusk light.

Sunpak 444D via Venca radio receiver, hidden behind valve, set at 1/8 power

Armatar 300 flash set at 300 watt-seconds via Venca radio receiver

Nikon FE2 with Nikkor 20mm wide-angle lens

CONTINUOUS LIGHT SOURCES

On assignment in Baden Baden, Germany, for Gourmet magazine, I didn't have official permission to shoot the weekly tea dance in the famous Casino Ballroom. Rather than walking in with full equipment and taking the chance of being denied access, I went all dressed up, with a little Nikon 28Ti and a table-top tripod in my blazer pockets. I like this camera because it looks like an amateur point-and-shoot camera but performs like (and costs as much as) a top-of-the-line professional camera. In the ballroom, the stage lights were much brighter than the floodlights used to illuminate the dance floor. But during every number, the stage lights were dimmed for a few moments, which is when I photographed. I bracketed as much as possible but depended largely on the camera's sophisticated matrix metering for the rest.

Why, you may ask yourself, would anyone bother to use continuous light sources for still photography when electronic flash packs so much power and convenience per dollar and pound? In many ways, continuous light sources, such as photofloods and quartz lights, do come up short. Except for the blue-coated, "daylight" photofloods, most incandescent sources aren't color-balanced for daylight film. So in order to achieve correct color balance, you must use them with one of the few tungsten-balanced slide films, which are designed for light sources in the 3200K-3400K range. Continuous light sources, which are also called *hot lights*, create plenty of heat and eat up a great deal of energy. Nevertheless, they rarely manage to generate enough light for the action-stopping shutter speeds required for photographing people. In an age of cordless TTL flash and matrix-balanced fill flash, it seems almost archaic to plug in one of these lights.

This certainly was my attitude until I had the opportunity to go on assignment with my colleague, photographer and publisher Bill Strode. We were photographing a college campus for a book project, and Strode had his kit of hotlights with him. I was amazed at the many creative ways he used them: lighting the inside of the chapel so the stained-glass windows would glow in his dusk, exterior shots of the structure; streaking a beam of light across a book in a still-life closeup; and boosting the general light level in a dormitory room without overpowering the existing light.

I realized that, in the right hands, continuous light sources could be valuable lighting tools in the age of TTL flash. I also discovered why many photographers prefer to work with continuous light sources, especially those who don't have to photograph people or other moving subjects. This group includes architectural and still-life specialists. Those location photographers who have tended to dismiss continuous lighting as antique technology for advanced-amateur photographers may find themselves singing the proverbial different tune. The advent of digital cameras and HMI lights may indeed signal a rebirth for continuous lighting.

WHAT CONTINUOUS LIGHT SOURCES OFFER

These festive food booths are set up during Moslem religious festivals, near the largest mosque in Singapore. The booths are illuminated with hanging lightbulbs, and the trick is to wait until the sky is dark enough so that it doesn't overpower the output of the bulbs. In addition to balancing the artificial and natural light, I used a burst of flash to illuminate the booth in the foreground. For this shot, I set my Nikon SB-24 flash on -1 stop in matrix-balanced, fill-flash mode.

Undeniably, working with continuous lighting offers some advantages. First, in multiple-light setups, continuous light sources preclude the potential for misfires, thereby eliminating a big worry. And you don't need to shoot Polaroids because your eyes can actually see the effects of the lights. In fact, the computer-terminology acronym WYSIWYG—What You See Is What You Get—probably originated with users of hot lights. Not having to shoot Polaroids is a comfort to many photographers who can't bring themselves to "trust" electronic flash.

Indeed, if you're just starting to explore location lighting, you can accelerate your understanding of the behavior of light by investing in two or three inexpensive photofloods. Bounce them off various surfaces, and notice how the shadows and highlights are affected. Flag or *gobo* (lighting shorthand for an object that "goes between" the light source and the camera or subject) them, and see how reducing the angle of coverage affects light quality. Be careful, though, when using these light sources in such enclosures as softboxes, snoots, etc. The heat can quickly rise to unsafe levels.

Don't underestimate the amount of knowledge you can pick up this way. Before I embarked on a full-time career as a photographer, I worked as an actor in several regional theater companies around the country. To supplement my meager acting wages, I started doing headshots and portfolio shots for my fellow thespians. I started in a small sublet apartment that had great, northern-exposure windows, and I shot most of my images this way. The soft, classic windowlight went over big with my colleagues, and I had quite a little sideline going.

When the sublet's lease was over, I found myself in an apartment with unappealing natural light. I had a steady stream of customers, so I realized that I had to do something. My local camera store outfitted me with a couple of Smith Victor photofloods, a lightstand, a white umbrella, and a few basic directions. I spent one entire day and a couple of rolls of film using Peggy, my wife, as a stand-in subject. By the time my next paying customer showed up, I knew how to mimic with the photofloods the beautiful window light that had made my reputation! Years later, when I made the transition from newspaper

photographer to freelance photographer, it was this early work with the photofloods that helped me to pick up a feel for multiple-flash lighting without having to put in the usually obligatory stint as a photo assistant.

But simplicity and ease of use aren't the only virtues of continuous light sources. Quartz lights and photofloods are lighter and, in most cases, smaller than electronic flash equipment. You can fit a three-light system into a small shoulder bag. And if you head into foreign-voltage territory, all you have to do is change to 220-volt bulbs and put on plug adaptors; no heavy transformers are required. A colleague who photographs hotels in the Caribbean, where the tiny planes often used for inter-island flights don't accommodate a lot of gear—at least not on the same plane that you're flying on—carries two broad-beam Tota lights and one focusing spotlight in his small suitcase. He has done beautiful work with these lights, often waiting until sunset and dusk to balance the indoor lighting with the outdoor light level. And he has never had to hold up the shoot to wait for his gear to arrive on the next flight.

HIGH-TECH VIDEO LAB,
New Jersey. Nikon 8008S,
Nikkor 80-200mm zoom lens,
tripod, Kodachrome 64
exposed for 1 second at f/11.

Bellcore hired me to shoot this high-tech lab for its annual report. I dropped a 6-foot-wide roll of tracing paper to cover the clutter, and then bounced a red-gelled Photek 51-inch umbrella with 250 watt-seconds of light coming from a Dyna-Lite M500x head into the paper. Next, I pumped another 250 watt-seconds of power from that pack through a grid spot with a blue filter in order to light the bank of machines on the left. I illuminated the foreground scientist with another grid spot with 500 watt-seconds of power coming from a Dyna-Lite M500x head. Finally, a Sunpak 444D with a red gel and dialed down to 1/8 power lighted the instrument in the lower right-hand corner of the frame.

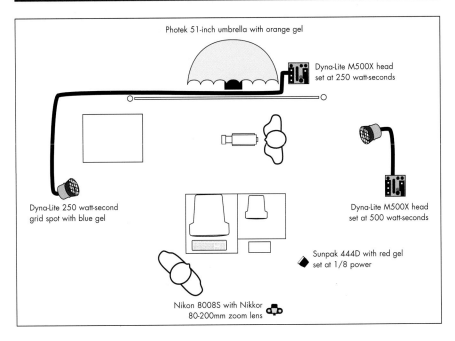

Photek 51-inch umbrella with orange gel

Dyna-Lite M500X head
set at 250 watt-seconds

Dyna-Lite 250 watt-second
grid spot with blue gel

Dyna-Lite M500X head
set at 500 watt-seconds

Sunpak 444D with red gel
set at 1/8 power

Nikon 8008S with Nikkor
80-200mm zoom lens

COMBINING LIGHT SOURCES

INNKEEPER AT TWO MEETING STREET INN, Charleston, South Carolina. Nikon FE2, Nikkor 20mm wide-angle lens, tripod, Kodachrome 64 exposed for 1/2 sec. at f/5.6.

The big problem in this shot of David Spell was illuminating the background and landing without the lights showing up in the frame. To work around this, I put an Enertec NE-1 bare-tube light, with 1000 watt-seconds of power from a Dyna-Lite M1000x pack, on the railing of the second-floor landing. The omni-directional light illuminated the staircase, the area behind the innkeeper on the ground floor, and the second-floor landing. A Photek 51-inch umbrella with a Converta Bank diffuser screen and 500 watt-seconds of power through a Dyna-Lite head, coming from high and to the right of camera, provided the main light on Spell. Then I bounced a second Dyna-Lite head, with 250 watt-seconds of light, into another Photek 51-inch umbrella with a Converta Bank diffuser to the left of the camera to provide fill. A slow shutter speed enabled the available light to burn in and to fill in the gaps.

Although you're bound to come across the occasional purist who works with only tungsten or only strobe, most photographers find that a combination of the two sources works best. I rarely carry more than an 800-watt Tota light in my kit, which I use either to boost the available light for focusing or to raise the level of illumination in the background for "strobe-and-burn" shots. I often shoot these images with the modeling lights built into the Dyna-Lite heads, too, especially if I need to show movement in the frame.

An informal canvassing of my colleagues turned up several other unorthodox ways to use tungsten lights in the field. When *National Geographic* photographer Steve McCurry arrives at an assignment location, one of his first actions is to buy a few inexpensive "clamp lamps" with 500-watt photofloods. The blue ones, which are color-corrected for daylight, are preferable. If they aren't available, he makes do with the regular white ones.

When McCurry has to go inside to photograph people going about their daily lives, as is often required for *National Geographic*, he clamps a few of these lights around the rooms. They boost the illumination to such a level that he can bounce his small, on-camera strobe and use a slow shutter speed to get natural-looking, well-lit interiors without worrying about multiple-strobe setups or having to use the very slow shutter speeds that cause blur when the subject or camera moves. Some photographers achieve similar results by replacing the regular bulbs in a room's lamp fixtures with higher-wattage photofloods. This may sound like a good idea, but most lamps aren't built to handle the heat that photofloods put out. As a result, you risk starting a fire. McCurry's idea of using clamp-lamp fixtures

designed to accommodate photofloods is a much better idea: the last thing you want to do when working on location is to literally burn your bridges.

Chuck O'Rear, another *National Geographic* photographer, is known for both his creative use of small flash units and his ability to improvise. While working on several high-tech stories for the magazine, he discovered that he needed light sources in a variety of colors. On a whim, he picked up a series of colored garden floodlights at a local Sears store and began experimenting. He found that their relatively weak light output balanced perfectly with the light sources in the labs he was shooting. The garden floodlights, which were lightweight and, at 5 dollars each, inexpensive, became an integral part of O'Rear's lighting kit (see page 134 for an example of what he is able to do with these lights).

One corporate photographer I know finds it necessary to photograph people in their homes and offices working with computers. Computer screens require lengthy exposures in order to register on film.

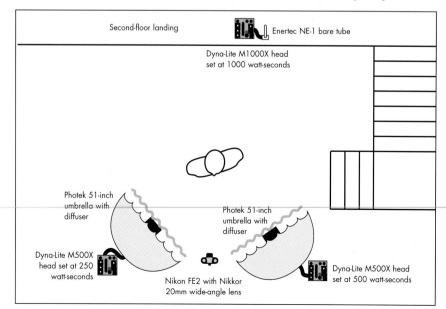

Second-floor landing

Enertec NE-1 bare tube

Dyna-Lite M1000X head set at 1000 watt-seconds

Photek 51-inch umbrella with diffuser

Dyna-Lite M500X head set at 250 watt-seconds

Photek 51-inch umbrella with diffuser

Nikon FE2 with Nikkor 20mm wide-angle lens

Dyna-Lite M500X head set at 500 watt-seconds

CENTRIFUGE IN MOTION, New Jersey.
Nikon 8008S, Angenieux 28-70mm
zoom lens, tripod, Kodachrome 64
exposed for 1/2 sec. at f/8.

*For a brochure about Cistron Inc., a
biotech firm, I was hired to shoot this
centrifuge. The company wanted a
clean, graphic image with a sense of
motion. I positioned a small, 2 x 3-foot
Chimera softbox with 250 watt-sec-
onds of light coming from a Dyna-Lite
head connected to an M500x power-
pack, just above and to one side of the
centrifuge. I left the modeling light on
and took an available-light reading.
Then I popped the flash and took a
flash meter reading. I slightly underex-
posed both readings since the two light
sources would blend in the final expo-
sure. I had the lab tech turn the
machine on and shot a bracketed
series with a tripod-mounted camera
and a 28-70mm lens set at 50mm
and aimed straight down at the cen-
trifuge chamber. The slow shutter
speed captured the motion, while the
pop of flash froze the rest of the image.*

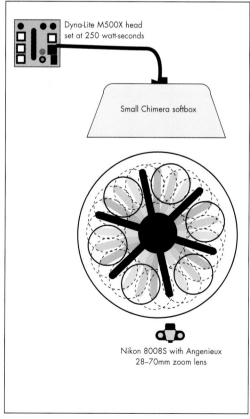

Dyna-Lite M500X head
set at 250 watt-seconds

Small Chimera softbox

Nikon 8008S with Angenieux
28–70mm zoom lens

The standard method is to turn off all the lights in
the room, use a long exposure for the screen, and use
a pop of strobes to illuminate the rest of the room.
Unfortunately, this approach negates using lamps or
other incandescent sources in the room, which can
often add an appealing bit of warmth and create a
mood. Incandescent lights are just too bright for long
exposures.

To solve this problem, my colleague started carry-
ing an extension cord fitted with heavy-duty dimmer
switches. Rather than turning off a desk lamp or
some other fixture that can add some atmosphere to
the shot, he plugs it into the dimmer cord, which he
then plugs into the wall. This enables him to dial
down the brightness of the lamp until it matches the
exposure he needs for the computer screen. The
resulting pictures have a natural feel, not the "over-
strobed" look of many computer pictures. When he
shoots with quartz lights, he uses the dimmer switch-
es to help him balance these sources with the exist-
ing room light.

EIFFEL TOWER AT DUSK, Paris, France. Nikon 8008S, Nikkor 20-35mm AF zoom lens, Tiffen 30CC magenta filter, tripod, Fujichrome Velvia exposed for 2 seconds at f/5.6.

The trick to shooting illuminated architecture is to wait until dusk so the sky is dark enough to allow the lights to glow, but not so late that the sky lacks detail. The Eiffel Tower is illuminated with some kind of vapor lighting, which tends to go green on film. To counteract this, I put a 30CC magenta filter over the lens. The filter also helped to intensify the reds in the dusk sky. I made a series of bracketed exposures to ensure a good result.

HMI LIGHTS

KAISER WILHELM BUST, Baden Baden, Germany.
Nikon 8008S, Nikkor 80-200mm AF zoom lens, tripod,
Fujichrome 100 exposed for 1/4 sec. at f/5.6.

*The inside promenade of Drink Hall in Baden Baden,
Germany, is illuminated with weak floodlights, which are
overwhelmed during daylight hours. Shooting an assignment
for Gourmet magazine, I returned just before dusk to shoot
this picture. This is the time when the interior lighting is
balanced with the daylight.*

A relatively new source of incandescent lighting,
HMI lights (hydragyrum medium-arc iodide lights), is
creating quite a buzz. These lights are daylight-bal-
anced, put out anywhere from four to seven times
more illumination than quartz lights of similar
wattage, and run much cooler than other incandes-
cent sources. Borrowed from the movie world, HMIs
run off one of two types of transformers, or *ballasts*;
these are either magnetic or electronic. An electronic
ballast is preferable for still photography because it
produces less flicker in the illumination.

HMI lights sound like the panacea still photogra-
phers have been waiting for: a cool, daylight-balanced,
continuous source with a power level similar to that
of strobe. But before you run off to your nearest
lighting store to buy some, consider the source of
these lights, the movies. Have you ever wondered
why even the simplest, most straightforward film can
cost between 30 million and 40 million dollars to
make today? After you pay the star the requisite 5
million to 10 million dollars, you still have at least 20
million dollars to spend. A large portion of this
amount goes to the rental or purchase of HMIs.
Unfortunately, these lights are incredibly expensive,
either to purchase or rent. A typical 1200-watt HMI
light runs about 4000 dollars for the ballast and
another 2500 dollars for the lamp. And the daily-
rental costs are well into three figures.

Either way, these prices are a little rich for most
assignment budgets these days. Nevertheless, HMI
lights are making inroads in the world of fashion pho-
tography and among some portraitists, especially
black-and-white photographers who use T-Max films.
These photographers claim the quality of HMI light-
ing is perfectly matched to the contrast curves of
these emulsions, which adds a magical quality to sub-
jects' skin tones.

But HMI lights will figure significantly in the
future of still photography because of their compati-
bility with digital still cameras. Electronic flash doesn't
work well with them, so HMIs are the light source of
choice for those photographers currently working
with filmless still cameras. It stands to reason that if
digital still cameras become the medium of the
future, HMI lighting will also gain prominence. How-
ever, either photographers' day rates will have to rise
dramatically or the prices—and the sizes—of HMI
lights will have to be reduced significantly before
they become common items.

LIGHT MODIFIERS

Sooner or later, you're going to need to modify the light coming from a flash or incandescent head. An unadorned light head is a versatile tool, but for many situations the light it produces is either too harsh and specular or not concentrated or focused enough. Not surprisingly, light modifiers fall into one of two broad categories: those that diffuse or spread the light, and those that concentrate it.

Both kinds of light modifiers are essential components of any location lighting kit. For the most part, the mix depends on your taste. But the requirements of the assignments that you shoot also dictate the type of modifiers that you carry and use. For example, I prefer broad, soft, directional light. I love the look of windowlight for almost everything I shoot. However, when I found myself photographing a computer screen in almost every picture I was hired to shoot for months at a time, I realized that I needed to get focused, specular light sources to do my job right.

Sharp-eyed magazine readers will also notice the trends in the use of light modifiers. Like clothing, different lighting "looks" are in for a while, until the latest look bumps them out. Since the number of modifiers available on the market is finite, these trends are cyclical: what goes around always eventually comes around again. For example, in the late 1970s and early 1980s, the distinctive look of the *ring flash*, a donut-shaped flash reflector that literally surrounds the lens itself, was very hot for fashion and portraiture. This reflector was originally developed as a shadowless light source for medical and closeup pictures. But almost as quickly as it came on the scene, it disappeared, replaced by other sources. Nearly two decades later, the ring flash has been "discovered" again and is enjoying a renaissance.

DIFFUSING LIGHT MODIFIERS

Since you don't always have a white wall or ceiling conveniently available for bouncing a light, the need for portable light diffusers is obvious. In the beginning, location photographers simply made use of what they had on hand. Bedsheets and shower curtains were early favorites, followed by white cards and Fomecore boards. Whenever the need for a new piece of photography equipment arises, however, manufacturers are only too happy to oblige. So, today photographers have a myriad of choices when it comes to selecting light modifiers. No matter which type you choose, though, you must remember a couple of points about diffusers.

First, the larger the light source (in relation to the size of the subject), the softer the light. If the subject is small, such as an insect, even the tiny reflector on a shoe-mount flash will act as an adequate soft light. In practical terms for portraiture, for the softest possible light, you shouldn't use a broad light source from a distance any larger than its diameter or, in the case of square and rectangular sources, the longest side. For example, you shouldn't position an umbrella with a 52-inch diameter farther than 52 inches from the subject in order to obtain the softest light. Similarly, a 36 x 48-inch softbox is most effective at distances of 4 feet or less.

Keeping this in mind, you can see why a large-group portrait requires a huge, diffused source for true soft lighting. This is one reason why bedsheets will never go completely out of style as diffusers. Although many high-tech diffusers on the market have superseded them, bedsheets are still an inexpensive, easy way to create a large, soft light.

Unwanted reflections are a problem with every light source, but they become quite obvious with diffusers because of their large size. There is nothing worse or more disappointing than opening up a box of slides to see an otherwise beautifully illuminated photograph with a large umbrella or softbox reflected in a window, mirror, or other reflective surface that you either didn't see or didn't anticipate during the shoot.

Remember, the angle of incidence equals the angle of reflection. So if your light source hit a reflective surface at a 45-degree angle, the reflection will be visible at that same angle, just like the way a pool ball caroms off the side of the table in a bank shot. This sounds pretty straightforward. But you might be surprised by how quickly unanticipated reflections can creep into pictures when you're working with multiple light sources in a room with multiple reflective surfaces, such as windows, mirrors, and polished wood surfaces all positioned at different angles! Knowing the rule about incidence and reflection is useful—if only to put you on alert that whenever you have one or more large light sources, you have to look for problematic reflections.

One of the best ways to check for these unwanted reflections is to use modeling lights. Since they mimic the behavior of the flash, they'll also give you an idea of where the reflections will fall. Keep in mind, though, that modeling lights are often dim in comparison to the available light, thereby making these reflections hard to spot. Also, many battery-operated flash units don't have modeling lights, so you are out of luck there, too. Polaroid tests, shot with the same focal length lens at the same camera position as the final shot, are the only reliable way

Opposite page:
BANKERS AND REAL-ESTATE
MODEL, New Jersey. Nikon
FE2, Nikkor 35mm wide-angle
lens, Kodachrome 64 exposed
for 1/60 sec. at f/8.

I made this boardroom portrait of bankers and a model of a trade complex that they were financing for United Jersey Bank's annual report. I wanted a rich, directional light to complement the surroundings. To the left of the camera, I set up two Domke 4 x 6-foot translucent panels at a 45-degree angle to the group. Behind each panel, I positioned a Dyna-Lite head bounced into a Photek 51-inch umbrella, connected to an M1000x pack set at full power. The double diffusion produces an appealing glow, but it eats up light. To the right of the camera, near the group of bankers, I suspended a king-sized white bedsheet between two lightstands to create bounce fill on the shadow side.

STEINWAY GRAND-PIANO
FORMS, New York City. Nikon
FE2, Nikkor 20mm wide-angle
lens, Kodachrome 64 exposed
for 1/250 sec. at f/11.

Shooting the Steinway piano factory for a Smithsonian magazine article proved to be a lighting challenge. I saw the graphic possibilities of the line-up of grand-piano forms, but I had to find a way to suppress the busy, cluttered background. I decided to do this by overriding the available light. So I set up a Photek 51-inch umbrella and a Dyna-Lite head with a full 1000 watt-seconds coming from a M1000x powerpack to the right of the piano forms. Next, I put a Domke 4 x 6-foot diffusion panel in front of the umbrella to further diffuse the light.

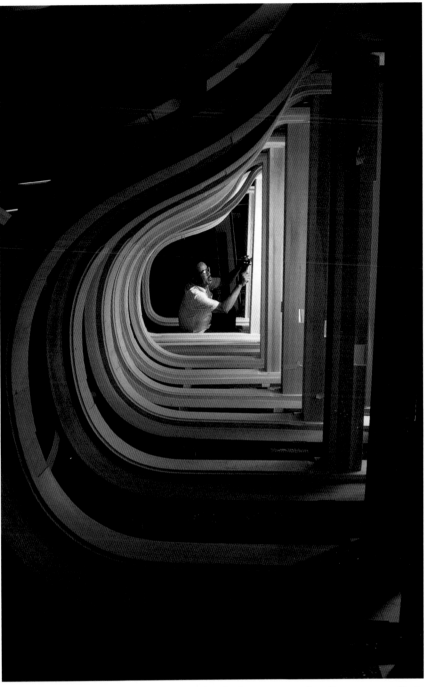

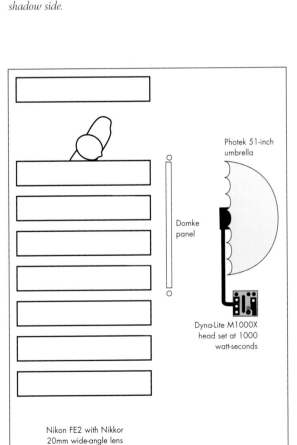

Photek 51-inch
umbrella

Domke
panel

Dyna-Lite M1000X
head set at 1000
watt-seconds

Nikon FE2 with Nikkor
20mm wide-angle lens

you can check for unwanted reflections in flash setups. This is why the Polaroid backs that enable you to use the same lenses as your regular camera are worth the premium prices they command.

UMBRELLAS

Probably the most popular type of diffuser and a good, all-around choice, umbrellas are easy to use and relatively inexpensive. Umbrellas are effective for illuminating large areas and for portraiture. Umbrellas are available in different sizes and in materials of different reflectivity. Silver-lined umbrellas ordinarily produce a harder light than soft-white ones.

Most photographers bounce their light into an umbrella. Some, however, prefer to shoot the light

EYEGLASS REFLECTIONS

PORTRAIT WITH STEINWAY
PIANOS AND PAINTINGS,
New York City. Nikon 8008S,
Nikkor 24mm wide-angle lens,
Kodachrome 64 exposed for
1/60 sec. at f/8.

*For an assignment for Smith-
sonian magazine on Steinway
pianos, I needed a portrait of
Henry Steinway. I chose a
corner of the company's Fifth
Avenue showroom. I bounced
a Dyna-Lite head with 1000
watt-seconds of light from an
M1000x powerpack into a
Photek 51-inch umbrella to
the right of the camera. Even
though double-diffused light
eats up power, I like its soft,
warm glow. To achieve this
extra layer of diffusion, I set
up a Domke 4 x 6-foot panel
with translucent white fabric
at about a 45-degree angle
between the umbrella and
Steinway. A Polaroid test
indicated that I could elimi-
nate most of the panel's reflec-
tion in his glasses by having
him turn slightly away from
the light source.*

One of the most difficult subjects a portrait pho-
tographer faces is a person wearing glasses. As a
whole, photographers don't have anything against
eyeglass wearers. Photographers simply don't like
seeing light sources reflected in eyeglasses. And if
your subject has very thick lenses, you might not
be able to entirely eliminate the light-source reflec-
tion because the lenses are just too curved. You
can, however, try a few remedies.

If you decide to use an umbrella, you should
keep it as high as possible and angle it downward.
In addition, you can often have your subjects
slightly raise the arms of their eyeglasses. This, in
turn, tilts the lenses down, thereby lessening the
chance for the appearance of reflections. If you use
a softbox and usually keep the box low and to the
side, you can try to have your subjects face away
from the softbox. A modeling light is quite useful
in these situations because a slight tilt of the sub-
ject's head or the movement of only an inch or so
often will make an enormous difference in elimi-
nating eyeglass reflections.

Having a portion of the light source show up in
the upper part of the glasses is acceptable as long
as it doesn't obscure the subject's eyes. This is one
of the many reasons why portrait photographers
ordinarily prefer a softbox. The square reflections
in the eyeglasses are somehow more natural look-
ing than those a round umbrella makes. The angu-
lar reflections could, for example, come from a
window, which is something that people are used
to seeing reflected in eyeglasses.

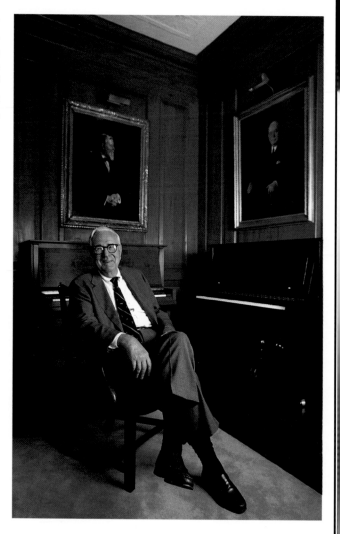

through the umbrella if it is made of a translucent,
white material. Either method is good. But the shoot-
through option generally creates a slightly softer light
than the bounce approach if for no other reason that
when photographers use an umbrella this way, they
place the umbrella closer to the subject; consequent-
ly, it serves as a larger light source.

Contrary to popular opinion, umbrella models
with black backing aren't any more efficient than
models without any lining. The black backing simply
blocks the portion of the light that usually passes
through the umbrella from spreading around. This
gives you a bit more control over the light, as well as
makes it less susceptible to picking up the color from
the walls and ceilings of the room in which you're
shooting. But unless the backing is removable, it also
prevents you from shooting through the umbrella.

You have several other choices to make regarding
umbrellas. Some have collapsing shafts and multi-
folding struts, thereby permitting them to fold down

to a fraction of their open size. Some umbrellas offer
a translucent, white "screen" that fits over the front;
this diffuses the light even further. My first choice of
an umbrella combines both of those options. The
Photek Compact Series Comp 18/51 is a black-backed
umbrella that opens to 51 inches, collapses to 18
inches, and has an optional diffuser called a "Conver-
ta Bank" that attaches over the front, giving it many
of the same characteristics of a softbox. I can place
two or more of these doubly diffused umbrellas side
by side in the corner of a room and create a soft,
pleasing "wall" of light. Any time a piece of gear can
do double duty like this, it saves you weight and gives
you extra space in your camera bag.

If umbrellas have a shortcoming, it is that they per-
haps do their job too well. They spread the light all
over, and the *spill*, the unused portion of the light, is
uncontrollable. What many photographers need is a
soft source that is more controllable—which is proba-
bly why softboxes were invented.

MAN PLAYING INSTRUMENT
IN INN, Shirakawa, Japan.
Nikon FE2, Nikkor 24mm wide-
angle lens, Kodachrome 64
exposed for 1/30 sec. at f/5.6.

I visited several traditional Japanese inns, called ryokan, while working on an assignment for National Geographic Traveler *magazine. This inn, located in the mountainous region of Shirakawa, was quite rustic and didn't have much in the way of electricity. After a sumptuous dinner, the landlady broke out traditional instruments for guests to try. Since there were no electrical outlets, I used an Armatar 200 battery-powered flash bounced full power into a Photek 51-inch umbrella off to one side of the camera position. I aimed another Armatar 200, set at half power, directly at the landlady and the background.*

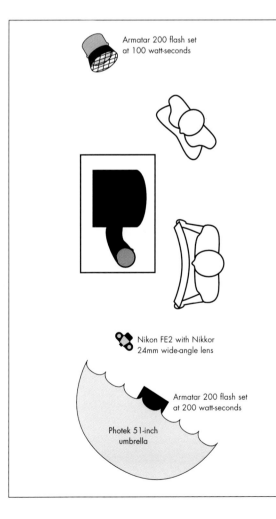

Armatar 200 flash set
at 100 watt-seconds

Nikon FE2 with Nikkor
24mm wide-angle lens

Armatar 200 flash set
at 200 watt-seconds

Photek 51-inch
umbrella

PHILLIPE MILLION RESTAURANT,
Charleston, South Carolina.
Nikon FE2, Nikkor 24mm
wide-angle lens, tripod,
Kodachrome 64 exposed
for 1/15 sec. at f/5.6.

This sequence shows the lighting-equipment setup that I used for a shot of Charleston's elegant Phillipe Million restaurant (right) and the final image (below). I used umbrellas, bedsheets, and grid spots to create this straightforward photograph, which Travel & Leisure *magazine hired me to do.*

STILL LIFE WITH CHEESE AND
DOG, Vermont. Nikon FE2,
Nikkor 35mm wide-angle lens,
tripod, Kodachrome 64 exposed
for 1/4 sec. at f/5.6.

*While I was shooting a story
about New England inns for
Travel & Leisure magazine,
my biggest problem was get-
ting the dog to sit still! To
avoid telltale, round umbrella
highlights in the wine glasses, I
shot a Dyna-Lite head set at
200 watt-seconds through a
Bowens Bowflecta 42-inch-
square white umbrella to the
left of the camera. I bounced
another Dyna-Lite head, also
at 200 watt-seconds of power,
off the ceiling in the back-
ground to clean up the
shadows. I used a slow
shutter speed in order to burn
in the fire and register the
available light in the room.*

MOLECULAR BEAM EPITAXY, New Jersey. Nikon 8008S, Nikkor 24mm wide-angle lens, tripod, Kodachrome 64 exposed for 1 second at f/8.

Photographed for the Siemens corporation, this high-tech machine almost completely filled the small room it occupied. To illuminate this shiny, metal machine, I placed a Dyna-Lite head with 500 watt-seconds of power in a medium, 3 x 4-foot Chimera softbox above the camera. I knew that the square highlights in the metal would look better than those that result from round umbrellas. I wanted omnidirectional light to separate all the nooks and crannies of the machine from the background. So I used an Enertec NE-1 bare-tube head with 1000 watt-seconds of light from a Dyna-Lite M1000x powerpack covered with a blue gel. The scientist had a work light aimed right at his station at the machine, and I decided to let the warm light it provided illuminate him by using a slow shutter speed.

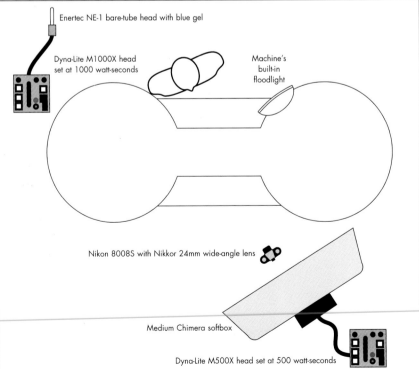

Enertec NE-1 bare-tube head with blue gel

Dyna-Lite M1000X head set at 1000 watt-seconds

Machine's built-in floodlight

Nikon 8008S with Nikkor 24mm wide-angle lens

Medium Chimera softbox

Dyna-Lite M500X head set at 500 watt-seconds

SUPERCONDUCTOR
RESEARCH, New Jersey. Nikon
8008S, Nikkor 80-200mm
zoom lens, Kodachrome 64
exposed for 1/125 sec. at f/8.

*AT&T hired me to shoot its
annual report. The only way
to visually show the proper-
ties of superconductivity that
AT&T's Bell Labs division
was researching was to photo-
graph the little piece of super-
conductive material floating
in the air above another piece
of material. The material has
to be super-chilled with liquid
nitrogen, which smokes nicely
and gave me an opportunity
to play around a bit. To
emphasize the cold smoke, I
placed the experiment on a
3 x 4-foot piece of translucent
plexiglas suspended between
two lab benches. An extra
small Chimera softbox, with
a Dyna-Lite head set at 250
watt-seconds and covered
with a blue gel, illuminated
the experiment from below.
Another small Chimera soft-
box with a 125 watt-second
Dyna-Lite head lit the scien-
tist in the background, and a
125 watt-second Dyna-Lite
head with a grid spot and a
red gel provided the kicker
light.*

SOFTBOXES

Softboxes, which are also called *banklights*, are essen-
tially tent-like enclosures with one translucent panel.
All the other panels are black on the outside and sil-
ver or white on the inside. When you aim the light
through the front panel, it is prevented from spilling
via the panel enclosures. In some large softboxes, an
additional diffusion panel between the light source
and the front panel further softens the light. Soft-
boxes usually mount onto the light source by means

of a ring that fits over the light and provides a place
to mount the poles. These, in turn, hold the softbox
open. Because softboxes are rectangular in shape,
these mounting rings often rotate, thereby enabling
you to change the orientation of the box from hori-
zontal to vertical.

Because the light source is enclosed in fabric, you
need to heed a couple of safety considerations when
using a softbox. It is best to use a flash head with a
fan cooling system. Even then, however, you should
be sparing in the use of the modeling light. The heat
of repeated high-power flashes, combined with the
heat the modeling light generates, can build up to
dangerous levels in the enclosed softbox. Softboxes
intended for use with incandescent sources are
specifically designed to withstand the tremendous
heat that those sources give off. But it isn't hard to
understand why softboxes aren't the overall primary
choice for incandescent sources.

Softboxes are great when you need a beautiful,
soft source that won't lead to excessive spill. Portrait
photographers favor them because they mimic the
classic windowlight that was so popular with Rem-
brandt and his contemporaries. Still-life photogra-
phers also like the controllable softness and flat dif-
fusion surface of these light sources. And because of
their construction, they won't "throw" light as far as
an umbrella, so you don't often find them being used
to light large areas.

Softboxes come in sizes that range from 5 x 7
inches to about 4 x 6 feet. Some photographers place
several large softboxes side by side in order to create
huge banks of light for group portraits. Large soft-
boxes can be quite deep when opened up. For exam-
ple, a 4 x 6-foot softbox can be more than 3 feet deep
when set up. Two design features that you should
look for in a softbox are the narrowest possible depth
and collapsible poles. The limited depth will help
you position the softbox in some tight places, and the
collapsible poles make permit you to pack the unit in
a small bag.

Softboxes don't have too many accessories. Some
manufacturers offer a grid screen for the front dif-
fuser, which in effect provides a small concentrated
area of soft illumination. Since these screens don't
fold or collapse, they are a bit awkward to carry
around on location. Some softbox models also have
louvers and barndoor attachments that give you fur-
ther control over the spread of light. Because soft-
boxes have more intricate designs and constructions,
as well as such extra hardware as mounting rings,
they are generally more expensive than umbrellas.

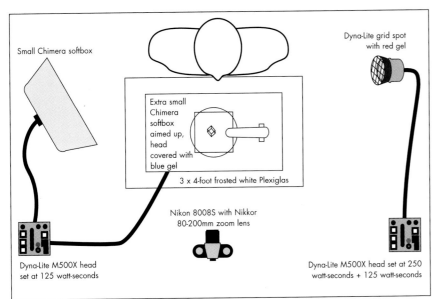

Small Chimera softbox

Dyna-Lite grid spot
with red gel

Extra small
Chimera
softbox
aimed up,
head
covered with
blue gel

3 x 4-foot frosted white Plexiglas

Nikon 8008S with Nikkor
80-200mm zoom lens

Dyna-Lite M500X head
set at 125 watt-seconds

Dyna-Lite M500X head set at 250
watt-seconds + 125 watt-seconds

BLUE JEANS PLANT, Tennessee. Nikon FE2, Nikkor 24mm wide-angle lens, Kodachrome 64 exposed for 1/60 sec. at f/8.

For a financial-service business's annual report, I had to photograph a blue-jeans factory that the company had worked with. But shooting on the factory floor was a problem because it was so messy and eerily reminiscent of a turn-of-the-century sweatshop! The forms hanging from the wall caught my eye, and I decided to build the shot around them. I laid out several forms for the tailor to work on in the foreground and illuminated him with a Dyna-Lite head with 1000 watt-seconds of power from an M1000x pack in a single medium Chimera softbox to the right of the elevated camera position. To highlight the translucent forms behind the tailor, I aimed two Dyna-Lite heads with grid spots, each connected to an M500x pack at full power, at 45-degree angles to the forms from behind.

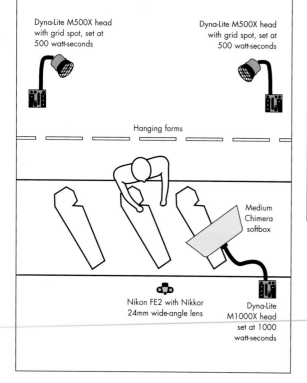

Dyna-Lite M500X head with grid spot, set at 500 watt-seconds

Dyna-Lite M500X head with grid spot, set at 500 watt-seconds

Hanging forms

Medium Chimera softbox

Nikon FE2 with Nikkor 24mm wide-angle lens

Dyna-Lite M1000X head set at 1000 watt-seconds

DOCTOR ON TRAMPOLINE, New Jersey. Nikon 8008S, Angenieux 28-70mm zoom lens, Fujichrome 64 Tungsten film exposed for 1/250 sec. at f/8-11.

I made this was shot for a magazine story about a doctor who used trampoline jumping as part of his patients' holistic therapy. I wanted to show him in action near his rural New Jersey home. My plan was to isolate him against the sky for a simple background. Unfortunately, the day was overcast, so I had to make a few "mistakes" to get the sky blue. Instead of using daylight film, I loaded tungsten-balanced film in my camera, knowing that the gray sky would register blue because of the mismatched light source. To illuminate the doctor, I used an extra-large, 52 x 72-inch Chimera softbox, placing it high and to the right of the camera. To bring the flash's light temperature in line with the tungsten film, I covered the Dyna-Lite head with a tungsten gel filter, a Roscolux #18 flame. I pumped 1000 watt-seconds of light from an M1000x power-pack through the single head because I wanted as small an aperture as possible. With my camera's top sync speed of 1/250 sec., I needed to have enough light to slightly under-expose the sky in order to make it register a rich blue. The doctor, an expert trampolinist, was able to consistently hit the same pose at the same height while I shot a series of bracketed exposures.

COLLECTIBLE SHOTGUN, Connecticut. Nikon FE2, Nikkor 50mm standard lens, Kodachrome 64 exposed for 1/60 sec. at f/11.

Hired for an article about collectible guns for Forbes *magazine, I made this shot right on the retail floor of a tony safari shop in the Connecticut hills. I worked under the close supervision of the shop's owner because the gun is worth quite a bit of money. I used the hand-tooled wooden case as the stage and laid the gun on top of it. I then started placing props around in a myriad of arrangements in order to fill the gaps in the composition. I'd set up a small boom stand with a Dyna-Lite head in a small, 2 x 3-foot Chimera softbox and set the M500x pack at full power. The boom enabled me to swing the softbox directly over the stage. Using the modeling light and Polaroid test shots, I checked for unwanted reflections and then fired away.*

DINNER IN AN INN, Kyoto, Japan. Nikon FE2, Nikkor 50mm standard lens, Kodachrome 64 exposed for 1/60 sec. at f/11.

On an assignment for a National Geographic Traveler *magazine article about Japanese inns, I needed a shot of an elegant dinner served in guests' rooms at the swanky ryokan. While the writer and our guide were busy eating their dinners at the other end of the room, I was working hard over the polished ebony table, arranging my dinner for a photograph before I could enjoy it. Fortunately, much of the food was cold to begin with, so this wasn't too much of a hardship! I decided to shoot straight down on the food. I had a small, 2 x 3-foot Chimera softbox mounted on a Dyna-Lite head with an M500x pack set on full power right next to my camera, and aimed at about a 45-degree angle to the food. I chose a softbox instead of an umbrella because I knew the reflection of the light would show up in the table, and the rectangular shape of the softbox would be much less distracting than the round umbrella reflection. I checked the reflection two ways: by using the modeling light and by taking Polaroid test shots.*

LIGHT PANELS

Early in my corporate career, an art director pulled me aside before an executive-portrait session. He asked me if I had anything more "professional look-ing" than the crumpled king-size bedsheet that I'd hung between two lightstands in front of my two umbrellas to provide a bank of soft, double-diffused light. I must not have been the only location photographer to hear this request because soon after that, several portable light panels came on the market.

These 4 x 4-foot and 4 x 6-foot panels don't do anything different or better than the bedsheet or shower curtain, but they do look more "professional!"

The big consideration for location photographers using light panels is their ease of assembly. One design features hollow, polyvinyl-chloride (PVC) piping that is shock-corded together. You can set up these panels quickly and easily. You simply take them out of the case and give them a shake, and they pop together in form. PVC panels are, however, somewhat bulky. The other design uses smaller, solid poles that you must fit together piece by piece. These light panels are slower to set up, but they take up less space in your bag. The collapsed sizes of light panels are another concern for location photographers. Generally, the panels get no smaller than the shorter side of the rectangle, so a 72 x 44-inch panel will be 44 inches long when collapsed.

Light panels have "feet" that enable you to stand them freely on the floor. Another choice is to suspend them between two lightstands, using the two clamps designed especially for this job. You can aim your lights directly into a panel to diffuse them. You can also use panels to provide a second layer of diffusion, as I do when I place them in front a flash bounced into an umbrella. Because they lack the sides and back of a softbox, a great deal of spill light results. In certain situations, this can work in your favor. For example, in a small room, one panel may provide enough spill to act as both a background light and a main light. In terms of price, light panels fall somewhere in between the costs of umbrellas and softboxes—but are far more expensive than bedsheets!

Like umbrellas, light panels come in a variety of fabric surfaces. Unlike umbrellas, however, a panel fitted with a reflective silver or gold material makes a superb reflector and can be used as a bounce fill when the sun or a light in a softbox, umbrella, or another panel functions as the main light. Utilized as reflectors and diffusers, panels are also useful in outdoor lighting situations. Depending on your taste in lighting, your budget, and the types of subject matter you shoot, you might end up with all three diffusion devices in your kit. Each has its own special application.

Opposite page:
VIOLIN MAKER WITH VIOLINS,
and Right: CLOSEUP OF
VIOLIN, Pennsylvania. Nikon
FE2, Nikkor 24mm wide-angle
lens, Nikkor 85mm telephoto
lens, Kodachrome 64 exposed
for 1/60 sec. at f/5.6.

I photographed Peter White, a well-known American violin maker, for Americana magazine. I made nearly all of the pictures for the story in White's small workshop in Pennsylvania. To the left of the camera, I placed a Photek 51-inch umbrella with a Dyna-Lite head. In front of that, I placed a Domke 4 x 6-foot panel with translucent material, for a second layer of diffusion. I used a wide-angle lens for the portrait of White and his violins. For the close-up of the violin, I remained in the same shooting position but switched to a medium-telephoto lens.

CONCENTRATING LIGHT MODIFIERS

ROBOTIC ARM IN MOTION, West Point, Pennsylvania. Nikon 8008S, Nikkor 35mm wide-angle lens, Kodachrome 64 exposed for 8 seconds at f/8–11.

This picture of a robotic arm used in a Merck & Co. annual report required showing motion in a still shot. I had to determine the range of the motion and illuminate that area. To do this, I used two Chimera softboxes, small and extra-small. I positioned a softbox, each with 500 watt-seconds of power, on either side of the robot. After determining the aperture to be f/8 for the strobe shot, I metered the available light coming from the strobes' modeling lights to be about 8 seconds. I asked the technician to reprogram the robot so that the action would take about that amount of time. Next, I turned off all the lights with the exception of the modeling lights. My assistant popped the strobes off at the beginning of the exposure, again when the arm reached the center, and a third time when the arm came to rest.

In some shooting situations, you'll want to restrict or decrease the angle of coverage of the light your flash head produces. The ability to selectively illuminate a small a portion of a photograph enables you to create drama with shadows and dark areas, highlighting only the elements you want. Any restriction of the angle of coverage of your light source is going to make the illumination more specular, of course. So you'll have to carefully position the resulting strong shadows or they'll wreak havoc in your photograph. You can modify your the light source several ways.

BARNDOORS

True to their descriptive name, these traditional modification tools usually consist of two and sometimes four flaps that attach to the light head. By folding them over the light source, you can restrict the spread of the illumination. You can vary the effect according to how tightly you close the barndoors. Incandescent light users favor barndoors, although many strobe systems feature them, too. But because of the gaps left by trying to cover a round source with square flaps, you're often faced with an annoying light-leakage problem when you work with strobes. In addition, the barndoor attachment is kind of clunky to pack.

SNOOTS

Most flash photographers find snoots to be more useful than barndoors. A snoot is a round tube, usually made of black metal, that fits over the flash head, creating a tunnel that the light must pass through. The longer the tube, the tighter the angle of coverage. Since carrying long snoots of various lengths is so inconvenient, some manufacturers offer a series of interlocking rings, called *angle-reducing rings*, that permit you to "build" snoots of different lengths by attaching more rings. Keep in mind, though, that these hollow nesting rings take up quite a bit of room in a packed case. To prevent wasting these precious, empty spaces when you travel, you should fill them with something pliable, like power cords (or socks and underwear).

Many location photographers create snoots on the spot using a thick, black, heat-resistant foil that is known by several names, including Blackwrap. This heavy-duty foil comes in rolls, just like household aluminum foil. This material is malleable enough for you to fashion it into various shapes around the front of your light; it is also strong enough to retain these configurations once you attach it to your flash head with gaffer tape. The foil wrap is reusable, relatively inexpensive, and easy to pack around lightstands and umbrellas.

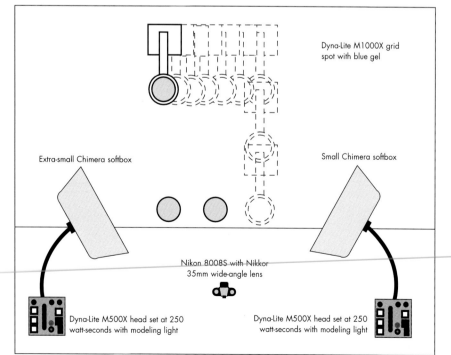

Dyna-Lite M1000X grid spot with blue gel

Extra-small Chimera softbox

Small Chimera softbox

Nikon 8008S with Nikkor 35mm wide-angle lens

Dyna-Lite M500X head set at 250 watt-seconds with modeling light

Dyna-Lite M500X head set at 250 watt-seconds with modeling light

SCIENTIST IN COLD ROOM, West Point, Pennsylvania. Nikon FE2, Nikkor 24mm wide-angle lens, Kodachrome 64 exposed for 1/125 sec. at f/5.6.

I made this photograph for a story about research in a pharmaceutical company's in-house magazine. Samples were stored in superfreezing conditions in refrigerators filled with liquid nitrogen. When opened, the supercold nitrogen actually "steams" up, creating smoke-like vapor. Unfortunately, these vats were shoved in an unattractive, sickly-green room. To effectively illuminate the background and overcome the room's green cast, I used an Enertec NE-1 bare-tube head that I'd wrapped in a Roscolux magenta gel and attached to a Dyna-Lite M500x head at full power. I used a grid spot on another Dyna-Lite powerpack set at 500 watt-seconds. I covered this head with a Roscolux blue gel to simulate cold and attached it to a Dyna-Lite M1000x power-pack that I'd positioned behind the scientist. Next, I put just a grid spot, no gel, on another Dyna-Lite head, set it to 125 watt-seconds, and aimed it at the scientist as a fill. To prevent the samples from getting over-heated, I was able to open the vat for only a short time. So my assistant stood off-camera and "fanned" the steam with an open, 38-inch Flexfill reflector to spread it out.

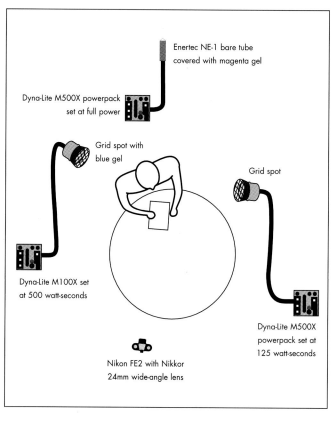

Enertec NE-1 bare tube covered with magenta gel

Dyna-Lite M500X powerpack set at full power

Grid spot with blue gel

Grid spot

Dyna-Lite M100X set at 500 watt-seconds

Dyna-Lite M500X powerpack set at 125 watt-seconds

Nikon FE2 with Nikkor 24mm wide-angle lens

Shooting a Bellcore Corporation annual report, I started with a grid spot on a Dyna-Lite head set at 500 watt-seconds and placed high and to the right of the teacher. It illuminated both the instructor and the student on the left. And while it provided rim-lighting for the student on the right, it didn't spill onto any screen or the background. To create a fill light, I placed another Dyna-Lite head, set at 250 watt-seconds and fitted with a grid spot, high and to the teacher's left. I illuminated the foreground student using a third Dyna-Lite head, also with a grid spot and set at 250 watt-seconds. Finally, I positioned an Armatar 200 battery-powered unit, dialed down to quarter power, on the desk; I aimed the light at the face, but not the screen, of the student in the lower-right, who was in shadow.

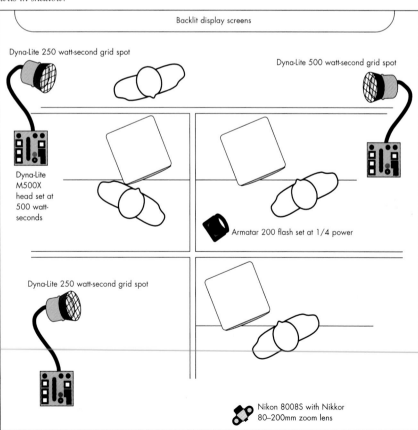

Backlit display screens

Dyna-Lite 250 watt-second grid spot

Dyna-Lite 500 watt-second grid spot

Dyna-Lite M500X head set at 500 watt-seconds

Armatar 200 flash set at 1/4 power

Dyna-Lite 250 watt-second grid spot

Nikon 8008S with Nikkor 80–200mm zoom lens

GRID SPOTS

By far the most convenient and precise method of reducing the angle of coverage for location photographers are grid spots, which are also called *honeycomb grids*. These metal discs, about 1/2 inch deep, contain metal, honeycomb-grid material.

The beauty of grid spots for space-conscious location photographers is that the pattern of the grid itself, not the depth of the disc, restricts the angle of coverage. This makes them compact and easy to pack. Tight grid patterns produce narrow spots of light, while loose grid patterns produce broader beams of light. Grid spots usually come in sets of three or four discs, with typical spreads of 25, 40, and 60 degrees.

To use the grid spots, you slip them into a holder that, in turn, attaches to the flash head. If you are in a pinch, however, you can attach them directly to the flash head with gaffer tape. You need a modeling light on your flash—or a great deal of patience and Polaroid film—in order to easily and accurately aim grid spots, especially those with tight patterns.

Grid spots simplify the task of placing a fairly tight circle of light wherever you want it. They really come into their own in photographs that would suffer from an abundance of light scattering around, such as those featuring computer screens or many reflective surfaces. For awhile, grid spots were even in vogue for portraiture. Magazines were loaded with pictures of celebrities, businesspeople, and other ordinary individuals looking ever so sinister as they stood in the dark with only their faces illuminated. (You can't really blame photographers, though. Since 90 percent of magazine photography today is environmental portraiture, photographers will do anything to inject a little variety into their pictures!) Grid-spot portraits aren't as hot as they were a short time ago, but I have no doubt that they'll become popular again in the future.

The downside to working with snoots and grids is that they eat up a great deal of light. You need a fair bit of power, 500 watt-seconds or more, in order to shoot ISO 100 film at a moderate aperture, f/5.6 or f/8. In addition to preventing stray light from escaping the flash head, these devices prevent heat from escaping as well. So even when you use a fan-cooled flash head covered with a grid spot or a snoot, it is wise to use the modeling light sparingly and not pop the flash too rapidly. This prevents overheating.

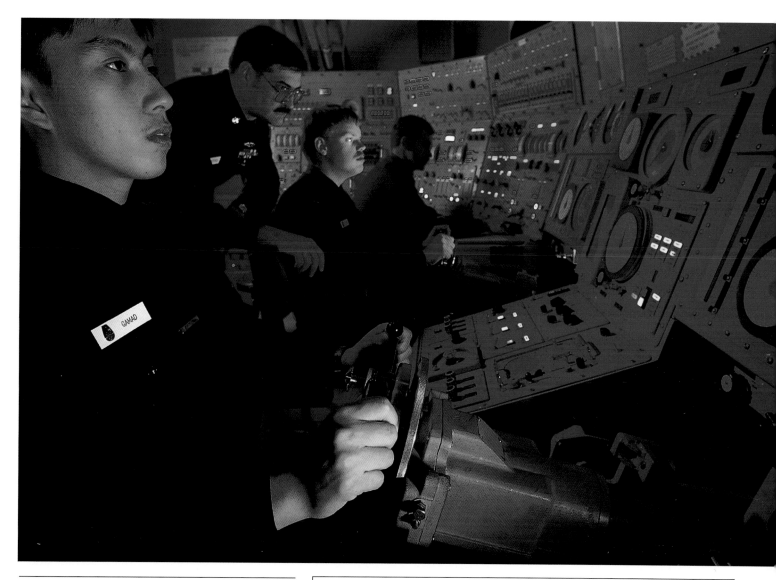

SUBMARINE TRAINING MODULE, Seattle, Washington.
Nikon FE2, Nikkor 20mm wide-angle lens, tripod,
Kodachrome 64 exposed for 1 second at f/8.

Unisys sent me to shoot the mock-up of a submarine command deck at Seattle's SeaTac Naval Station for its annual report. Because the simulated training module was gunmetal gray under fluorescent lights, my instructions were to make it look snazzy and high-tech. I decided to jazz it up with some dramatic lighting. My first step was to turn off the overhead lights. Next, I placed a Dyna-Lite head set at 250 watt-seconds and fitted with a grid spot at the base of each steering column, aiming the units at the sailors' faces. Then I covered an Enertec NE-1 bare-tube head set at 800 watt-seconds with a blue gel, placed it in a small Chimera softbox, and aimed it at the console in the background. I directed another Dyna-Lite head with a grid spot and a red gel at the console between the two drivers. I used a slow shutter speed to burn in the console lights.

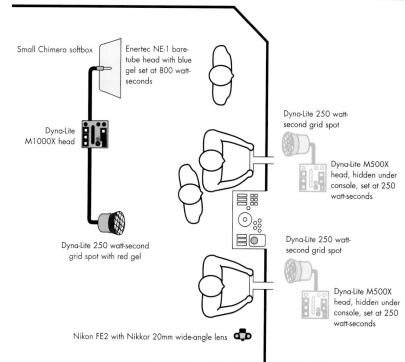

Small Chimera softbox

Enertec NE-1 bare-tube head with blue gel set at 800 watt-seconds

Dyna-Lite M1000X head

Dyna-Lite 250 watt-second grid spot

Dyna-Lite M500X head, hidden under console, set at 250 watt-seconds

Dyna-Lite 250 watt-second grid spot with red gel

Dyna-Lite 250 watt-second grid spot

Dyna-Lite M500X head, hidden under console, set at 250 watt-seconds

Nikon FE2 with Nikkor 20mm wide-angle lens

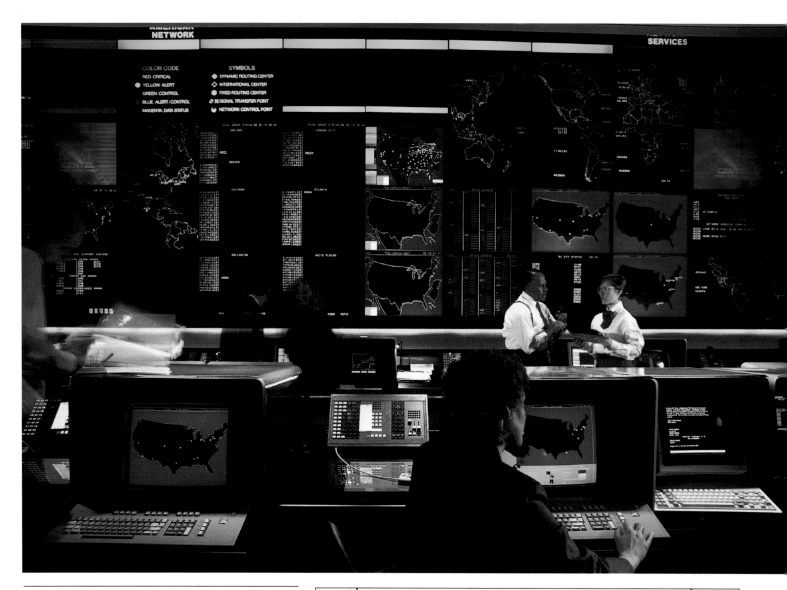

COLOR CODE

RED: CRITICAL
YELLOW: ALERT
GREEN: CONTROL
BLUE: ALERT/CONTROL
MAGENTA: DATA STATUS

SYMBOLS

DYNAMIC ROUTING CENTER
INTERNATIONAL CENTER
FIXED ROUTING CENTER
SIGNAL TRANSFER POINT
NETWORK CONTROL POINT

AT&T NETWORK CENTER, New Jersey. Nikon 8008S, Nikkor 20mm wide-angle lens, tripod, Fujichrome Velvia exposed for 2 seconds at f/5.6.

Shot for an AT&T annual report, this picture shows the company's Network Control Room, which is the nerve center of the long-distance service. The trick was to illuminate the people without washing out the many screens and backlit displays. I used a Dyna-Lite head in a small Chimera softbox with about 100 watt-seconds of power to the right of the woman in the foreground; I positioned the Dyna-Lite in such a way that none of its light would spill onto the screen. To illuminate the man and the woman talking in the background, I fitted two Dyna-Lite heads with grid spots, set them for 500 watt-seconds each, and placed one way off to each side of the individuals. I asked them not to move during the long exposures, which were necessary to burn in the screens. Since the Network Center is in active use 24 hours a day, other people passed through the frame. Their speed determined how much blur registered on film.

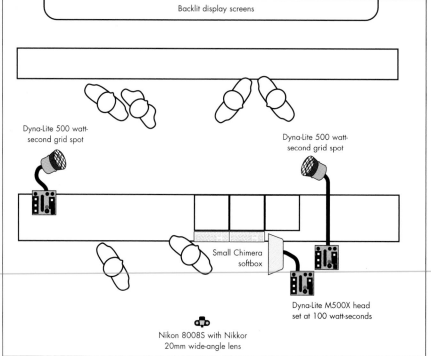

Backlit display screens

Dyna-Lite 500 watt-second grid spot

Dyna-Lite 500 watt-second grid spot

Small Chimera softbox

Dyna-Lite M500X head set at 100 watt-seconds

Nikon 8008S with Nikkor 20mm wide-angle lens

CHEMISTRY PROFESSOR
LECTURING, Massachusetts.
Nikon 8008S, Nikkor 28-70mm
zoom lens, Fujichrome Velvia
exposed for 1/125 sec. at f/4.

To create drama in some classroom shots while working at Williams College, I decided to use the projection spot to simulate late-afternoon light pouring in through some Venetian blinds. I aimed the Profoto projector spot with a Venetian-blind cookie at a 45-degree angle to the lecturer. But even with a Profoto 2400 watt-second pack set at full power pumping through the head, I was still getting an aperture of only f/4. I then put a warming filter on the Profoto lamp to achieve the effect I wanted.

FOCUSING SPOTLIGHTS

These spotlights are fairly specialized devices that not only restrict the angle of coverage of a light source, but also focus and project the light through a Fresnel-lens arrangement. Similar to theatrical spotlights, focusing spotlights, which are also called *projection spotlights*, have the ability to throw the light a great distance. Remember, though, that they're throwing strobe light.

In and of itself, this ability to throw light isn't too useful to most location photographers. But you can fit the spotlights with various patterned cutouts, called *cookaloris*, or *cookies* for short, and project shadow patterns as well. This opens up a whole range of possibilities for sprucing up uninteresting backgrounds. You can, for example, simulate light pouring

in through Venetian blinds or unusual-shaped windows, thereby casting interesting shadow patterns on backgrounds. Also, a focusing spotlight is a good "bailout" tool that serves as a main light and adds a bit of drama to your images.

Not every strobe manufacturer offers a focusing spot, so photographers generally rent these lights on a per-case basis—unless they fall in love with a particular effect and simply have to own the spotlight that produced it. Keep in mind that because focusing spotlights concentrate light so severely, they also eat up a tremendous amount of light. As a result, besides the long spotlight itself, you usually need to carry a 2400 watt-second powerpack in order to run it. This makes for a heavy, bulky combination, but when you need it, you need it.

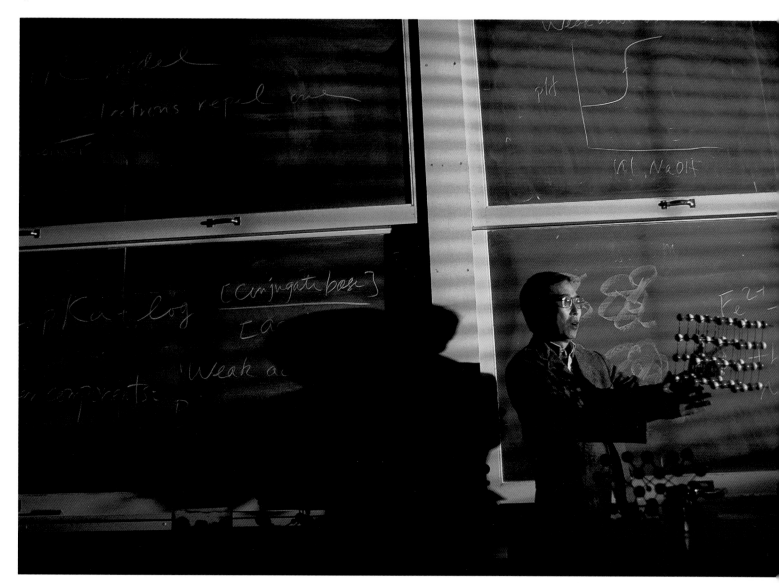

WOMAN STUDYING IN
CLASSROOM, Massachusetts.
Nikon 8008S, Nikkor
80–200mm AF zoom lens,
tripod, Kodachrome 64
exposed for 1/8 sec. at f/4.

*I was trying to pull an inter-
esting shot out of a cinder-
block classroom while on an
assignment for Williams Col-
lege in the Berkshire Moun-
tains of Massachusetts. One
afternoon, I saw the last rays
of sunlight project a shadow
through the big window case-
ments in this chemistry class-
room, but there was nobody
around to place in the picture.
I never saw the light again, so
I decided to recreate it with a
projector spot that I'd rented
for a weekend during the
shoot. I used a cookie with a
similar pattern to the actual
window and projected the
modeling light from a Profoto
2400 watt-second powerpack
through the Profoto spot to
create the shadow. I didn't
even bother using the flash;
since the available-light level
was so low, the balance of the
modeling light and the room
light was perfect.*

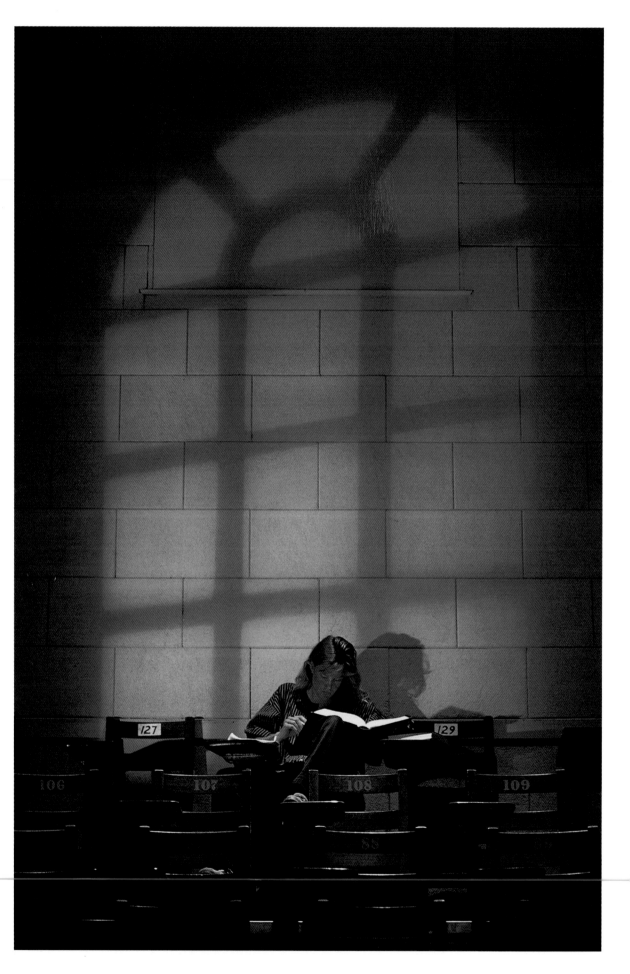

THE MAGIC OF BARE-TUBE LIGHTING

*For a brochure for Quantum
Chemical Corporation, the
object was to show the Emer-
gency Medical Service volun-
teers in action, and to make
sure that they were recogniz-
able. To provide an up-close
perspective, I mounted my
camera and wide-angle lens
on a monopod, which I'd
attached to the ambulance
bumper via gaffer's tape and
a Bogen Super Clamp. I
taped a Venca radio receiver
into the camera's hotshoe. I
opted to thread a cord into
my camera's electronic-release
socket to trip the shutter. I
taped an Armato-modified
Vivitar 283 with 300 watt-
seconds of power onto the
dashboard, midway between
the driver and the passenger.
I used the bare-bulb mode,
so the wide spread of light
would reach both men. To
simulate dashboard lighting, I
covered the flash tube with a
Roscolux #18 flame gel. I ran
a long Paramount sync cord,
with a manual tripper
attached, to the back of the
ambulance. Using the flash's
power variator, I dialed down
the strobe to about quarter
power and got a flash-meter
reading of f/5.6 on Koda-
chrome 64. A Polaroid test
shot indicated that the shutter
speed needed was about 15
seconds. Then I climbed in the
back of the ambulance. I
selected areas of the chemical
plant with plenty of lights.
Using the Venca radio trans-
mitter, I opened the camera's
shutter and, midway through
the exposure, popped the flash.
The street lights created the
light streaks, while the cam-
era, moving at the same speed
as the ambulance, rendered
the vehicle and its passengers
sharply.*

While the advantages to modifying light sources are clear, you might be wondering if you can successfully use an unmodified light source. By this, I don't mean just a bare flash head, which has its own reflector built in, but a completely bare flash tube with no reflector or anything else to restrict the light. You wouldn't think so at first, and many location photographers are content to write off this somewhat off-beat light source.

But, in fact, a myriad of uses for the 360-degree coverage of a bare-tube light exists, and these are limited only by your imagination. Bare-tube light, which is also called *bare-bulb light*, produces shadows, but generally they are more open than those that straight flash heads produce. The resulting illumination is soft, but not as soft as umbrella or ceiling-bounced light. You'll discover that much of the character of bare-tube lighting comes from the surroundings in which it is used.

Because of its 360-degree spread, you can put a bare-tube light behind a person in a portrait setup. The light will both illuminate the background and serve as a rim or kicker light on the subject. If you need to light multiple planes or surfaces, such as two walls and a ceiling in the corner of a room, a bare tube can do what it would take three ordinary reflector lights to accomplish. Because of their small size, you can "hide" bare tubes in a lamp or lantern to simulate the type of light those sources ordinarily emit. If you're covering a party or a gathering in a large room, a bare tube suspended from the ceiling in the center of the room will function as a background

light wherever you point your camera. Then all you need to do is use an on-camera flash to provide the main light. What makes these lights so versatile is that, in addition to utilizing their wide beam spread, you can add a reflector and use them as a straight flash head that you can bounce into an umbrella. You can also put them in a softbox.

When I first started working for *Travel & Leisure* magazine, I met the late Dan Wynn, one of the most accomplished location photographers of the last few decades. He was shooting environmental-portrait assignments all over the world for the magazine and making beautiful photographs. I was shocked to learn that his lighting kit was a tiny bag filled with only two small powerpacks and several bare-tube lights. Wynn didn't even bother with commercially made reflectors: once on location, he bought some aluminum pie plates that he would tape to the bare tubes when he needed a reflector to bounce light or to use an umbrella. Wynn would stick a bare tube in the corner of a white-walled room and create a giant umbrella effect. He could make a few bare tubes look like a major lighting production. He didn't need a pack animal to move his gear either, which is probably why he had such a long and fruitful career in location work.

If your flash manufacturer doesn't offer a bare-tube head, try Light Tec's Enertec NE-1 head or Drama Lighting's DR-BH (see Resources on page 142). These units are adaptable to almost any strobe manufacturer's equipment. In addition, the NE-1 comes with a series of accessories, including umbrella reflectors and gel holders.

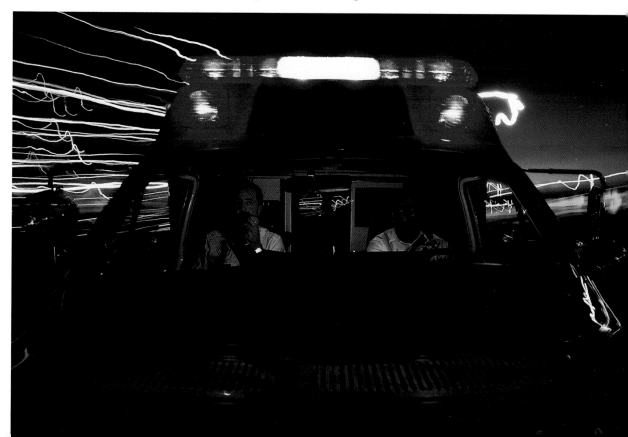

STUDENT WITH TELESCOPE AND FULL MOON, Massachusetts. Nikon FM2, Nikkor 20-35mm AF D zoom lens, tripod, Fujichrome Velvia exposed for 2 seconds at f/5.6.

During an assignment for Williams College in the Berkshire Mountains, I needed a dramatic shot of the new observatory. I was struck by the red "safe" lights used in it. The illumination makes it possible for students using the telescope to see enough in order to make their away around the observatory without losing their night vision. I had to recreate that light for this photograph because it was much too weak to record on film. I also wanted the student to have something to look at besides a bare sky, so I went outside and shot a roll of full-moon images with a 200mm telephoto lens, placing it in the upper-right-hand corner of the frame where I knew the observatory opening would be. I rewound the film, leaving the leader out, and reloaded it in the camera, being careful to align it the same way in the sprocket holes. Next, I placed an Enertec NE-1 bare tube, wrapped in a red gel, with 500 watt-seconds of power from a Dyna-Lite M1000x pack, behind the telescope and took a reading. I shot at dusk so that the sky would be royal blue instead of black. A Polaroid test helped me balance the strobe exposure with the night sky, and I had to trust that the moon would be in the right place in the final pictures.

SUPPORTING AND TRANSPORTING LIGHT SOURCES

Learning to use light modifiers is only half the battle of location work. Once you have them, you must figure out the easiest way to support them and get them to the job. This is more critical than it sounds. There is nothing worse than arriving at the shoot so exhausted from lugging your gear that you barely have enough energy to get the assignment done.

Quite unexpectedly, my career in location photography has given me a heightened awareness of the problems that physically challenged people who travel must face. Maneuvering a wheeled handcart loaded with heavy bags is similar to getting around in a wheelchair: you quickly realize how little of the infrastructure is set up to accommodate you.

Common items, such as revolving doors, escalators, staircases, and high curbs, can become nightmarish obstacles. Suddenly, you understand why barrier-free access is critical. Look for ramps and elevators everywhere you go, and don't be surprised at how infrequently you find them in places like airports and train stations. Despite their rarity, it is worth the extra time seeking them out so that you don't wear yourself out. It is much less stressful to roll your cart along flat surfaces searching for elevators or ramps than to hoist your gear up and down stairs.

Perhaps the most important aspect of assembling a location-lighting kit is keeping in mind that lightstands are like neckties: what appeals to one person may be absolutely repulsive to another. Buying a lightstand might seem to be the most straightforward purchase you'll need to make. But the many variations you have to choose from might drive you crazy unless you know exactly what you need. Consider the following criteria before you make up your mind about which lighting-equipment supports to get.

LIGHTSTANDS

This Photek 54-inch umbrella has a Converta Bank diffuser.

Height and weight are important features. A good, practical lightstand height for most applications is 9 feet. This is high enough for effective light placement in nearly every portrait situation, and the lightstand itself isn't too heavy or too long to transport. If you do a great deal of work in large industrial locations, you may find that an 11-foot stand is necessary for these high-ceiling warehouse and factory shots.

Not too many people consider the leg-spread diameter of a lightstand, but it can be a critical feature. The wider the leg spread, the more stable the light will be on the stand. This is particularly important for photographers who use monolights since the additional weight at the top of the stand requires extra stability at the bottom. Remember, though, that a wide leg spread increases the folded length of a lightstand. So once again, you have to weigh the importance of stability against that of size.

If you have a great deal of weight at the top of the stand, you might want to get an air-cushioned model. If one of the tightening screws works loose, the cushion of air will prevent the lightstand section from crashing down under the weight of the light. In the rough-and-tumble world of location lighting, this extra margin of safety not only saves you from injury, but also reduces the wear and tear on the lights.

BOOMS

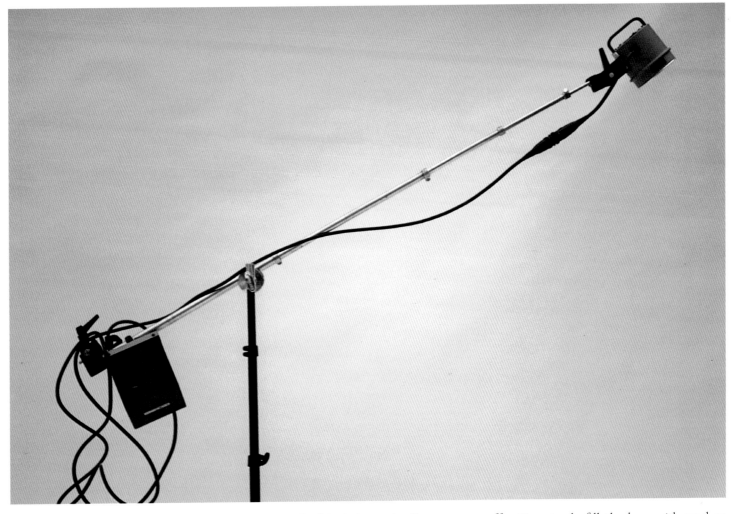

This is my crude but effective boom setup. It consists almost entirely of other parts of my lighting kit, so the only extra weight is the 20-ounce Matthews 2½-inch grip head, which I use as a boom bracket. I take the middle sections out of a PIC 228 stand and attach it to the grip head. I use the Dyna-Lite powerpack as a counterweight, slipping the handle over the end of the stand and holding it in place with a Bogen Super Clamp. The rig attaches to one of my Bogen lightstands. This isn't a particularly heavy-duty arrangement, but for my occasional use of a boom, it works.

Sometimes the vertical shaft of the lightstand will get in your way no matter how you try to avoid it. In these situations, a boom comes in handy. Essentially a crossbeam at the top of a typical lightstand, a boom enables you to place a light directly over you or your subject without any direct vertical support beneath it to clutter up the picture.

Booms are a mixed blessing for shooting on location. They solve a number of light-placement problems, but they are unstable: the physics of balancing a heavy object at the end of a long pole requires precise balance and counterweighing. Special boom brackets, such as those Bogen and Matthews make, are critical to pulling this off. Every boom bracket comes with a counterweight that attaches to the opposite end of the boom arm to balance the light. These counterweights are essentially a 6- or 8-pound hunk of metal with a hook and a tightening screw.

I consider carrying heavy counterweights to be an exercise in futility. I've found other ways to counterweigh a boom without toting around a hunk of metal that serves no other purpose. Try one of the plastic-bag counterweights that Lowell and other manufac-

turers offer. You simply fill the bags with sand or water when you set up the boom, and empty them when you pack your gear for transport. I've also used a clamp and gaffers tape to hang my flash powerpack at the end of the boom pole as a counterweight. As you experiment, you'll discover more and more objects in your lighting kit or on the location itself that you can press into service as a counterweight. Employ a little ingenuity, and you can save an unnecessary 8 pounds. Remember, when you travel, every ounce counts.

If working with a boom catches your lighting fancy, look into the Red Wing boom arm, the latest design on the market. Essentially a four-part arm in the shape of a parallelogram, the Red Wing boom arm is so perfectly balanced that you can swing it into any position with finger pressure only. Considering the construction of the arm, the counterweight is relatively light. The whole arrangement is bulkier and heavier than a standard, portable boom assembly, but the ease-of-use factor goes a long way in mitigating this inconvenience, especially if you regularly work with a boom.

ALTERNATIVE LIGHT-POSITIONING DEVICES

One of the corollaries of Murphy's Law states that the best shots on location always occur in the most crowded and inhospitable surroundings. So what do you do when the lightstand gets in the way of the shot or the boom arm is just too short? Fortunately, you can choose from a host of alternative methods of placing lights. Clamps, suction cups, magnets, putty knives—ingenious lighting-hardware designers have adapted these items in a number of ways for photographic use.

CLAMPS

I admit to being a gadget connoisseur. This started during my boyhood when I marveled at the way Batman could always reach into his utility belt for a gizmo that would get him out of a jam. Photography is a fertile field for the "gadget-phile," especially when it comes to lighting. The subcategory of photography gadgets I like most is clamps. Whenever someone comes up with a new way to hang a light or a camera, I just have to have it. The following clamps are a few of my tried-and-true favorites.

Bogen Super Clamp. This is a great device with a 2½-inch jaw and a wide array of support devices. These include 1/4-inch #20 studs and the versatile Bogen Magic Arm. This multi-jointed locking arm allows you to position a light (or a camera) just about anywhere at any angle.

Lowell Scissor Mount. This cleverly designed grip is a stud attached to a small scissor clamp that, in turn, attaches to the grid of dropped ceilings in offices and other areas. It is quite useful for hanging hairlights and background lights for portraits, including those shot in office settings.

Lowell Alligator Clamp. This is a large electrician's alligator clamp fitted with a 1/4-inch #20 screw and stud. The clamp, which is spring-mounted, is useful for positioning lightweight flash units in a variety of places.

COOL LUX PUTTY KNIFE

This is exactly what its name says it is, a standard putty knife; however, it has a 1/4-inch #20 screw through its handle that enables you to mount many diverse lighting devices. With this ingenious device, you simply slip the blade under books on a bookshelf, between the top of a door or window and the door or window frame, or under a stereo speaker, etc., in order to suspend the light.

MAGNAPOD

This small, round, magnetic disc with a 1/4-inch #20 screw through its middle allows you to mount a light to anything metal. The Magnapod's strong pull holds nearly anything, but you must be careful using a magnet around computer-operated flash units, like the Smartflashes from Minolta, Nikon, and Canon. You don't want the magnet to interfere with their delicate, computerized internal systems.

SUCTION-CUP MOUNTS

These devices, suction cups mounted with a 1/4-inch #20 stud, come in three sizes: 3 inches, 6 inches, and 10 inches. The smallest device can support most shoe-mount strobes, the middle size is good for small flash heads, and the largest mount accommodates large, fan-cooled flash heads. Although you need a clean, smooth surface for these to work and must take great care when you use them, they can be quite helpful.

My favorite clamps (clockwise from upper left) include: a C-clamp, a Lowell alligator clamp with a Gitzo ballhead, a Magnapod, a Cool Lux putty knife, a Lowell scissor clamp (center of picture), and a Bogen Super Clamp.

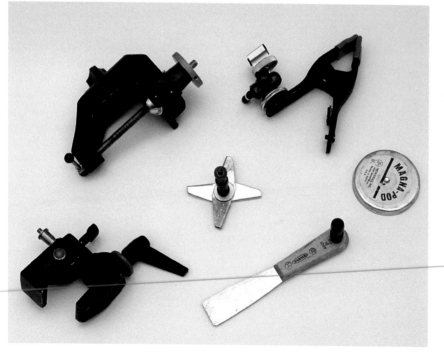

LIGHTING-EQUIPMENT CASES

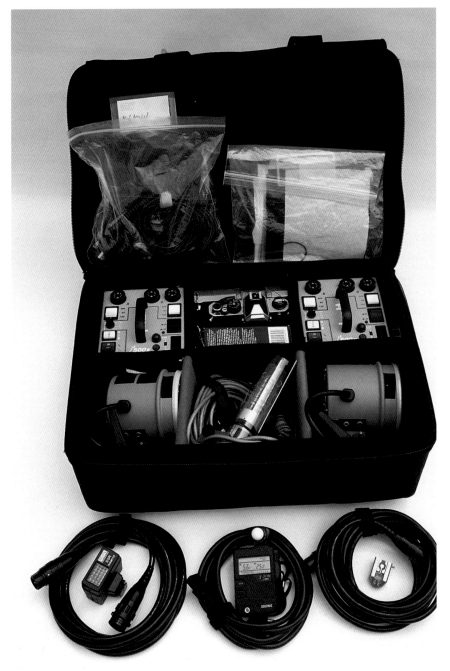

This is my main Dyna-Lite bag, a Lightware 1420 medium-format case. It holds two powerpacks, three heads, a Polaroid back, an infrared triggering system, a spare flashmeter, cords, slaves, and gels. In the outside top pocket, I carry a 25-foot extension cord for heads and a 38-inch Flexfill reflector. Although I usually check this bag as luggage, it meets the carry-on requirements of most airlines.

I remember sitting in the window seat on a connecting flight in the airport in Denver on my way to shoot a factory in Nebraska for an annual report. As I watched suitcases being loaded onto the luggage-conveyer belt, I saw the Lightware case containing my Dyna-Lite strobes get thrown on the belt, nearly sliding off the opposite side. Halfway up the belt, the bag in front of mine got stuck, and my case was neatly pushed right off, falling about 8 feet to the tarmac and landing on its corner. A luggage handler picked up the bag and threw it on the belt. I then spent the entire flight wondering how I was going to shoot a factory with broken lighting gear.

When my assistant and I retrieved the case in baggage claim, it looked dirty but none the worse for the wear. We took out the gear, plugged it in, and tested it on the spot, thinking that we would have to make a claim right away if the equipment were damaged. Fortunately, the three powerpacks and three flash heads worked perfectly. The 8-foot drop did nothing but scuff up the Cordura nylon outside. This incident dispelled any reservations I had about the then-new lightweight lighting cases made out of high-tech plastics and foams by such manufacturers as Lightware and Tenba (see Resources on page 142).

I'm not suggesting that a traditional, heavyweight, aluminum case wouldn't have offered the same protection as my nylon bag. Indeed, many photographers don't feel secure unless their gear is packed in cases that weigh as much or more than the equipment itself. But after years of bumping my knees and straining my back lugging heavy, hard-sided cases, I didn't need much convincing to switch to high-tech, lightweight bags. Many lighting-equipment rental houses in New York City send out their gear in these type of cases, which is more proof that these bags are generally accepted. I doubt that no gear takes more abuse than rental gear!

No matter what type of case you choose, however, you should look for one that has a flexible divider system rather than a built-in support system for one specific brand or type of lighting equipment. This way, if you ever switch brands or types of lighting equipment, you can simply reconfigure your bag, and not have to buy a new one. When I head for an assignment in the Caribbean, for example, I often pull the lights out of one of my Lightware medium-format equipment cases, move a few dividers, and replace them with my underwater housing and its assorted paraphernalia.

PACKING LIGHTING EQUIPMENT

The following list shows all of my lighting equipment and how I pack it (see page 126). I don't take every bag on every assignment. In fact, I often carry just my Nikon SB-24 and SB-26 flashes with small, SD-8 battery packs; one small lightstand; and a small umbrella shoved in my clothes suitcase! If I'm going on an assignment demands a great deal of lighting equipment, I can stack the entire system on my Nal-Pak TK-400 cart and head off for the airport—preferably with an assistant.

But since I work alone so often, I've made a science out of finding the smallest, lightest, and most compact version of whatever equipment I need. Tracking down these pieces of equipment may be annoying at first, but the aggravation they prevent along the way is well worth the initial trouble. Any photo assistant will tell you that one of the most stressful parts of hauling a luggage cart filled with gear is having to turn it sideways, bend down, and drag it through doorways because the lightstand bag

Here you see the lightstands and umbrellas I ordinarily use for location shooting, along with their case.

is too wide to fit through otherwise and you have too many bags on your cart to orient it vertically. This problem is particularly bad in Europe and other parts of the world where elevator doors are no wider than a typical man's shoulder span.

The bag that holds my lightstand and tripod is a Lightware 24-inch-long cargo case. This bag is much shorter than most bags of its kind; I found a tripod and lightstands that break down to that height and still do the job. Using collapsible, shock-corded poles for my medium Chimera softbox enabled met to pack it in half the space it takes up with rigid poles.

I can say with great satisfaction that when I pack these bags, I've been able to wheel my cart standing upright through every doorway on every continent I've visited. I've also been able to fit these cases in tiny taxi trunks. I can also say, with great pride, that I am one of the few middle-aged photographers I know who doesn't owe his soul to a chiropractor or orthopedic surgeon because of lower-back problems!

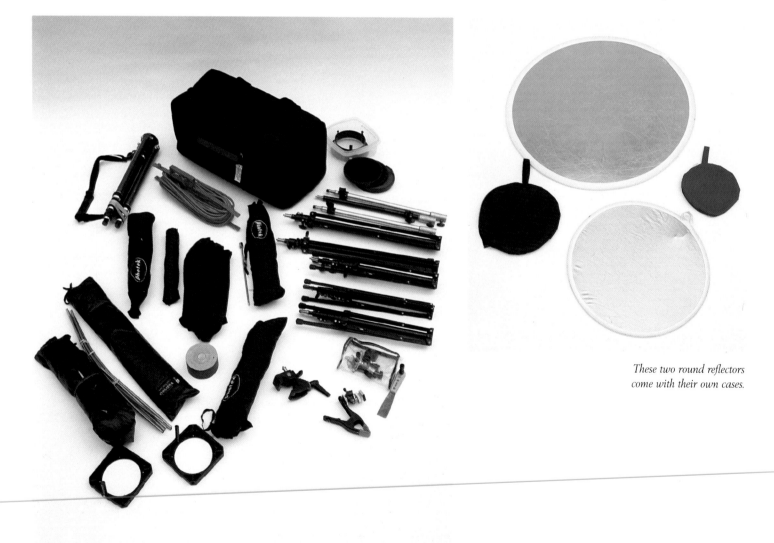

These two round reflectors come with their own cases.

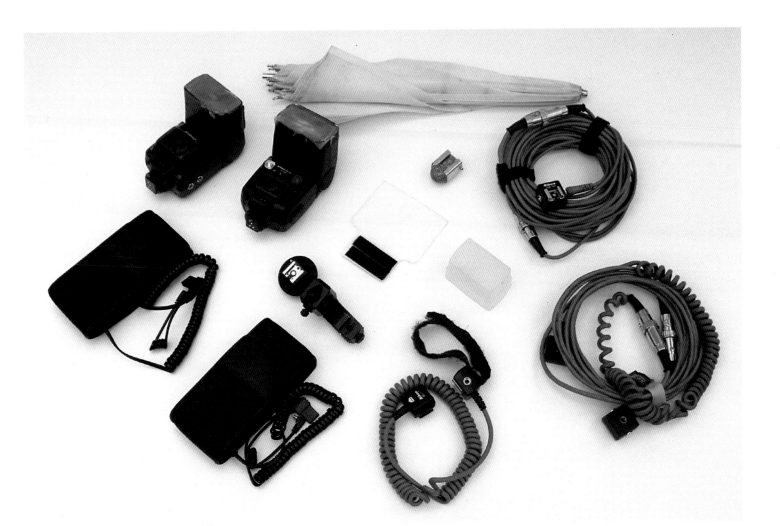

My typical light-duty lighting kit includes: two Nikon SB strobes, two SD8 battery packs, a 20-inch white umbrella, a Domke twin-flash bracket for holding the umbrella, a Domke Sommers fill card, an Omni-Dome diffuser, a Wein HS-XL slave, one regular SC-17 cord with a wrist strap, one modified SC-17 cord with a 12-foot extension, and one modified SC-19 cord with a 25-foot extension.

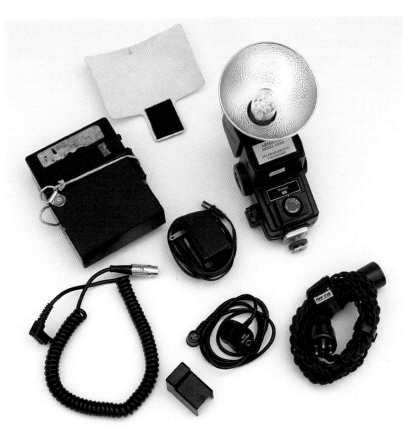

This is my Armatar 300 watt-second flash, complete with its high-voltage battery pack, cord, and charger, as well as a fill card, an extension cord with an auto sensor and a sensor shield, and a flash-tube extension cord that is known as a "strobe on a rope."

PACKING LIST

1 LIGHTWARE 1420 MEDIUM-FORMAT CASE CONTAINS:*
 1 Armatar 300 watt-second strobe
 1 Nikon SB-26 strobe
 3 Armato HS 350 high-voltage batteries with modules and
 cords for Nikon and Armatar
 3 high-voltage battery chargers with voltage and plug convert-
 ers
 2 Nikon SD 8 battery packs
 1 ziplock bag with 2 Wein HS-XL slaves, umbrella brackets,
 TTL connector cords, and Wein SSR infrared transmitter
 1 ziplock bag with various small clamps
 2 Bogen ART 3373 lightstands
 2 Westcott 38-inch collapsible umbrellas
 1 generic 20-inch umbrella with Domke twin-flash bracket
 and wrist strap
 1 stretched Nikon SC-17 cord with 12- and 25-foot extensions

* This case is often the only lighting gear I bring when I don't
 need the AC equipment. I add the 35mm Polaroid back in
 those instances.

Total weight: 36 lbs.

1 LIGHTWARE 1420 MEDIUM-FORMAT CASE CONTAINS:
 2 Dyna-Lite M500x powerpacks with cords
 2 Dyna-Lite 2040 blower heads with cords
 1 Enertec NE-1 bare-tube head with cord and reflectors
 1 15-foot head extension cord for Enertec bare-tube head
 1 Nikon FM2 with Polaroid back
 1 Wein SSR infrared trigger and receiver
 1 8x loupe for viewing Polaroids
 1 spare Sekonic L328 Flashmeter
 1 ziplock bag with spare PC cords and slave eyes
 1 ziplock bag with an assortment of Roscolux colored gels
 1 38-inch gold and white Flexfill (in case's outer pocket)
 1 Dyna-Lite 25-foot head extension cord (in case's outer pocket)

Total weight: 33 lbs.

1 LIGHTWARE NORMAN 200B CASE CONTAINS:
 1 Dyna-Lite M1000X powerpack with cord
 1 Dyna-Lite 2040 blower head with cord
 1 Enertec NE-1 bare-tube head with cord
 1 Lowell 800-watt Tota light with cord

Total weight: 12 lbs.

1 LIGHTWARE 24-INCH CARGO CASE CONTAINS:
 3 Bogen ART 3373 lightstands
 2 Bogen ART 3375 lightstands
 3 Bogen 3368 extension poles with connectors
 2 Photek 51-inch compact umbrellas
 2 Converta Bank diffusers for umbrellas
 1 Westcott 34-inch compact umbrella
 1 Dyna-Lite grid holder (in Tupperware container)
 1 set of three Dyna-Lite grids
 1 medium Chimera softbox with collapsible poles
 1 small Chimera softbox
 2 Chimera speed rings for Dyna-Lite
 1 Gitzo 320 tripod with Linhof ballhead
 1 50-foot extension cord
 1 roll of gaffer tape
 1 small bag of miscellaneous clamps
 1 piece of 4 x 6-foot black velvet
 1 small roll of Blackwrap

Total weight: 40 lbs.

1 LIGHTWARE 1420 MEDIUM-FORMAT CASE CONTAINS:
 2 Bowens Monolight Voyagers with cords and brackets
 2 Chimera speed rings
 1 ziplock bag with various plug adaptors
 1 ziplock bag with PC cords, backup slave eyes,
 and Roscolux gel filters
 2 25-foot orange extension cords

Total weight: 30 lbs.

SURVIVAL TIPS FOR ROAD WARRIORS

First, you should make yourself a packing list for each bag, especially if you're working with an assistant who isn't familiar with your equipment. Refer to the list often when leaving a location. Even if you know your gear intimately, you'll be surprised at how easy it is to leave pieces of equipment behind.

Use luggage locks with user-set combinations rather than keys. Assign one combination to all your locks. This way, you don't have to worry about losing keys or forgetting combinations. Put two luggage-identification tags on each of your bags in the event that one gets torn off in transit. Tape a business card to the inside of your luggage as well.

If you are over 5'10", look for a luggage cart with a long enough handle so you don't have to literally bend over backward to use the cart. Most standard luggage-cart handles are simply too short for anyone of above-average height. Two models have sufficiently long handles. The Nalpak TK-400 has a second set of small, fold-down wheels and is suitable for heavy loads. The large, rubber wheels of the German-made Ruxxac XL cart fold flat, so when the cart is collapsed, it is only an inch or so deep; you can slip it into a space only a couple of inches high. This is a great convenience with the tight space in most midsized-rental-car trunks and three-star business hotel rooms.

And remember, skycaps, porters, and bellhops are your friends! Enlist their aid whenever possible to help you with your gear and reduce the strain on yourself. Tip them generously and graciously. Whether a skycap or an airline clerk is tagging your luggage, double-check the tags to make sure your bags will be sent to the proper destination. If the handles of your Lightware or Tenba air case attach together with velcro, make sure that the airline clerk puts the tags on one of the side straps. The handles can easily pull apart, tearing off the luggage-destination tag in the process and sending your bag to never-never land.

Leave plenty of time for check-in, especially for overseas flights that require the X-ray screening of checked bags. Once on a flight to London, I crossed paths with a Virgin Airways security officer (who formerly worked for El Al). He spent nearly an hour examining the lighting gear in every bag, and even made me remove the fuses from my power-packs. This was no hardship, however, because I routinely check-in two to three hours before an international flight. You might think that I sound paranoid, but I have never missed a flight.

Be aware that while United States airlines charge by the piece for excess baggage, some foreign airlines charge by the kilogram! This usually isn't a problem when you use the same airline for both your intracontinental flights and your transoceanic flights. Ordinarily, the airline will honor the system used at the point of departure. But if you switch airlines in mid-trip, you might get hit with some enormous excess-baggage charges.

Try to carry spares of everything—sync cords, slaves, and meters, not to mention cameras, lenses, and flash units. You'll probably be lucky and you won't have to use them. Murphy's Law states that the only time you'll need a spare piece of equipment is when you don't have one with you.

Finally, although it might seem logical to pack all your heads in one bag, all your generators in another, and all your flashes and batteries in yet another, don't—even when you carry spares. Instead, pack your gear in small, complete working "modules." Then if one of your bags gets lost or turns up late, you still have enough equipment to work with.

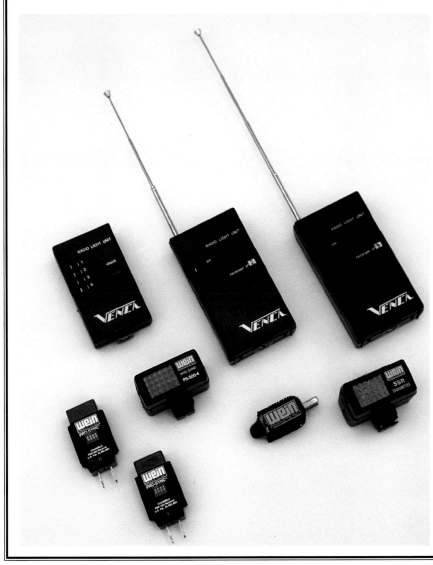

When I shoot on location, I have several cordless triggering options for flash: a Venca radio transmitter with two receivers (top), a Wein four-channel infrared transmitter with two receivers (bottom left), and a Wein nonchanneled infrared system with one receiver (bottom right).

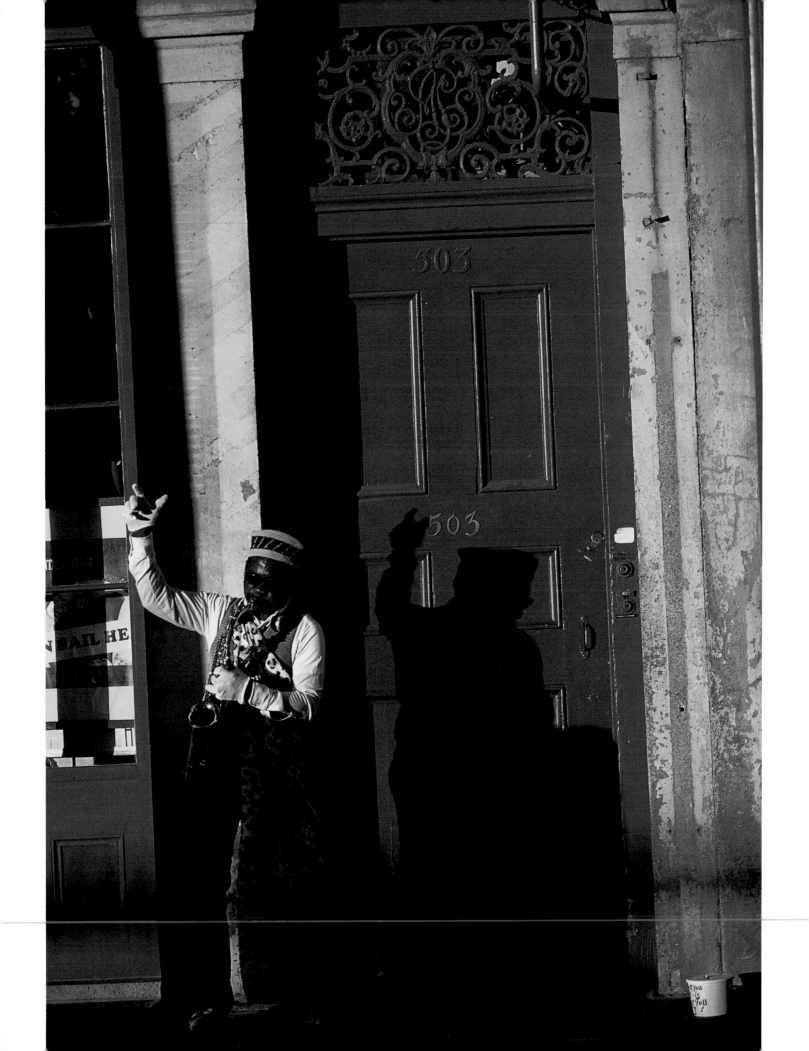

GALLERY

Working on a story about the French Quarter in New Orleans shot for Travel/Holiday magazine, I noticed these few shafts of golden, late-afternoon sunlight penetrating the arcade area surrounding Jackson Square. I also spotted this musician, who calls himself the Sax Machine, in the shadows. After some negotiation, I was able to persuade him to step into the light for some shots before the sun set.

Successful lighting on location is the result of a combination of hard work, a great eye, finely honed interpersonal skills, and a little bit of luck. Of course, the same can be said of successful location photography in general. As you've probably noticed in the preceding chapters, and as you'll notice in the following gallery, much of this success depends on your abiltity to deal with people. Many situations call for you to convince people to do what you want. This can range from something as simple as coaxing a pose from a subject to persuading a plant manager to stop an entire production for a while so that you can shoot a picture.

No pat formula exists for pulling off these situations. All successful photographers have their own method for accomplishing this. But throughout my career and while interviewing the master photographers included in this section, I've come across a couple of common approaches.

First, don't be afraid to ask. If you don't ask, you definitely won't get what you want. Don't automatically assume that you'll be turned down; you'll be surprised at how willing people are to cooperate. Second, don't bully. The old adage about catching more flies with sugar than with vinegar holds true in these situations. If you involve your subjects in the planning of your shot, they'll probably pick up some of your enthusiasm. Most photographers are able to use charm or to razzle-dazzle in order to get their way—although sometimes, such as in an emergency, you may have to resort to begging and whining!

In this gallery, six outstanding location photographers from the corporate and editorial worlds reveal how they handled some difficult situations (without pleading). Although their approaches are widely divergent, the photographers have in common ingenuity, intelligence, and the ability to improvise.

KEN HAAS

*Ken Haas has been travel-
ing the world on award-
winning assignments for 25
years, including two based
in Asia. His work has
appeared in scores of inter-
national publications and
on behalf of many of the
largest multinational corpo-
rations. Haas is the author
of The Location Photogra-
pher's Handbook and the
co-author of Cross-Cultur-
al Design: Communicating
in the Global Marketplace,
and his photographs illus-
trate the book Tango!*

CITICORP INVESTMENT BANK ANNUAL REPORT, England.
Nikon FE2, Nikkor 80-200mm zoom lens, tripod,
Fujichrome 100 exposed for 1/4 sec. at f/8.

This picture is from a six-week, annual-report assign-
ment for Citicorp Investment Bank. My brief in Lon-
don was to photograph the executives of a British
financial institution the bank had just purchased.
The client wanted the image to say "England."

I wasn't about to wrap these fellows in the Union
Jack, but I did request a shot of them wearing bowler
hats and carrying a "brolly" (umbrella). They refused.
Undaunted, I asked the art director to purchase a hat
and an umbrella at a nearby haberdasher. His brushy
mustache was perfect for the role, and I projected
this Hitchcockian shadow of him against a wall at the
edge of the frame. The shadow was placed there so it
wouldn't overwhelm the subjects and could be
cropped out if the client found it too whimsical.

The shadow was created with a simple Vivitar 285
with its adjustable head set to "telephoto," which
made the shadow hard and the beam of light creating
it easier to control. I funneled the light further by
wrapping the black paper lead from a pack of
Polaroid film around the flash head.

I used a long shutter speed to let the warm, ambi-
ent light burn in and to register the lighting from the
fixtures above the subjects' heads. I needed to fill in
the shadows with strobe, but prevent any light, nat-
ural or otherwise, from washing out the shadow I so
carefully created in the foreground. I set up Dyna-
Lite 800 packs with heads into umbrellas in each of
two doorways in the hallway and in the boardroom
behind the subjects, set at about 400 watt-seconds
each. Strobe meter readings and Polaroid tests deter-
mined the exposure.

The client approved of our little conceit, which
made me happy, as the art director was a big fan of
1940s radio shows, and his favorite was "The Shadow."

R. IAN LLOYD

One of the busiest and best-known photographers in Asia, Singapore-based Ian Lloyd divides his time carefully. He shoots editorial, advertising, and corporate assignments for a host of blue-chip clients; manages a thriving stock agency; and runs his own publishing company. He has photographed and published more than 30 coffee-table books, including Bali: The Ultimate Island and To Know Malaysia, and is the co-author (along with yours truly) of the upcoming Spirit of Place: The Art of Travel & Photography.

KECAK DANCERS, Bali. Canon EOS 1, 28mm wide-angle lens, Fujichrome Velvia pushed to ISO 80 and exposed for 1/30 sec. at f/5.6.

I'd been asked by an airline to photograph a group of 100 Balinese Kecak dancers, who gather in a circle and with hypnotic chanting and singing, reenact part of the great Hindu Ramanyana epic. The sound of 100 voices calling out in perfect unison is very powerful and sets the scene for a clash between the forces of good and evil.

I wanted a dramatic backdrop for the shot, so I chose the temple of Tanah Lot, one of the most sacred sites in Bali and famous for its dramatic sunsets. Once I actually settled on the location, the biggest logistical problem was not getting the dancers to cooperate, but keeping curious tourists and onlookers from wandering into the setup! I used security guards to handle that.

I'd determined the exact time of the sunset and planned to balance this light with some flash on the dancers themselves. When everyone was in position, I had only about 10 minutes to do a Polaroid test and correct any problems, as sunsets and twilight on the equator are much shorter than in other latitudes. To maintain an air of mystery and not overlight the dancers, I decided to use a single flash head at about a 45-degree angle to the group. I also warmed this up to simulate tungsten light by placing a warming filter on the head of my Metz 60 CT flash. The unit was on a lightstand about 50 feet away from me, and I used a radio slave to trigger it.

The first Polaroid looked bright, so I angled the flash away from the camera and raised the lightstand as far as it would go. To overcome the severe falloff and not overexpose the dancers closest to the light, I put a 6-inch piece of black paper on the bottom of the flash to act as a gobo, cutting out some of the light falling on the dancers in the foreground. The dusk was fading, and I didn't have time for another Polaroid, so I went ahead and hoped for the best.

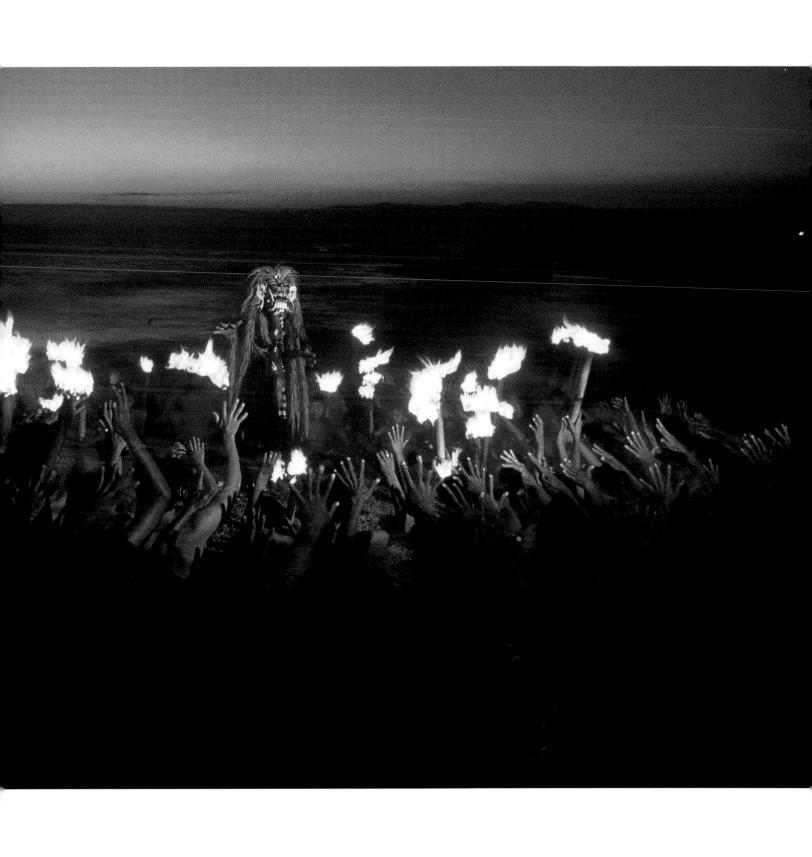

CHUCK O'REAR

During the course of his 25-year career shooting for National Geographic, Chuck O'Rear has photographed such diverse and difficult stories as "Money," "Bacteria," "The Silicon Chip," "Indonesia," "Vancouver," and "Napa Valley," to name a few. He has published two books, High Tech: Window to the Future and Napa Valley. O'Rear is known for his versatility, professionalism, and ingenious solutions to difficult technical problems.

LASERS, MOUNTAIN VIEW, California. Nikon FE, Nikkor 24mm wide-angle lens, tripod, Kodachrome 64 exposed for 5 seconds at f/5.6.

I was shooting a story about lasers for *National Geographic* and knew I needed a strong opening picture. In the course of my research for the story, which entailed making several thousand phone calls, I found a rare, multibeam, multicolored laser in a research lab of a laser manufacturer in Mountain View, the heart of California's Silicon Valley.

The problem with photographing lasers, of course, is that they are invisible unless they pass through some kind of vapor particles. Smoke is good but can leave a residue on the delicate optics. I solved the problem instead by using a can of compressed air, the kind you use to blow negatives and slides clean. Held upside down with the valve open (which is the incorrect way to use it for its intended purpose), the freon vapors pour out. You can trace the path of the laser, and it will become visible and register on film.

Once I had the laser visible, I still had to light the rest of the scene. I needed something to separate the scientist from the background. For a lot of my laser shots on this assignment, I didn't rely on my normal kit of electronic-flash equipment. Rather, I bought a bunch of 5-dollar outdoor reflector floodlights, the kind you use to light your patio, in a local Sears. I found their relatively weak output well matched to the lasers. They come in a variety of colors, and I used an orange one for this photograph, which I placed behind the scientist aimed at the back wall.

As I held the shutter open with cable release in one hand, with the other I traced the laser path with the compressed air cans (being careful to stay out of the frame). The output of the high-tech laser and the low-tech floodlight combined was enough to light the picture. Although I zeroed-in on the exposure with the help of a Polaroid test, I shot enough of them to nearly go through a case of compressed air!

JIM RICHARDSON

Long one of the most respected and well-known newspaper photographers in the country, Jim Richardson now freelances for National Geographic from his Denver home. He is a keen observer and sensitive photojournalist, and his award-winning books include High School, USA and The Colorado, A River at Risk. Richardson's magazine work often deals with hard-to-photograph environmental issues, like water quality and sustainable agriculture.

WATER QUALITY, MISSISSIPPI RIVER, Mississippi. Olympus OM4, 50mm lens, tripod, Fujichrome 100 exposed for 4 seconds at f/4.

I was assigned to shoot a story on the water quality of the Mississippi River for a special issue *National Geographic* was doing on water. For this story, I wanted to come up with a picture where the water would actually be the subject of the photograph, rather than merely a component. You can only do so many pictures of large bodies of water before they all start looking alike.

Wherever I went, the scientists and hydrologists were talking about the "water column." This term describes the turbidity, oxygen level, and other characteristics of the water from the surface to the bottom. The character of the water column determines, among other things, how much sunlight penetrates to the bottom and that, in turn, determines what plant and animal growth will go on there. I wanted to come up with a picture that would illustrate the concept of the water column and how light penetrates it.

I asked around, and one of the researchers actually had a 7-foot Plexiglas column that was used in some experiments. We sealed the bottom and filled it with water. To light the water column, I taped a Lumedyne 200 watt-second head to the top of the column. I ran black gaffers tape all around the top of the column to the water level because I didn't want any light to leak out—it all had to come through the water. I had a lightstand with the battery pack on the banks of the river holding the cord out of the frame.

I took a strobe meter reading of his face to get a ballpark exposure and shot a couple of Polaroids. I bracketed because the dusk light fades quickly.

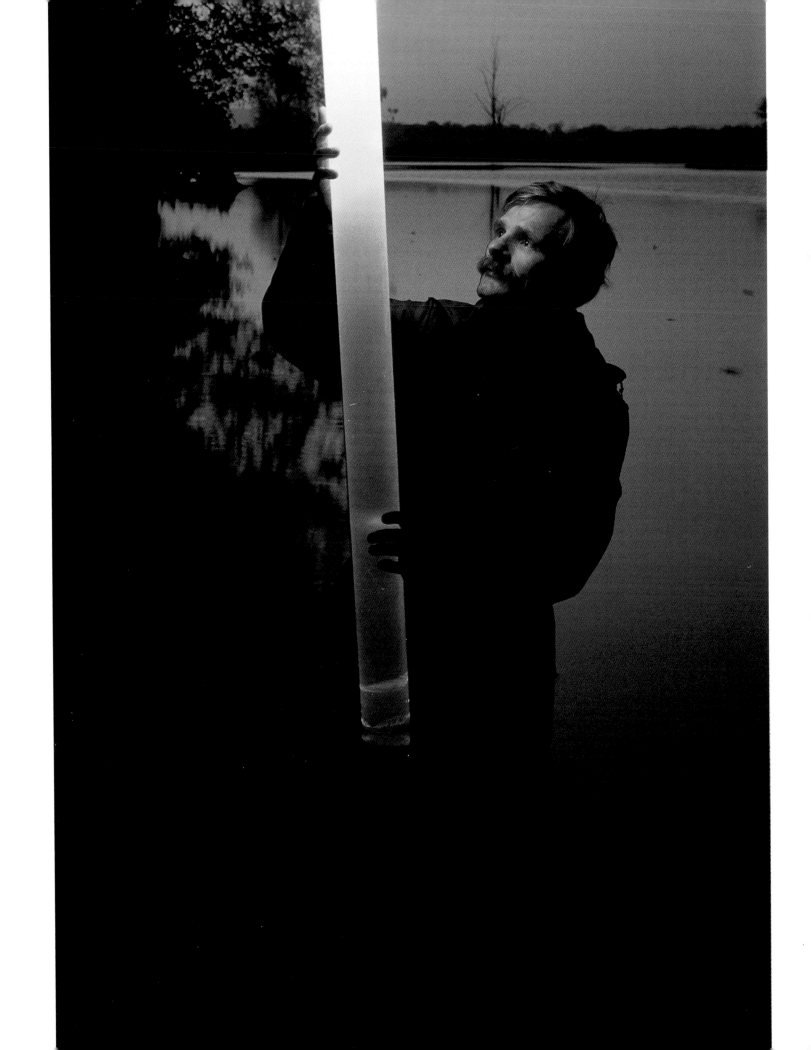

BOB SACHA

New York-based Bob Sacha roams the globe shooting award-winning photographs for National Geographic, Life, Fortune, Islands, Travel/Holiday, *and a wide range of corporate clients. An innovative problem-solver who seems to reinvent himself with each new assignment, Sacha is equally at home handling tough technical problems or shooting photojournalistic assignments that require a more intimate approach.*

MOAI, Easter Island. Two Nikon 8008s cameras, Nikkor 28mm wide-angle lenses, tripods, Kodachrome 64 and Fujichrome Velvia exposed for 15 seconds at f/5.6.

This image is similar to the lead picture from a story about Easter Island that I photographed for *National Geographic* magazine. The statues, called moai, are well-known symbols; they represent the seven brothers who first discovered the island.

Whenever I photograph a site that is as important to a story as these moai are to Easter Island, I make sure to cover it in a wide variety of ways—shooting at different times of day, using an array lenses in a variety of weather conditions. The idea of photographing the statues at night with star trails behind them appealed to me on several levels.

Since the legend says that the seven brothers first approached the island navigating by starlight, a night shot with stars in the sky would have some editorial significance. Also, I've photographed a variety of these mystical ancient sites around the world, and you really feel their majesty and power when you are out there at night.

Timing is critical when you're shooting at night. If you shoot too early in the evening, the long exposures blow the sky out; if you shoot too late or on a totally moonless night, the sky goes black. You don't get much opportunity to bracket in these situations since each exposure takes so long (about 15 minutes minimum). So to make the most of my time, I set up two cameras, each with different films but similar focal-length lenses. Using two films gave me a choice of color rendition, since each film reacts differently to these long exposures in terms of color and reciprocity failure (the tendency of film to lose some of its speed, or light sensitivity, during a long exposure).

I decided to "paint" the statues with light from one battery-operated flash, a powerful 600 watt-second MiniCam Master, set at half-power and covered with an orange gel to simulate tungsten light, which I would move and fire several times throughout a very long exposure. To retain an element of mystery, I used a low-angled light, sometimes called "Halloween" or "ghoul" lighting because of the eerie effects it has on faces, human or otherwise. I laid the flash on the

ground and took a reading. You have to go a lot on instinct when you shoot on location because it is nearly impossible to judge a Polaroid by the light from a flashlight.

Once I had my basic flash exposure, I set the lens to *f*/5.6 and simply opened the cameras' shutters, walked into the frame and laid the flash down on the ground (behind a pile of rocks I set up to gobo, or block, the light itself), aimed at the first two statues, walked out of the frame, and popped it with a long PC cord. I repeated the same procedure three more times as I lit the statues in the background.

I got off about four or five exposures that night, all of them at least 15 minutes long, and since I wouldn't see the film until several months later at the *Geographic* offices in Washington, I did what the Rapa Nui people are said to have done when they were searching for Easter Island: I prayed a lot!

JEFF SMITH

Jeff Smith's client roster reads like a "Who's Who" of corporate America: Digital Equipment Corporation, USF&G Insurance, and Stop 'N Shop, to name a few. Smith spends the better part of every year traveling the globe on annual-report assignments, and is known throughout the industry for his ability to pull off tough lighting challenges.

This picture of a Doppler weather radar station under construction was shot for Raytheon's annual report. Timing was critical, however, because the position of the fiberglas panels—which resemble a cracked eggshell in the final picture—would only be in that configuration for less than an hour during the construction.

The sight was outside Atlanta, and I carefully monitored the progress with daily phone calls. We arrived a day before the shell construction reached its critical phase to a host of logistical problems. The radar antenna is about 150 feet off the ground and another 150 feet from any electrical outlet. We visited Home Depot and picked up 1,200 feet of cable, which an on-site electrician hooked up for us. The large crane from which I was going to shoot was having trouble getting in position—heavy rains had turned the sight very muddy, and the crane's stabilizing legs kept skidding on the hillside.

Once the crane was stabilized and the electricity was in place, my assistant and I began to place lights. I used four Comet C24As with four heads at full power. I covered each head with a double layer of Rosco CTO to warm them up, and aimed three directly at the dish and bounced one off the interior of the panel. I triggered the lights with a Wein SSR Infrared transmitter and tested the setup by using Fuji 100C instant color-print film in an NPC back on my Nikon F4. With everything in place, we planned to return to do the shot early the next morning.

It was completely foggy the next morning, but that helped to suppress some elements in the background that could have been distracting. The eggshell was only going to be in that configuration for another hour, and by the time I got into position, nearly half that time was gone. To get a variety of framings, I used a tripod-mounted F4 with two zooms, an 80-200mm and a 35-70mm, each with an 80A filter to accentuate the blues.

I directed the worker by walkie-talkie, which became his prop in the picture. The hanging platform on the crane was very stable—in the beginning, when the light was low, the shutter speeds were in the 1-second range. I shot as long as possible, bracketing shutter speeds as the light got brighter. The resulting picture was one of several used on the cover of the report.

RESOURCES

Acme-Lite Manufacturing Co.
3659 West Lunt Avenue
Lincolnwood, IL 60645
(312) 588-2776
Lighting equipment

Agfa Corporation
100 Challenger Road
Ridgefield Park, NJ 07660
(201) 440-2500
Film, paper

Ambico, Inc.
50 Maple Street
Norwood, NJ 07648
(201) 767-4100
Filter systems

American Photo Instruments
12 Lincoln Boulevard
Emerson, NJ 07620
(201) 261-2160
PIC lightstands

Andrews Photographic
7401 Axton Street
Springfield, VA 22151
(703) 941-7568
fax (703) 941-8071
*Custom-modified Nikon TTL
flash cord*

Armato's Photo Services
67-16 Myrtle Avenue
Glendale, NY 11385
(800) 545 2774
*Custom-modifies Vivitar 283
flashes, battery packs, brackets*

Bogen Photo Corporation
565 East Crescent Avenue
P. O. Box 506
Ramsey, NJ 07446
(201) 818-9500
*Gitzo tripods, Elinchrom flash
equipment, lightstands, and
other gear*

Calumet Photographic, Inc.
890 Supreme Drive
Bensenville, IL 60106
(708) 860-7447
Bowens strobe equipment

Canon U.S.A. Inc.
1 Canon Plaza
Lake Success, NY 10042
(516) 328-4809
Cameras, flashes

Chimera
1812 Valtec Lane
Boulder, CO 80301
(800) 424-4075
Softboxes

Comet World
311-319 Long Avenue
Hillside, NJ 07205
(908) 687-8800
*Comet flashes, high-powered
battery strobes*

Domke Photo Resources
The Saunders Group
21 Jet View Drive
Rochester, NY 14624
(716) 328-7800
Camera and lighting-gear bags

Dyna-Lite Inc.
311-319 Long Avenue
Hillside, NJ 07205
(908) 687-8800
*Compact, rugged pack and
head systems; Uni-400
monolights; Jackrabbit
batteries*

Eastman Kodak Company
343 State Street
Rochester, NY 14650
(716) 724-6970
Film, paper

Fiberbilt Cases
601 West 26th Street
New York, NY 10001
(212) 675-5820
Camera and lighting-gear cases

F.J. Westcott Company
1447 Summit Street
Toledo, OH 43606
(419) 243-7311
Umbrellas, diffusers

Flash Clinic/Drama Lighting
9 East 19th Street
New York, NY 10003
(212) 673-4030, (800) 752-
7536
*Flash Clinic: equipment
purchases, rentals, and repairs;
Drama Lighting: adaptable
lighting gear, such as bare
tubes, zoom spot projectors,
and fiber-optic systems*

Fuji Photo Film, U.S.A. Inc.
555 Taxter Road
Elmsford, NY 10523
(914) 789-8140
Film, paper

Four Designs Inc.
9400 Wystone Avenue
Northridge, CA 91324
(818) 882-2878
*Converts Polaroid cameras for
use as testers, 35mm backs,
and AC-powered supplies*

Light-Tec
1311 Chemical
Dallas, TX 75207
(214) 350-8990
*NE-1 bare-tube heads
adaptable to many strobe
systems*

Lightware
1541 Platte Street
Denver, CO 80202
(303) 455-6944
Camera and lighting-gear cases

Lowell Light Manufacturing
140 58th Street
Brooklyn, NY 11220
*Complete line of tungsten
lights, and light-support and
light-modification gadgets*

Lumedyne, Inc.
6010 Wall Street
Port Richey, FL 34668
(813) 847-5394
*High-powered, battery-
powered strobes*

Magellan's
Box 5485
Santa Barbara, CA 93150
(800) 962-4943,
fax (805) 568-5406
*Voltage transformers, plug
adaptors, fax and telephone
adaptors, and other travel gear*

Matthews Studio Equipment
2505 Empire Avenue
Burbank, CA 91504
(213) 849-6811
*Mounts, clamps, scissor clips,
and heavy-duty stands*

Minolta Corporation
101 Williams Drive
Ramsey, NJ 07446
(201) 825-4000
*Cameras, some with cordless
TTL flash control; flash and
color meters*

Nikon Inc.
1300 Walt Whitman Road
Melville, NY 11747
(516) 547-4355
*Cameras; lenses; and SB-24, SB-
25, SB-26 flash units*

Norman Enterprises, Inc.
2601 Empire Avenue
Burbank, CA 91504
(818) 843-6811
*AC- and battery-powered
strobes*

Novatron of Dallas, Inc.
8230 Moberly Lane
Dallas, TX 75227
800-527-1595
AC strobes

NPC Photo Division
1238 Chestnut Street
Newton Upper Falls, MA
02164
*Polaroid backs for 35mm- and
larger-format cameras*

Paramount Cords
720 East 239th Street
Bronx, NY 10466
(718) 325-9100
PC cords

Photak
P.O. Box 2104
Neenah, WI 54927
(414) 722-8733
*Lighting gadgets, velcro wrist
straps*

Photek
909 Bridgeport Avenue
Shelton, CT 06948
(800) 648-8868
*Umbrellas, portable
backgrounds*

Photoflex Products, Inc.
541 Capitola Road Extension,
Suite G
Santa Cruz, CA 95062
(408) 476-7575
Softboxes, Lite Disc reflectors

Plume, Ltd.
432 Main Street
Silver Plume, CO 80476
(303) 569-3236
High-tech, compact softboxes

Quantum Instruments, Inc.
1075 Stewart Avenue
Garden City, NY 11530
(516) 222-0611
Battery packs, "Q" flash

R.T.S. Sekonic
100 Broad Hollow Plaza
Route 110
Farmingdale, NY 11735
(516) 242-6801
Flash and ambient-light meters

Rosco Laboratories
38 Bush Avenue
Port Chester, NY 10573
(914) 937 1300
Gel and diffusion materials

Sinar Bron
17 Progress Street
Edison, NJ 08820
(908) 754-5800
Strobes, view cameras

Smith-Victor Sales
Corporation
301 North Colfax Street
Griffith, IN 46319
(219) 924-6136
Quartz lights

Sto-Fen Products
P. O. Box 7609
Santa Cruz, CA 95061
(800) 538-0730
*Omni bounce diffusers, sensor
shields for Vivitar flash units*

Tamrac
9240 Jordan Avenue
Chatsworth, CA 91311
(818) 407-9500
Camera and lighting-gear bags

Tenba, Inc.
503 Broadway
New York, NY 10012
(212) 966-1013
Camera and lighting-gear cases

The Saunders Group
21 Jet View Drive
Rochester, NY 14624
(716) 328-7800
*California Sunbounce
reflectors, Domke bags and
accessories*

Tiffen Manufacturing
Corporation
90 Oser Avenue
Hauppauge, NY 11788
(516) 273-2500
Filters

Tocad Marketing Company
Division of Tocad America Inc.
300 Webro Road
Parsippany, NJ 07054
(201) 428-9800
*Sunpak strobes and video
lights*

Tokina Optical Corporation
1512 Kona Drive
Compton, CA 90220
(213) 537-9380
Lenses

Venca Sales International
6537 Cecilia Circle
Minneapolis, MN 55439
(800) 688-3622
Radio remote triggers

Visual Departures
13 Chapel Lane
Riverside, CT 06878
(800) 628-2003
fax (203) 698-0770
*Flexfill reflectors, Steadybags,
Suction Cup Mounts, other
accessories, HiTech filters*

Vivitar
1280 Rancho Conejo Road
Newbury Park, CA 91320
(805) 498-7008
Vivitar 283 strobes

Wein Products Inc.
115 West 25th Street
Los Angeles, CA 90007
(213) 749-6049
*Slaves, infrared and sound
triggers, other accessories*

White Lightning
2725 Bransford Avenue
Nashville, TN 37204
(800) 443-5542
Ultra monolights

INDEX